D1366656

Figuring Redemption

RESIGHTING MY SELF IN THE ART
OF MICHAEL SNOW

Figuring Redemption

RESIGHTING MY SELF IN THE ART
OF MICHAEL SNOW

TILA L. KELLMAN

Wilfrid Laurier University Press

WLU

This book has been published with the help of a grant from the Humanities and Social Sciences Federation of Canada, using funds provided by the Social Sciences and Humanities Research Council of Canada. We acknowledge the financial support of the Government of Canada through the Book Publishing Industry Development Program for our publishing activities.

National Library of Canada Cataloguing in Publication Data

Kellman, Tila Landon, 1943-
 Figuring redemption : resighting my self in the art of Michael Snow

Includes bibliographical references and index.
ISBN 0-88920-399-7

 1. Snow, Michael, 1929- —Criticism and interpretation.
2. Self-perception in art. I. Snow, Michael, 1929 - II. Title.

N6549.S64K44 2002 709'.2 C2002-900017-3

© 2002 Wilfrid Laurier University Press
Waterloo, Ontario, Canada N2L 3C5
www.wlupress.wlu.ca

Cover design by Leslie Macredie. Cover image: *iris-Iris* 1979 by Michael Snow. Colour photograph, acrylic paint, postcard, masonite, 121.9 x 119.4 cm each panel (2). Art Gallery of Ontario, Toronto. Photo courtesy Michael Snow.

Printed in Canada

Contents

List of Illustrations

COLOUR PLATES

Illustrations face page 100.

Acknowledgements

My thanks must go first of all to my husband, Martin, for his support during this project. I am indebted to Michael Snow for always encouraging my most speculative gambles, for his cheerful accessibility, messages about my mistakes, and for his irreplaceable help obtaining photographs. Without the generous thinking of Brian Henderson and Sandra Woolfrey, the truly patient current and former directors of Wilfrid Laurier University Press, and editor Jacqueline Larson, this work never could have been published. Thank you Louise Dompierre for initially piquing my interest in Snow's practice, and Yvonne Singer, Gerta Moray, and Patrick Mahon for offering trenchant, constructive criticism. Faye Van Horne, Felicia Cukier, Liana Radvak, and Anna Hudson at the Art Gallery of Ontario, Denise Leclerc at the National Gallery of Canada, and Suzanne Wolfe at the Canada Council Art Bank helped obtain photographs and answered numerous questions regarding documentation of Michael Snow's work. Thanks also to the Canadian Film-Makers' Distribution Centre in Toronto for permission to screen Snow's *La région centrale* and to make film stills. I am indebted to the late Zdenka Volavka, formerly professor of Art History at York University, for her support and advice even while she knew she could not live to see this project's completion. The collective interest of wonderful friends who put up with me for a long time while I was writing this kept me going. Thank you all.

Preface

The overall purpose of this study is to explore how the visual art practice of Michael Snow asks the viewer, "who?" This is the question of how spectators, you and I, implicitly renegotiate how we understand ourselves when faced with the task of making sense of a challenging piece of contemporary art. The project flows initially from the utopian idea, which has gained increasing acceptance in art practice since the period between the two world wars, that art potentially has the capacity to heal or redeem the self from the metaphorical wounds caused by the impact of rapid technological change on society. The self, my self as a problem of self-recognition, comprises my understanding of how, where, and who I am among others both real and imagined. Michael Snow's practice has focussed extensively on techniques of mass production in visual representation, especially photography and film, which is one place where technology finds a site in visual art. It is my contention that much art criticism written concurrently with Snow's production, and retrospectively, has placed the viewer in the artist's shoes and implicitly attempts to return the artist's view and its outcomes. However, what happens if the problem of the audience is turned around and addressed from the perspective of my self who comes later and faces Snow's work across an acknowledged gap created by the factors of concrete representation, my other time, place, experience, and (in my case) gender? Do these interventions necessarily mean that some value or capacity of the art is lost, or does

this displacement open multiple new, unforeseen connections and recognitions for you or me? As I see it, engaging with Snow's exceptionally funny, sensual, confrontational practice, with its obvious roots in the history of Western art, is not primarily an act of repeating Snow's experience or his process of working, but a precarious act of reading my way towards self-understanding and living among others. Because this study takes being a viewer as its problem, and I can only renegotiate my own self-understanding, the voice in the text oscillates between first-person engagement with art work and third-person analysis of art criticism and theories of discourse, reading, and writing.

Inasmuch as visual art, like writing, is a matter of figuration and notation, but so is computing loans or mortgages, the global phrase for the problem, "Figuring Redemption," leaped into mind while I was thinking about the relationship between Snow's use of mass production techniques and the running debate over technology and art. The paradox of the phrase opens a rich trove of ironic metaphors and puns about borrowing, interest, circulation of funds, etc., and frames the question of "who?" through metaphors of loans, speculations, and returns to the sight of my self. When Snow's frames mobilize and borrow my sight (comprising my everyday understanding of who I am), can the loan ever be repaid? What do I expect as a return, or do I gamble for returns that exceed legitimate interest, and what might that interest be? How do I figure redemption on "returns" of my sight to me?

Chapter 1 maps the question regarding the potential capacity for visual art, or reading and writing, to ask the question of "who?" as the problem has been considered and reconfigured by a group of twentieth-century writers. Although I have done my best to present relevant thinking by these writers as simply as possible, readers might want to return to this chapter after reading other chapters which play between the first chapter and Snow's practice. Seeing or thinking about visual art can illuminate texts as well as the other way around, although in our culture primacy is almost always given to the written word. For myself, I developed some understanding of certain of these texts only in the light of Snow's practice. The book studies groups of related work rather than following a narrative line or progressive argument. Consequently, the chapters can be read according to the reader's interest.

Snow's primary visual strategy engages the expressive and interpretative effects of framing. Framing is also the central metaphor in Martin Heidegger's meditations on how modern technology and mass reproduction cause the destruction of the self as it's traditionally understood in Western culture, and how art might have the potential capacity to redeem the self from this destruction. Both Heidegger and Walter Benjamin approached these questions from different points of view, and their answers in turn question what can or even should be meant by the redemptive capacity of art. For this reason, the end-

point—the capacity for art to figure redemption—becomes questionable: what can or should redemption be? What do we mean by it?

Next, I pursue a line of thought regarding texts or art works, reading, and the body; I respond to Heidegger but am wary of his fascist yearnings towards purity and the rejection of different forms of linguistic and corporeal contamination, real or imagined. This line of thought, developed especially through the work of Paul Ricoeur and Jacques Derrida, defines human beings as psychological with the problems that self-misrecognition incurs, but also rejects Freudian and Lacanian theories as the true interpretative key for this misrecognition. At the core of Ricoeur's and Derrida's thought is the important argument that there is neither a given "I" immediately known as my "true" self, nor transparent raw perception: we "read," whether texts, visual art, or snowstorms, towards a mediated understanding of the self. I hope to show how an enormous amount of criticism and visual art assumes that the viewer will stand transparently in the artist's place and repeat the artist's sight and experience. Ricoeur and Derrida demonstrate that this assumption is a fallacy. These two writers develop a theory of reception (seeing-reading) which challenges you and me to answer "who?" as readership establishes the field of representation, with the effect that you and I are not external message receivers or decoders, but belated producers of meaning included in the field around us. Their notion of readership establishes reading and understanding as desirous and intimate, and also as a promise made to and for others. Promising transforms desire into an act of love rather than simply desire. As a result, thinking of seeing as a type of reading transfers love and the problem of refiguring self-understanding into the public domain where you and I exchange recognition with others; this exchange destabilizes and has the potential to reconfigure understanding my self. This new notion of seeing-reading and self-understanding frustrates the self-absorption of Heidegger's poet-artist who listens only to himself and his neutralized, self-contained Conscience, a model which can be turned to bolster arguments defending purity of language and the bodies of those who speak it, or vice-versa. Frustrated as well are other models that formulate you and me as the end points of messages, or as consumers, or as units of a technology, for example.

The subsequent chapters place in conjunction elements of Snow's practice and the debate over reading and interpreting my self, and play off possibilities opened between the two. A controlling perspective from the first chapter is not applied to Snow's work for the latter to confirm or deny; rather, a conversation is opened on the slippery field of visual representation regarding self-recognition and understanding. Chapter 2 follows the *Walking Woman* through every medium and situation that Snow could think of, from painting to film, from subways to car doors to art galleries. The *Walking Woman* is simultaneously frame, figure framed by environment, autonomous figure, and a sign for sight,

all of which are also objects or sites. Chapter 3 focusses on the potential effects raised by the real and imagined transfer of images through Snow's framing sculptures and a photographic installation. While two of these use mirrors and two of them are only frames, all of them transfer my image away from me and return another to ask, who sees? Whom do I expect to see, or to see me? How do I recognize my self: through the eyes of an other, through yours, with love? Chapter 4 looks at Snow's anti-self-portraits, how they ask who emerges, or disappears, as he constructs a field of representation including you and me. Chapter 5 asks the question of self-recognition raised through Snow's beautiful and challenging film, *La région centrale*, too often ignored in favour of the well-known *Wavelength*. Although *La région centrale* is a film in which no people appear and for which no eye directed the camera, "who?" is the central issue. I am careful to place the film in the contexts of Canadian landscape painting and of literary criticism which have claimed that the collective Canadian identity is grounded in fear before a hostile wilderness. I argue that the film contradicts this line of thought, as has much historical Canadian painting, and that it opens far more joyous, complex possibilities. Chapter 6 explores and questions the often hilarious uncertainties promised by displacements that the circulation of images brings about, especially when the effects of institutions which circulate images, such as the National Gallery of Canada or a commercial postcard company, are taken into account. In the language of loans, interest, and redemption, both of the latter convert reading capital (a picture) into symbolic capital (e.g., scenes of nationalist interest) and cash (e.g., entrance fees, purchase prices). Yet, you and I pay the price and risk instability for a return of interest. So, what is the interest of the interest, and how does the field of circulating images refigure self-understanding and recognition for you and me?

Figuring Redemption

A THEORETICAL FRAME

INTRODUCTORY FRAMEWORK

Among contemporary Canadian artists, Michael Snow has achieved international pre-eminence for his witty, ironic practice of setting up contestatory relationships between subject matter, usage of medium, the Western art tradition, and the audience. Most criticism of Snow's work to date has judged the use and exploration of the intrinsic properties and capabilities of a medium. The viewpoint of this style of writing is either objective or nobody's. But while critics of Snow's work often mention his interest in the audience, their analyses of possibilities for the spectator have focussed principally on the viewer becoming conscious of material operations and thereby of consciousness.[1] One critic, for example, after evaluating one of Snow's films as "How it is is how it is," declared that the film was less a metaphor for consciousness than a form of consciousness itself.[2] Recent poststructural and postmodern criticism concerned with the viewer has argued often that Snow's practice is "distancing," concerned with loss of access to the "real world" or with disconnection from and even fear of an indifferent and hostile nature.[3] This view expresses the fear that mediation, especially by contemporary technology, damages humans' understanding of each other, of nature, of history, and of other cultural productions. Finally, feminist critics have argued that Snow's practice provides a viewer position that is

singular and thus patriarchal or Oedipal.[4] This would mean that, when looking at a work of art, we are obliged to see through the artist's eyes, understanding, and gender. In this case, our "sight" and understanding return to him, with all the masculine implications and exclusions.

But, pragmatically the audience is you and me, not some abstract spectator, and what needs discussion about Snow's practice is the funny, ironic, sensual, thought-provoking, at times offensive confrontation with the question of "who" in each of us. These confrontations and engagements in his practice raise the stakes in a gamble that questions not only the division between the "real" world and some mediated reality, but asks whether you and I can approach the "who?" of self-recognition only *through* mediation, and especially the media of mass production. And if art practice can open the question of "who?" in its viewers, then has lightning already struck and fractured the immediacy, certainty, and self-knowledge of "I am?" If "I am" is dispersed, how is my self to be accounted for, or refigured? And can, or perhaps should we expect that the calculation of refiguration through the mediation of Snow's practice add up to an ethics of redemption? This study might not, of course, answer these questions for everyone since it is a practice of readership and interpretation theory, one response to the question in Snow's work. However, the singularity of critical perspective over many years in the face of my own conflicting responses to Snow's work called for rethinking, for getting the conversation going again on a different track.

The guiding strategy of Snow's practice is framing. It acts as the signpost of mediation. Framing detaches the content of the frame from its context and "sends" it reconstituted as a picture or view to you and me. Snow's multiple frames, real and figurative, focus attention and sight on questions such as, "What am I doing?" "Is this to be seen or read?" or, in more pointed cases, "What is the difference?" Testing these sights, what are my possibilities? Snow's frames embroil my sight in different temporalities of viewing, tests of reading, references to historical Western art, and a vast network of visual and verbal puns, all conditioned by different personal memories and sensual responses. In photography, cinema, and other mass media, the mobilizing capacity of framing is augmented by different kinds of printing and other means of reproduction, which can be considered as mediation imitating itself and yielding returns with compound interest. So, when Snow's frames borrow my sight from how I understand myself to be, why do I risk this speculation, this self-dispossession? When, and if, the loan is redeemed, and this is where the interest comes in, what are my returns? Have I suffered damage or loss, or retrieved yields beyond calculation? How am I to figure my redemption, and what might that redemption be?

FRAMING REDEMPTION

I would like to look briefly at what "redemption" has meant historically, and then at its importance in a line of Western thought about the capacity for art to repair the damage wrought by technology in contemporary daily life. In a survey of the meanings of redemption, Mircea Eliade pointed out that the Latin *redemptio* literally meant liberation of one person after payment of a price or ransom by a second party to a third. This means that redemption was a tripartite, hierarchical relationship involving someone in bondage, an intervener who could and would agree to pay, and an owner or holder of a contract who could set the required compensation. Traditionally, then, redemption involves three parties with at least two, the intervener and owner, in negotiation. At the end, other relationships of indebtedness might exist, whether emotional or symbolic, with further obligations and rituals. Redemption was personal and its obligations on both sides did not necessarily terminate with release from bondage. In what must be the modern version of ransom, we redeem mortgages, loans, and credit card balances. Voluntarily, we submit ourselves and our future to relationships of indebtedness with a bank manager and the bank's institutional loan schedule. Possible interveners include family and friends, but otherwise the position of interveners has been collapsed into other institutional forms such as credit cards, lines of credit, or cooperative credit unions. From the other side, we might lend money. But the folding of interveners into institutions has meant that secular, financial redemption has lost much of its personal quality. As many complain, what does the head office of a large, chartered bank care about underemployed fishermen who fall behind on payments for loans in depopulating maritime villages? Of course as debtors, we want to restore our status of non-indebtedness; as creditors, we want our profits. These desires and necessities bring codified law and notions of moral obligation into the arena. But on all levels we are motivated by desire for "happiness" intertwined with some idea of freedom. While debtors seek liberation, creditors theoretically seek a just and sanctioned return on the volunteered risk of loss, a risk of dispossession. But face it, emotionally isn't such happiness likely to involve "more!" or, how can I make greater returns?

Crossing into the domain of belief and its taken-for-granted presence in daily life, Eliade points out that we understand redemption better within its long history of signifying salvation from doom or perdition wrought by the Saviour or by the individual, so that it commonly refers to divine or secular justice.[5] We beg, appealing to faith alone, for deliverance in a crisis, whether illness, accident, or financial ruin. Some of the earliest surviving paintings in Canada are thanks offerings for being saved from crisis—saved inexplicably except perhaps by faith (e.g., Michel Dessailliant de Richeterre [attrib.], *Ex-voto*

de l'Ange-gardien, c.1707; Hôtel-Dieu, Québec). In the same manner, we appeal for justice from juries and judges in courts. In all cases, internal to the understanding of redemption are power relationships: the power to judge and extract payment, the power to intercede, the power to make a loan, and on the part of the sufferer-debtor, a willingness to accept the conditions for redemption granted by another, in advance.

While the structure of indebtedness, promise, repayment and thankfulness might help keep personal and community ties open, it can turn poisonous. Despair and debt have in common a scenario of punishment which is part of the scene of redemption. Punishment carries with it a murky area of pleasure related to complicated notions of vengeance, sadism, guilt, masochism, and the fear of real or metaphorical contamination or condemnation. Consequently, punishment makes clear that the scene of redemption is not just about squaring accounts or freedom; it is about the conflicted emotions that produce desire. Now, the fact that we can talk of redemption and punishment as an imagined drama circulating around desire leads to the question in visual art of whether metaphorically redeeming loans, taking profits, or calling on divine intercession lays out two polarized viewpoints with which the spectator can identify: the passive, specular debtor-supplicant, target of the gaze and considered by much recent criticism as feminine; and the active gaze of the creditor or figurative Other (the bank, the Father, or the divine) conventionally termed masculine. If these are the limits of the notion of redemption in terms of the visual field, then redemption places you or me inevitably on the Oedipal stage, as Teresa de Lauretis argues.[6] What has become, in this contemporary and much-debated layout, of the third person, the intervener who pays the price? Is it possible that Snow's practice of circulating sight mobilizes the notion of redemption itself in terms of the visual field, opening it to reconfiguration?

One of the most cherished aspirations for Western art in the twentieth century has been that the practice of art contribute towards redeeming the self and society from real or perceived domination and damage wrought by the demands of globalizing technology. Today, as individuals, community and family members, or workers, many of us feel wounded by the technological imperative of efficiency, which prescribes that the greatest gain be extracted from any process for the least expenditure. As its effects on economic and social life are demonstrating, the demands of efficiency usually have the effect of closing down alternatives and redundancies, streamlining processes so that there are no byways. Photography is a site where modern technology and the field of visual art have collided since 1839, with the invention and release of the photographic process to the public in France.

Following on new advances in the chemistry of photosensitivity and printing, especially the advent of the *carte de visite* format and process patented in 1854,

photography granted unprecedented access to unbelievably realistic images through procedures seemingly untouched by human hands. It was also cheap and efficient. Over the next two decades, influential nineteenth-century critics such as Alphonse de Lamartine and Charles Baudelaire articulated a debate which set out art and photography as mutually exclusive metaphors for soul and machine. For reasons quite similar to those for which we criticize what globalizing business and electronic technology are doing to our lives today, these nineteenth-century writers condemned photography as a cheap and mechanical substitute for the mysterious power of art and its connections with the human soul. Yet, as John Tagg asked, was the real problem for these two major writers, as well as for many others, fear that access to inexpensive images posed a threat to the hierarchy of social values and classes?[7] What might be the real-world consequences if the capacity to make and interpret images were placed in the hands of the populace? Photography could be revolutionary; the social body could be imaginarily rent asunder. This same belief in the capacity for image-making to change the imagination that shapes the individual self, collective social values, and hierarchies continues today in projects which place cameras in the hands of the marginalized and disadvantaged, such as slum-dwelling children, in order to picture their lives. Practices like these respond to fears of critics similar to those cited above: previously unimagined sights project the unfamiliar, the desired, the newly imagined, and the feared with unpredictable results. In the context of a 150-year-long debate over the capacity for photographs to influence change in the self-image of individuals and collective groups, Regina Cornwell and Philip Monk recognized retrospectively that the camera was Michael Snow's implicit model for production, even for sculptural work of the 1960s.[8]

TALES OF FALL AND REDEMPTION

Among European philosophers and critics early in the twentieth century, Martin Heidegger and Walter Benjamin proposed that the technological imperative had precipitated a "fall" at both individual and social levels from a more integrated, organic self-understanding and mode of being with others and with nature. Their thinking remains contentious. Heidegger's work, much of it published after World War II, has heavily influenced poststructural concern with contemporary self-identity and language, as well as current debates on the effects of technology. It articulates and provides a history for so much of what we take for granted in our daily relationships to technology. His major essays on art and poetry, in which he calls upon the arts to redress the wounding effects of modern technology, sum up a perspective on the Western tradition concerning art and yet obscure some of its troubling, unsaid moral and political implications. Since this is the Western tradition, and yours and mine, being disseminated

throughout the picturing world, Heidegger's interpretation of the ends and function of art needs close examination. Walter Benjamin's writing, only now being widely translated into English, is finding an increasingly large reception among contemporary artists concerned with the impact on the self of image-making, memory, and modernity. Benjamin understood the dangers inherent in Heidegger's writing and in the larger Western tradition that saw individual identity as an organic whole which extended to family and nation. Despite their differences, Heidegger, the conservative philosopher of phenomenology and language, and Benjamin, the Marxist materialist, concurred in the possibility that, by recasting representation, the practice of art might rectify the wounded sense of self experienced in a technological society. Both question whether we can regard representation from an exterior viewpoint. Both of their accounts rest on the notion that presently "I" suffer, and so does society, but implicitly self and society were free of this burden at some time "before," even if how or when remains hazy. They agree that rather than a curse from an external source, the damage is something that collectively and individually we, like the Biblical Eve, brought and continue to bring upon ourselves by tinkering with our surroundings to better our lot. After Eve brought on the Expulsion as a consequence of her original experiment in humans' relationship to the rest of nature, Adam's labour and technology had to provide them with the means for sustenance. In the West, it seems that we have always given ourselves to ourselves as refusing to accept the status quo, and we look to technology as a way to better our lot and to get more.

———— • • • ————

In a lecture first given in 1938, between the world wars, Heidegger argued that the relationship between man and nature had been fundamentally altered by a basic change in representation brought about by modern science, especially by modern physics. Unlike previous forms of representation, modern physics defines knowledge as a sphere of research circumscribed by a law to be confirmed or disproved. The law sketches out in advance what will or will not be discovered and influences which method will be followed that can make use of the greatest possible precision, which means calculation. Following from this, nature becomes "the self-contained system of motion of units of mass related spatiotemporally."[9] Nature is transformed into what can be represented and investigated systematically and by calculation as *foreseen* by the representational-investigatory system, and emerges for the first time in Western tradition as what Heidegger called a world picture set before man who is already equipped and prepared for it—who can grasp it.[10] So, having set up the rules for the answer, I *already* know, but cannot know in another "language" or under other rules.

After World War II, Heidegger included technology under the same conceptual umbrella as science, joining the two in a codependent and synergistic circle. Just as modern technology differs from its predecessor because it is based on the exact science of modern physics, so modern physics depends on modern technology for producing precise instrumentation.[11] Furthermore, in an analogy to Heisenberg's principle in microphysics that the object is changed by observation, Heidegger turned this around to claim that the viewer is changed by the frame of technique without knowing it.[12] So, like Michael Snow, Heidegger was concerned with the metaphorically mobilizing capacity of framing. With the neologism Enframing (*Gestell*) Heidegger recast the ordinary meaning of *Gestell* (frame) as the distinguishing gesture of modern technology: it is a tool for imaginatively detaching and mobilizing whatever falls within its bounds.[13] When coupled with the technological imperative for efficiency, the notion of value is restricted to what can be mobilized, calculated, regulated, and especially stored up before being destined elsewhere at will. Any incalculable parameter of value is discredited and the world becomes a standing-reserve, which gives access to the dream of realizing mastery over the power of nature. Having turned Heisenberg's principle onto the observer, Heidegger concluded that observation of a non-substantive energetic network results in humans losing sight of themselves except as orderers commanding the network, or worse, as part of the standing-reserve network.[14] The capacity to reorder the world as numerable units of energy awaiting use as a resource is instrumentalist. This is the true danger, according to Heidegger, for as long as we consider technology only as instrumental, then we ourselves remain trapped by instrumentality.[15] Following from the reduction of truth value to calculation, other systems or languages of description lose their legibility as well as credibility. Consequently, I am relieved of my self-image—and of the ability to imagine alternatives—in any form or language other than that validated by instrumentalizing technology.[16]

Heidegger is claiming that the seduction of technology comes not just from its power, but from the fact that since we are born into an already technological age, becoming expert in instrumental thinking makes us feel more in tune with our context, and so we feel more powerful and find ways to exercise more control. We are "thrown" not only into seeing everything around us as equipment for our lives and already interpreted by everyone else, but also already seized by the technological mode of interpreting how the world reveals itself to us.[17] So we accept this state without much question; it is normal. Heidegger heaped scorn on general unwillingness to question the already-interpreted world and the "languages" shaped to achieve this. He called daily life the "they-world," the world as understood by mass consensus and perceived at the level of the lowest common denominator. Mass consensus is easy to accommodate and obstructs authentic understanding of how each of us can cast her individual possibili-

ties.[18] Now blind and deaf to other modes valuing and describing colleagues, friends, and especially nature as "world," the truth about "world" can no longer be pictorial at all. It is no longer valid subject matter for hypotheses probed through the paintbrush of Claude Monet, for example, but a domain to be represented and interpreted through scientific method and instruments such as the Hubble telescope. In the scientific paradigm, there is no way I might sight my self before Monet's paintings of a landscape in transition between agricultural and industrial values, unless that understanding were examined and quantified through objective sampling by the social sciences or neurobiology.

Looking at some of the visual research in the nineteenth century, and consumer products preceding photography, we can see the development of technology's seizure of popular perception. The previous model of the viewer-subject of the camera obscura was based on an immobile viewer, as was the case for perspectival painting. However, there was an alternative seventeenth-century tradition of theatre, tavern, and fairground scenography, and public or private rooms painted with continuous scenes around the walls. In retrospect, this tradition was a precursor to the huge popularity of painted panoramas as entertainment.[19] The first painted panorama, built by Robert Barker in London in 1795, mobilized viewers. Panorama painting brought perspective based on a central viewing circle to the tradition of wall painting, but you still had to walk and turn around. However, while tavern or fairground wall scenes were valued for "pure" entertainment, John Sweetman's research concluded that the attraction of panoramas was understanding: the desire to make everything graspable visually, a conclusion which confirms Heidegger's argument for the seduction of technological instrumentality.[20]

The model of the immobile, monocular viewer broke down before interest in isolating vision for scientific study. Nineteenth-century interest in vision was in part propelled by pure science and in part by the need to understand how to harness sight and the body to the industrial workplace. In both cases, vision was abstracted from the body and from its entwinement with understanding. The devices used to study vision by science paralleled adult toys such as the phenakistiscope and the zootrope, which utilized the capacity to see afterimages to generate the perception of motion. Both of these items were entertainment instruments available for purchase; they were analogous to scientific investigative tools; and they incorporated a viewer into the machine production of images.[21] In a similar fashion, the spectator was seated on a revolving platform and incorporated into a mechanical device designed for temporally unfolding visual experience in the diorama (a light show), perfected by Louis Daguerre in the 1820s.

However, one of the most pervasive interests for scientists by the 1830s was the fact that each eye sees a slightly different image, especially when objects are close. Binocular vision had been observed for thousands of years but now, for the

first time, it could be scientifically investigated and measured according to modern scientific method. How do our bodies and understanding reconcile seeing disparate images and, more acutely, how to measure it? Based on research into this problem, especially by Charles Wheatstone and Sir David Brewster in the 1820s and 1830s, the stereoscope was developed and became widely available to the public as entertainment in the 1850s.[22] Stereoscopes utilize slightly dissimilar images in sets of two, and produce a sense of depth which seems magical. After the development of photography the images were taken with two lenses the same distance apart as the average span between human eyes so that the photographs were crafted for the body. The public hunger for stereoscopic images was immense, despite the fact that the "reality" that they produce is highly illusionary and obviously a mechanical production. Yet, according to Jonathan Crary, single photographs ultimately displaced stereographs, as they had displaced the camera obscura, because they perpetuated the fiction of a "free" subject not bound to a machine, even though this freedom was itself only an illusion.[23]

In Canada the historical technological seizure of subjective vision can be seen in the production of William Notman, a Montreal photographer who was well-known throughout Canada, the eastern United States, and Great Britain. His beautiful photographs and stereographic images were made with the most advanced photographic techniques, equipment, and skill. His famous series of photographs of the construction of the Victoria Bridge across the St. Lawrence River in Montreal (1858-59), which were superbly composed, and precisely recorded and printed, and in some cases stereographically reproduced, set up a spectator equipped to challenge forth (in Heidegger's words) what appears in view. Above the wide sweep of water I look straight across a line of identical, giant stone piers. In severe, abstract stereo images, the gigantic enclosed tube of the bridge crosses the field of view. These are not romanticizing, picturesque photographs. I am challenged forth through precise techniques that make me a producer of a unified and starkly modern image, that make me subsequently a pragmatic consumer of stereographic equipment and photographs—standing-reserve several times over—demonstrating just to what extent I am foreseen by the world picture.[24] I am already a variable held constant, classified and addressed in a precise time, place, format, and economy. From Heidegger's devastating perspective, how can art rectify this situation by redeeming me, the spectator, from what amounts to a willing dispossession of my self—and my money?

——— • • • ———

Heidegger understood that both modern technology and the ancient Greek concept of *technē* participated in "destining" and were historically linked, so he appealed to their potential interaction through his famous quote from Friedrich

Hölderlin, "But where the danger is, grows/The saving power also."[25] Heidegger does not ask us to abandon modern technology; the task is to embrace it to turn the danger to advantage. So what relationship does *techné* open as an antidote to the "challenging-forth" of technological Enframing, and how is my sight lent to this transaction? Heidegger did not have much use for sight; it is too easily embroiled in the everyday distractions of the chattering "they." Sight was part of curiosity, idle talk, and gossip.[26] Yet, in visual art, the quality of *techné* approaches me initially through my eyes and for Heidegger, *techné* also means the ancient Greek idea of revealing "whatever does not bring itself forth and does not yet lie here before us."[27] Although *techné* shared the property of *physis* (nature) of bringing-forth what lies concealed, the revealing proper to *techné* does not happen naturally, as with plants from seeds, but emerges through the intervention of craftsmen or artists.[28] Materials and techniques must show themselves as proper and natural to the project at hand, figuratively indebted to it, so that the decisive difference between *techné* and manufacturing or utilitarian, mindless fabrication would be visible as a sort of power unleashed from materials and means to result in a project with visible integrity, which says something other than, as well as, the form-material relation.[29] So the work of art is neither just a thing nor equipment that facilitates daily life. Rather, it brings together objects, or materials and their associations, from radically different domains in a manner that they become symbolic.[30] *Techné* encompassed not only fine art but craft and the "arts of the mind," so that all of these were brought into the realm of thought. As Heidegger presented it, inasmuch as ancient Greek culture conceived of truth as unconcealment, *techné* could reveal knowledge. Before the emergence of modern technology, he argues, *techné* belonged to *poiēsis*, the bringing-forth proper to the arts and poetic language. So art, craft, and certain modes of thinking were poetic and truthful.[31]

In contemporary terms, we could think about Pablo Picasso's *Head of a Woman* (1931; artist's estate) made from pitchforks, colanders, and other scrap, or Michael Snow's photographed grid of trash objects clamped flat under Plexiglas (*Press*, figure 7). But one of Heidegger's own famous examples of *techné* is an ancient Greek temple, chosen for being non-representational and removed from its cultural context and time. While he admits that the contextual "world" of historical works is permanently lost, that does not mean that they have become mere objects or have no current "world."[32] The temple ruin remains clearly related to its material, stone. Heidegger calls the stone "earth," meaning both parent material and metaphorical ground, a play on words joining temple construction to philosophy, but also a rhetorical device connoting origins and authenticity. The temple not only has its own resolved design but coaxes forth the capacities of stone (strength, shape-holding ability, grain, reflectivity, colour, etc.) to appear in ways that are not visually and symbolically meaningful when the

stone is just lying around before artistic investment in it. When a work is properly executed, the artist has revealed material, means, object, and the artistic capacity to envision this creation as proper to each other. For you and me, coming later, the temple offers the potential to project a world revealed in the relationship between how material has been brought into the project and the temple itself, because it draws us into projecting new possibilities for dwelling on the earth with others in a way suggested by the "world-earth" relationship in the temple. The temple, or work of art, changes my world and relationships, and thereby my self-understanding, if I have "seen" it. The ground shifts beneath my feet.

The world-earth relationship is Heidegger's predominant visual rhetorical figure, through which he sets forth the relationship between "earth" and "world" as an ongoing struggle which produces and maintains a "rift." The "rift" incorporates, let's say incarnates, this struggle between the two. Although these terms remain somewhat obscure, Heidegger must be given credit for writing what he meant, so the difficulty of these concepts must have been his choice. This choice parallels his binary regarding art and truth, concealment/unconcealment. Heidegger rejects the world-earth struggle as the simplistic romantic convention of wresting form from nature. The language in which Heidegger works out this figure is unabashedly erotic, although "earth" and "world" do not fall into simple and mutually exclusive masculine and feminine roles: "The world grounds itself on the earth and earth juts through world....The world, in resting upon the earth and strives to surmount it. As self-opening, it cannot endure anything closed. The earth, however, as sheltering and concealing, tends always to draw the world into itself and keep it there."[33] The conflict is constitutive of art, or how art comes to be recognizable, so that the work *to be* art is based on this visible differential. Whereas the "rift" is the delineation between "world" and "earth," it keeps them together as opposition between measure and un-measure, or bounded and boundlessness.[34] The task of the work is to hold forth this relationship of struggle while setting it back into the safekeeping and shelter of "earth."[35] This means that one of the primary truths that art "unconceals" is that "earth" is not dumb matter, but material that remains potentially invested by and for the work, metaphorically pregnant, as Heidegger's language suggested.[36] However, if "earth" is already invested by the work, the earth's characteristic of "self-seclusion" must be considered suspect.

For example, consider a sculpture by Constantin Brancusi, *Fish* (1930; Museum of Modern Art, New York). *Fish* is a superb simplification of shape carrying connotations of speed and easy passage through water. You or I can see how the strong contour, the choice and treatment of streaked blue-grey marble that make *Fish* "flip" between form and material, and beyond. Given the characteristics of fish, stone would seem an unconvincing material, or a mere story-telling material. But Brancusi offers neither realistic appearance nor stories. He

overcame the visual weight of stone by proportions and polish, and by balanc-
ing the piece atop a small white cylinder which floats *Fish* in the air above a
broad cylindrical base. The fine, wavy surface pattern and smooth polish are def-
initely "marble," and its less than complete absorption into reporting a fish
keeps this fact of marble alive. However, the stone also metamorphoses into my
experience of reflections, the wetness of water, and slipperiness of a fish. The
marble as mute rock "disappears," while its potential for action does not. What
is caught sight of is a complex relationship between fishiness, water, and stone,
and something to do with my self, but not technologically Enframed.

However, a work by Michael Snow, *Immediate Delivery* (1998, colour plate 1),
raises doubts about whether Heidegger's thesis regarding art as the manifestation
of the world-earth struggle in visual art or criticism is universal.[37] *Immediate
Delivery*, a backlit transparency and light box (including electrical cord and trans-
former box), presents all of the materials that went into making this piece in an
ironically improvisational style. Framed and backlit by the light box, the trans-
parency pictures a clamped, taped, and precariously balanced tangle of brilliant,
transparent theatrical gels along with items such as pieces of wood and cardboard
tubing, studio lights, photographic equipment, vacuum cleaner parts, pieces of
steel, duct tape, step ladders, a bicycle tire, and clamps which hold it all from the
"inside" to the invisible picture plane that presses against the material from my
side. The studio lights light the image from behind, so that the real light box
mimics their action. At the back of the picture, containing the pictorial space, is
a large light box (the same as the "real" frame?), back side towards the front plane.
Like much of Snow's work, *Immediate Delivery* delivers a joking commentary on
the primary problem of drawing, painting, photography, and film: the reduction
of three dimensions to two. The real light box, cord, and transformer thrust the
piece back into three dimensions, so that it stands between two and three dimen-
sions. There are sly references to many problems such as the construction of per-
spective and illusion, foreshortening, photographic processes, as well as the his-
tory of still life and framing, and to some of Snow's previous work. Besides the
light box, the transformer box on the floor and the cord are re-presented in the
transparency, so that every element in two and three dimensions is connected
and nothing can be left aside as uninterpreted. There is no concealed truth
revealed there, no unused or uninterpreted material left in reserve as "earth,"
and no "nature," either. I see artistic materials, references, and problems of pro-
duction and reproduction contained in the space where they must work. This
work does not promise access to the sight of an ever-receding Being or the uncon-
cealment of the concealed hazily intuited in the "rift" between invested matter
and a notion of properly indebted form and materials. This jumble of materials
from daily life mixed with studio equipment makes fun of the idea of a previously
envisioned form for which materials are "properly" or appropriately selected.

Instead, *Immediate Delivery* refers to the messy, improvisational, and fun-filled studio practice of using casual materials from the street and hanging around the studio, and involving the artist's own prior pieces and ideas. The materials are put together in a pun on a balancing act, sometimes aided by tape, but drawing upon each other materially, metaphorically, and by historical association.

The title tests what, in this entanglement, gets delivered immediately. There is no question that *Immediate Delivery* is seductive visually in just the curious and distracted way that Heidegger denigrated as the mode produced by technological Enframing. Brilliant colours and dynamic composition compel my immediate visual and kinaesthetic response. But rather than being idly curious, I can hardly tear myself away. The colours and amusing objects secure my attention for the long time that it takes to sort through the complexity of items and their relationships, along with their allusions and jokes. So what is immediately delivered is my sensuous, embodied sight, while the rest follows over an extended time. I find my self operating at different speeds, but not divided between flesh and mind.

Heidegger acknowledged that sight was more than simple perception. He even thought that truthful encounters with things in themselves, and even access to Being, were possible through sight, events which let *Dasein* encounter itself and sight as understanding.[38] Nonetheless, he demoted sight (but not hearing, touch, or speaking) because of its immediate, primary quality to the everyday world of distraction.[39] His denigration of sight becomes important in his assessment of the task of art because it permitted him to validate spoken poetry as the pre-eminent Western art, and because he had a contemporary, discursive view of art. To be art, a work needs "preservers"; it requires our sights from beyond its borders. This reinforces his notion that art is not only an object, but language-like. We don't just see works of art, we interpret them by projecting our own possibilities upon the world opened by the work. Finding myself as a preserver is an unforced, discovered relationship which renews itself (or not) each time. There is no guarantee that I will arrive on the scene, and I'm not expected to re-experience the artist's vision, for what I "see" will happen, for me, for the first time. This is one of the meanings of the "origin" of the work of art: in the realm of art, the artist and I are co-creators of the work, while the piece validates itself as art if the art/preserver relationship succeeds in establishing itself.[40] Neither is this a private experience. Since the work makes something known publicly, Heidegger argues, then I am brought into this realm and my understanding is affiliated with public knowledge.[41]

There remains the problem of the redemption of my self from the forgetful sight of Enframing through the intervention of the world-earth struggle and the "rift." The world-earth struggle unveils truth *as* unveiling or revelation. Heidegger claimed: "This opening up, i.e., this deconcealing, the truth of beings, happens

in the work."[42] Since the work of art includes my self among "preservers," Being is the unconcealedness of beings, not as a fixed order or static state, but as a dynamic interrelationship opened by my comportment towards concealing and revealing. The revelation of how I comport my self in relation to revealing must be part of the work. So it can be said that I find my self in the "rift," working upon and worked over by the work of art, and not conforming to previously recognized sights of my self.

In the experience of the work of art, the truth of Being as concealment and revealing leads to understanding that beings can remain concealed to various degrees of which I remain uncertain. Another condition in the play of beings is dissembling, which reveals itself as my problem: an ability to be deceived. "World" is not simply a clear, positivist vision for me to take on as a possibility, and "earth" is not simply concealment, since "world" has been set back into it, but "clearing" as comportment towards revealing is a task that requires decisions. Ironically, the decision to "clear" is both the will to let go of preconceptions and the desire to impose my view or master a problem. While this paradox might seem to grant the benefit of a more holistic view, it has unforeseen implications: "Every decision, however, bases itself on something not mastered, something concealed, confusing; else it would never be a decision."[43] "There is but little that comes to be known. What is known remains inexact, what is mastered insecure."[44] This decision to guide my comportment to let beings be encountered in a non-Enframing manner does not secure my knowledge or confidence but, on the contrary, fills me with anxiety. With this concept of truth and its relationship to how I see and understand other beings and my self, Heidegger has dethroned, destabilized, or decentred (to use various contemporary terms) the notion of the Cartesian, self-knowing subject and master of knowledge.

However, even Heidegger admitted that the whole program of truth as unconcealment, alētheia in the broadest sense, was not something that the ancient Greeks defined or thought out.[45] Alētheia, poiēsis, technē, the forms of truth as unconcealment which give access to the Being of beings, are Heidegger's modern reading of the past made in order to usurp the universal, historical validity in the present-day West of truth as conformity to fact and of the Cartesian self, master of measure and the universe. Truth as unconcealment is something that Heidegger infers, interprets through fragmentary texts, and certainly desires. It could be called his own projection for possibilities. As an explanation of a decisive concept projected back to the origins of Western thought and given a structure that will supposedly sustain it in an unknown future, Heidegger's concept of truth in the work of art verges on the mythical.

The relationship between the work of art and viewers, for Heidegger, was also burdened with nationalist undertones ("The Origin of the Work of Art" was first published in 1936), a problem which became more evident in his later

essays on language. While his viewer-based theory of reception and its relationship to negotiating personal identity have been enormously important and continue to be attractive, skeptical scrutiny is required when Heidegger liberally expands "earth" to native ground, and "world" to the projection of possibilities of a people unified by family, history, strife, and civilization. While making art was never simple fabrication for Heidegger, "setting up" a work of art became "holy."[46] Heidegger used the temple as an example which embodied aspirations of the holy, nation, history, civilization, and related attributes:

> The temple-work, standing there, opens up a world and at the same time sets this world back again on earth, which itself only thus emerges as native ground....It is the temple-work that first fits together and at the same time gathers around itself the unity of those paths and relations in which birth and death, disaster and blessing, victory and disgrace, endurance and decline acquire the shape of destiny for human being. The all-governing expanse of this open relational context is the world of this historical people. Only from and in this expanse does the nation first return to itself for the fulfilment of its vocation.[47]

Quoting Hölderlin yet again, Heidegger claimed that this problem still confronted Germans as a test.[48] So, Heidegger's analysis shifts rather abruptly from an inquiry into the function and reception of art addressed to individuals (e.g., what happens when I visit Paestum or look at a painting by Van Gogh?) to a nationalist project placing an historical people on their native and holy ground.[49] This is a danger-fraught step, as both German and European history have shown, and moves towards connecting the history and reception of art with justifying the aims of German National Socialism of which, it is now public knowledge, Heidegger became a formal supporter. For these reasons, Heidegger's project, including recovering access to the Being of beings, truth as unconcealment, and especially the recovery of my self-understanding and self-recognition through his interpretation of the functioning of art, need to be seriously re-thought.

Heidegger's displacement of sight, in the process of understanding how I understand my self in the world and with others, left him free to elevate spoken poetry to the highest artistic medium and achievement. While Heidegger regarded *technē* in the fine arts as poetic, he argued nonetheless that spoken poetry was the privileged domain of *poiēsis*. Unlike visual art which, he thought, unfolded in a space already cleared by language, in poetry things and "world" are nominated into being for the first time (which suggests that Heidegger had a notion of visual art based in realism).[50] While we might believe, reasonably in terms of everyday experience, that things endure while language and words change, Heidegger argued the reverse: "Where word breaks off no thing may be," suggesting that things *persist* for us, or even *give themselves* poetically to us for

the first time, experienced through language already our own.[51] For this reason *poiēsis* potentially escapes the instrumental fate of technological Enframing which "speaks" in units predetermined by the demands of technological ordering. But why is it important to name the world in a language "already" ours?

The privilege that Heidegger granted to language, especially to spoken poetry rather than written language, makes the notion of discourse and even poetic productions in other mediums problematic. His reasons are troubling. As he had discussed in *Being and Time*, at the origin of Western thought the ancient Greeks had described human being as the entity which discloses its world and self in talking.[52] Integrating the senses and musculature of the body with language in the most intimate way, spoken poetry brings the speaker closer to his essence (only male poets are cited), granting access to the Being of beings in the everyday world and consequently to his Western cultural origins in the language and thought of ancient Greece. Heidegger ransacked Friedrich Hölderlin's poetry to find references to mouth, ear, voice, and vision, freed from organism and delivered over to the true organ, spoken poetry.[53] Heidegger himself added lips, teeth, tongue, even the larynx, as well as the hand because handcraft is rooted in thinking, and thus language.[54] He denied that the self is in any way indebted to language because "language...is the foundation of human being. We are, then, within language....A way to language is not needed."[55] Finally, Heidegger quotes Hölderlin's lines from a draft entitled *Mnemosyne* (the muse of memory): "We are a sign that is not read./We feel no pain, we almost have/Lost our tongue in foreign lands."[56] Whereas Heidegger had called mankind a sign pointing to nothing, Hölderlin himself indicates that a sign, including a human being, is codified to be read. However, lacking readers competent in the proper (i.e., native) language, we become illegible for bodies and languages ("tongues") less "our own."

Each of Heidegger's references to a part of the body absorbed by poetry is accompanied by a denial that these organs belong to the kind of human being termed *homo animalis* or the *animal rationale*. These two terms (*homo animalis* and *animal rationale*) are Latin and refer indirectly to Roman and later European humanism and metaphysics, which Heidegger considered a corruption of ancient Greek thought about the essence of humanity.[57] Losing the tongue in foreign lands could also refer to biology. In his "Letter on Humanism," Heidegger railed that living creatures are the "most difficult to think about because on the one hand they are in a certain way most closely related to us."[58] They, like us, are alive, and the history of Western thought since the intervention of Roman humanism has accustomed us to think of ourselves as the *animal rationale*, a biological animal with better thinking and a claim to spirituality attached.[59] Heidegger was repulsed by this nearness. In an emphatic effort to deny "our appalling and scarcely conceivable bodily kinship

with the beast," he declared, "the human body is something essentially other than an animal organism."[60] So, attached to Latin and humanist contamination of language and thought, there is the deeply emotional problem for Heidegger of contamination by the body of the Other already my own, named and held forth by the Latin *animal rationale*.

Do I hear disgust? Is Heidegger's *poiēsis* built on a foundation of disgust? Is this where nature, the unanalyzed ground of "earth," surfaces in poetic speech? Without question, many of the poems by Georg Trakl, Stefan George, Rainer Maria Rilke, and Friedrich Hölderlin which are the subjects of his essays make extraordinary appeals to the senses. Heidegger's insistence that the body is transparent to poetic language suggests how the human body transcends nature so that you and I are completely different from other organisms around us. Enclosed in the circle of hearing and speaking in our own poetic voices, even the notion of the body as "earth" becomes questionable. However, Heidegger had elaborated the concept of "earth" in eroticizing language appropriate to bodies in motion. In his account of the world-earth struggle, *poiēsis* sounds like the masculine version of *jouissance* described in contemporary poststructural criticism. *Jouissance* refers to the idea that sexual pleasure is not purely physical, but mediated by phallic signification. In *jouissance*, pleasure crosses a threshold mediated by language and the symbolic order. As in poststructural criticism, Heidegger's selected poems do not evoke pleasure as pure bliss. Several, especially Trakl's "A Winter Evening" and those about the descent of the spirit of the West discussed in "Language in the Poem," focus on pain as the spirit crosses an imaginative threshold into the "world" of the poem. In both essays, pain discloses the threshold, which Heidegger calls the "dif-ference," in which case the threshold is arguably the same as the "rift" which joins but sustains the opening in the world-earth struggle of the work of art. The pain mentioned in these poems is paradoxically not physical, but is fixed where language has fallen away. Now, in Heidegger's world, the physical, animal body is also a place where language has fallen away. So, despite his assertion that the human body shares nothing with other organisms, the threshold of poetic pleasure reveals itself as a moment of pleasure/pain focussed where the *animale rationale* might be transcended, but remains undeniably necessary. Although Heidegger skirted the issue by arguing that this "pain" is part of transparency as the animator of disclosure, the question remains: did Heidegger have to admit backhandedly that poetry and visual art are penetrated with physicality and desire, and that there might be some necessary traffic between art, poetry, and my embodied self as part of nature?

The grounds from which he wishes to redeem the self remain deeply troubling: the contamination of self, language, and thought by the sensuous, the animal, the humanist, the interpreter, the un-Greek, nauseating Other. His ver-

sion of *poiēsis* emerges as a highly suspect vehicle of redemption that deserves rejection. As a way out of this dilemma, self-understanding through interpretation of symbolic expressions concretely realized in a variety of mediums surely has some potential.

READING REDEMPTION

At about the same time that Heidegger was warning about the devastating effects on the modern subject ("you"and "I") by modern technology and the world picture, Walter Benjamin, a leading German literary and culture critic, was also writing about the intervention of machine-based technology in the self-understanding of individuals, families, and nations.[66] In his view, while man's (and it is man's) use of machine technology in World War I had severely exploited his relationship with nature, Benjamin argued that this damage should be taken as a lesson in abusive conduct which demanded a reconception of the relationship between nature, technology, and human being.[67] In European nationalisms, as we still see today, the understanding of families and nations as a natural organism with a claim to an authentic ("native") place and language is still being used to justify arguments of ethnic or racial purity and nationalist expansion. The intervention of modern technology in the working self and community had the potential to alter these views. For example, in Italy, Futurist visual artists prior to World War I included the sounds and sights of the industrialized city as part of a positive image of a modern self participating in urbanization—both a migration from the "native" place and a new self-construction—as did some French Cubists. Russian Constructivist artists before and during the Revolutionary period had also worked out a positive aesthetic of the working body in a fusion of the formal with the utilitarian. So the human-machine body as a scene of modernity and struggle for liberation was desirable for many despite the catastrophe of World War I. Benjamin, however, recalled that the industrialized working body had been idealized previously and sold to exploited working classes by the German Socialists after 1875, in the name of nationalism.[68] He objected strongly to aesthetic criteria which identified beauty with the human body blended with the machines and scene of war. A beautiful war-body could be used to justify war as a worthy sacrifice to nationalist power disguised as the social good.[69] He quoted Futurist poet Emilio Marinetti as a warning: "War is beautiful because it establishes man's dominion over the subjugated machinery by means of gas masks, terrifying megaphones, flame throwers, and small tanks. War is beautiful because it initiates the dreamt-of metallization of the human body....War is beautiful because it combines the gunfire, the cannonades, the cease-fire, the scents, and the stench of putrefaction into a symphony."[70] As Benjamin emphasized, positive and negative images were based on the domination of nature (including the

working body), and the general model was being absorbed into fascist rhetoric before World War II in both Italy and Germany.

So in Benjamin's eyes, a major problem prior to World War II was how to free the idea of one's self as a modern subject in an industrialized world from the perdition of organicism and authenticity without falling prey to a rhetoric of domination. In 1929, Benjamin was struck by an image by the French Surrealists that appeared alarming and appropriate: "They exchange, to a man, the play of human features for an alarm clock that in each minute rings for sixty seconds."[71] In the context of the European art tradition, this image must have been as shocking as the lines of Marinetti, especially with regard to the face. The traditional painted portrait that expressed the whole person, with apparent transparency between inner thought and exterior expression, had been an ideal since the Renaissance. *Baldassare Castiglione* (c.1514; Louvre, Paris) by Raphael is paradigmatic. From the 1860s through the early twentieth century, photographers in England and North America were studying portrait painting in the interest of retaining certain values of painting and solving problems of lighting. There was an "Adam Salomon" style, a "Rembrandt" style, and advice to study Velázquez.[72] Now Benjamin was advocating a deliberate "fall" from this ideal. In its place a clock stares, ringing. This previously unknown body demands a response. What language is appropriate? Is this the condition for redemption?

Benjamin took as given that the modern human body was already "lost." In his view, often similar to Heidegger's, the evolution of European culture had led to self-exile from the sensuous body and non-literate modes of communicating.[73] Benjamin agreed with Heidegger that, subconsciously and consciously, we are horrified at being recognized by animals or by ourselves as animal: animals at a profound level are disgusting.[74] Exiled and alienated from the body still inhabited, even my own body is fundamentally indecipherable. Like Franz Kafka's characters, you and I are constrained to experience and read our own and others' gestures and language as though in an alien land.[75] But is this condition dehumanizing, or does it open new possibilities? Sigrid Weigel argues that Benjamin, who we know was reading Freud from his references, understood Freud as finishing off the long tradition of transparency between internal feeling and external expression in gesture, facial expression, or language, and that Benjamin overlaid his notion of redemption on the psychoanalytic model.[76] Benjamin's thesis is that the body is the medium of distortion, its scene, not the representation of something distorted.[77] This means there are neither forgotten meanings nor a mode of communication, such as ancient Greek *poiēsis*, to be recovered. What is available is not the subconscious memory of particular images but the retention of a structure of responses to certain perceptions, a repetition of affects which is not the repetition of the same, but the return of the Other.[78] Calling these moments when the body becomes legible as a scene of

distortion "profane illumination," Benjamin proposed that "illumination" occurred in moments of special awareness or danger, when the past suddenly made sense in terms of the present and acted as a warning. It's not that the past is always hidden from us, but that it is only intermittently legible—as a scene of distortion.[79] Consequently, we can understand the "lost," gesturing body that demands to be read as Benjamin's candidate for redemption for, as he said, "forgetting always involves the best, for it involves the possibility of redemption."[80]

For reading gestures, Benjamin put to use a notion of mimesis that pursued the path of a character of Kafka's who sought refuge in the Nature Theatre, miming people thoughtlessly because he was looking for "a way out" and no more. Mimesis had the virtue of being both unthinking and lodged in humans' primal, animal capacities. At the same time, he argued, mimesis pervades the highest human achievements, including language.[81] From this we can understand that the mimetic capacity, although mysterious, "speaks" in language while retrieving the irrational and "animal." Yet this does not mean that mimicry becomes transparent in language. Benjamin thought that language is a *medium* of being but not, as it was for Heidegger, part of human beings' essence; language is separate. All of nature, animate and inanimate, communicates in its own language (e.g., a plant through colour and fragrance, a rock by its chemistry and hardness, birds through song, gesture, and colour) which is "read" by other organisms or non-organisms according to their capacities (e.g., insects, lichens, erosion processes). Language exists then, only when realized in a medium to which other beings respond according to their capacities.

Since Benjamin's definition of language includes unsystemized language, we can extend it to visual art. Through studies in handwriting, he became convinced that script contains traces of the unconscious of the writer, and since he thought also that mimesis was found in script, then mimesis would participate in realizing traces of the unconscious, thereby disseminating an unknown and unintentional utterance destined nowhere. In such cases, the mimetic element can be manifested only by a reader who senses it in a flash: "To read what was never written."[82] For example, how often have you had an insatiable urge to run your hands over a stone or metal sculpture, or felt dissatisfaction and yearning before a Calder mobile until you saw it spinning through the air? This, too, is a moment of illumination, when desire becomes legible and you or I become constituted as a reader. We have not consciously, except if deliberately acting, adopted the sight of another, but without memory, reflection, or reason, seen as Other. The experience shows that we cannot definitively read the "script" of the sculpture or mobile, or even a text, only translate it through our own perceptions and affects. Following from experiencing reading as an act of the senses and desire, Benjamin argued that mimicry and reading *produce* an embodied subject, a self who can make or read gestures for which there are no conventional motivations or interpretations.[83]

From another "site," with which Benjamin was fascinated, he imagined how we are beheld by society's losers from the past and called to redeem their unfulfilled desires in a moment of recognition.[84] Benjamin thought that surrealist poet André Breton was the first to

> perceive the revolutionary energies that appear in the "outmoded," in the first iron constructions, the first factory buildings, the earliest photos, the objects that have begun to be extinct....No one before these visionaries [the Paris Surrealists] perceived how destitution—not only social but architectonic, the poverty of interiors, enslaved and enslaving objects—can be suddenly transformed into revolutionary nihilism....The trick by which this world of things is mastered...consists in the substitution of a political for a historical view of the past.[85]

This meant rereading progressivist history (including art history and its cultural treasures) as a series of victories over losers who were dispossessed of their claims and achievements, so that the "trick" had the effect of politicizing the public beholding look, showing it as a scene distorted by relations of power and interest. From this insight, very similar to his ideas about of mimesis, Benjamin elaborated the notion of the *illuminati* as modern subjects *born* out of a changed mode of perception, of which at least one consequence would be that self-understanding through "reading" is called to become self-critical, that is, how do I take account of my self in the light of these relationships?

In 1936, increasingly driven to advocate means to resist Nazi propaganda by rethinking reception of cultural productions, Benjamin reconsidered the capacity of cinema to alter people's perceptions and affects. He pointed out that while industrial technology had only perpetuated oppression suffered by the lower classes in an agricultural society in which they had been treated already for centuries as standing-reserve, technology as represented by cinema engaged viewers individually and collectively in a new way, based in a new mode of perception and a new social body. Benjamin thought that the relentlessly moving image made extended and absorbing contemplation impossible for everyone involved. Cinema by default imposed a new mode of reception: "distraction."[86] If a viewer were constantly distracted by moving images, then cinema should enable critical viewing (hence every viewer a critic) with the capacity to eclipse the discursive power of the elite. However, we have to remember that movies were already important in popular culture in the late 1930s, and filmmakers in the huge movie studios that had the capital to make popular films were already treating audiences and employees as standing-reserve.

Benjamin adapted the psychoanalytic model as a metaphor to challenge progressivist and historicist models of history, as well as models of the self,

nations, and families considered as integrated organisms, valued as authentic and ideal. Based on the nineteenth-century notion that man himself was a subject of progress, fundamentally improvable, progressivist historians and mainstream capitalist culture already assumed that our bodies and sense of self were primarily historical and discursive, malleable social entities produced by class, religion, nation, power, etc. Through a blend of Freudian metaphors, literary models, and Jewish messianism, Benjamin tried to redirect the idea of a discursive and historical, but still biological sense of identity against historicist rhetoric. His proposals that perceptual structures of individuals are hooked into an irrational emotional life which carries on a dynamic exchange with surrounding "languages," meaning that we unknowingly and unintentionally initially filter our utilitarian and supposedly rational relationships of labour, communication, or law, for example, through imaginative and irrational "lenses," call for rethinking self-understanding through literary and other artful means. Benjamin's ideas, however, remind us that recognizing and suddenly "reading" a scene of distortion does not offer access to the truth of past intentions or desires. We can never learn the truth of others' desires; their "language" remains indecipherable. What is redeemed is traces of desire deferred into the future. For our own purposes, then, is redemption a relay of the undeciphered or distorted through the indeterminable gesture or expressions of art? Is this scene of misbegotten translation and error-prone reading "a way out?"

Benjamin's compressed account of mimesis brings to mind Jacques Derrida's recent discussions. However, I want to approach this through arguments about the interventions of texts in figuring self-understanding made by the contemporary French philosopher and theologian Paul Ricoeur. Ricoeur is deeply involved in the project of reviving a hermeneutics of the self, or the task of understanding my self, through my capacities and my context—meaning both others who surround me and the legible monuments that they leave. Critical of Heidegger's *Dasein* as an overvaluation of self-affection at the expense of everyday relationships, as well as foundational Cartesian philosophies ("I think; I am"), Ricoeur takes up the task of demonstrating that writing is discursive (which I am extending to include visual art, as figurative notation), an event and critique of self-understanding, but it is not a reproduction of speech. He points out that the Being-in-the-world of *Dasein* means that *Dasein* can only have its being by having a world, which should mean a self opened in total concern to everything in the world. A full taking into account of "world" is required, with no distinctions between authentic and inauthentic. So in formulating a hermeneutics of the self, Ricoeur takes as given that the question of "who?" or the self can be approached only by a detour through the question of "what?" circulated through texts or "monuments" in other mediums, where otherness is deposited.[87]

Like Ricoeur, Eliade thought that continuing and contemporary interest in the idea of redemption expresses the "need or desire to suppress an essential lack in human existence and to be delivered from all its disabling circumstances."[88] Eliade employs the language of symptom, leaving open whether this "lack" originates in feelings alone or in suffering actual bondage or loss; nonetheless I suffer. However, Eliade and Ricoeur agree that I attest to suffering loss or lack in believing that only a figurative Other such as God, to whom I pledge indebtedness in advance, can restore me to some sense of normalcy or even fulfilment. In traditional Christian belief, I can jump-start the process of redemption by agreeing beforehand to suffer judgement on whether redemption will be granted or not. Although this appears to be deliberately sacrificing my sense of autonomy, Eliade points out that the Biblical teaching of Paul characterized redemption as gratuitous and an act of love.[89] Now, proof of grace or redemption, and many therapeutic cures, rests only on self-attestation. This is the scandal of Christianity, as Ricoeur wrote: "The Gospel will always be carried by an extraordinarily fragile testimony, that of the preacher....There is no proof which can support either the experience or the rationale. In this sense the Cross *remains* a folly for the intelligent, a scandal for the wise."[90] My faith in the possibility for redemption could be a deception; I am in effect challenging my faith to be a lie. However, I believe anyway, out of love. Shunning validation, redemption gives love as the task, price and proof of being redeemed, a force which participates in constituting the self and its place among others. However, if redemption is experienced through testimony, are debtor and redeemer collapsed into one? Does this return to the circle of poetic auto-affection or the self-producing hero?

Ricoeur attacks this problem by refiguring the idea of the self as polysemic; that is, self-understanding derives from different sources or voices of otherness, including texts and similar concrete expressions, where the meaning of otherness cannot be reduced to that of another "Person."[91] Taking on the foundational "I" of philosophies such as Descartes', he argues that this monolithic Same can be split along the lines of temporality. First, he keeps a notion of sameness as enduring character, meaning my distinguishing characteristics and body, which I retain continuously and which permits other people to re-identify me over time.[92] Here he has dethroned the notion of substance as primary, which he finds weak if it is to denote "my" body and not a thing out there in the world. Selfhood would benefit if it were considered as existence rather than substance plus attributes. Existence can be thought of as "I want, I move, I do," which requires and includes my body. Equating existence with action and desire rather than being brings my own body into non-representative certainty, something felt and known immediately without representation, whereas Descartes' cogito, Ricoeur argues, depended on deduction from the imagined spectacle before him of his body as only substance.[93] This opens the potential to escape the trap

of categories of being. If "I want, I move, I do," the importance of my body for my self is not as an object but that it belongs to someone who can designate herself as the owner or inhabitant.[94] Immediately my own, I sense that I, my self, share the same kind of bodies as others have, so that I am another like them. However, considering the situation temporally, others must have preceded me, so that others are completely foreign to me. I can sense the difference of beings other than me such as muskrats or even octopi. In this way, my body slides me between my fleshly self and radical otherness. Rather than recoiling in disdain from the they-world or in disgust from animals, as Heidegger did, Ricoeur argues that the felt, unspoken linkages and distinctions between my flesh, the bodies of others, and other matter are essential in providing a support for the sense of own, proper "otherness" that supports my self.[95]

Meanwhile, the self-attestation which announces, "Here I stand!" comprising self-designation and a promise to remain self-constant over time shifts to another register of temporality and action. In actions such as characteristic habits, the notion of self-constancy overlaps character. However, at the far end of the continuum of selfhood and sameness they no longer coincide.[96] Keeping one's promise is a denial of time, as Ricoeur says, a challenge to oneself to hold firm even if desire or opinion should change.[97]

Ricoeur analyzes the complexities of "Here I am!" as a promise motivated by conscience in response to an implicit injunction, "Be there for me!" For Ricoeur, this response means that I am already listening for your injunction, close to me, as the intimate "Thou! Be there for me!" which, in turn, carries the implicit cry, "Thou! Love me!"[98] To answer "Here I am!" seems, in part, to be an internalization and identification mechanism. Ricoeur understands the capacity for being-affected through the mode of injunction as an indicator of the phenomenon of identification, which itself is anything but transparent.[99] Here he makes room for something similar to the Freudian unconscious and superego, but it is multi-voiced and generational. In his model, the conscience is made up of sedimented, forgotten and, to a large extent, subconscious identifications with parental, ancestral, and historical figures. The more historically distant these are, the more they become ancestors of myth and cult, the figure of the Ancestor or Other, which is the equivalent of the Law because it demands obedience.[100] He draws a further conclusion: the universal phenomena of identification and obedience to Law indicate that "*being enjoined [is] the structure of selfhood*."[101]

Ricoeur's voice of testimony bears an acknowledged relationship to Heidegger's notion of Conscience. As Ricoeur points out, Conscience (Heidegger's *Gewissen*), before distinguishing between good and evil, "signifies attestation...conscience as attestation."[102] However, Heidegger neutralized Conscience; it calls the self to itself only as an order to withdraw from getting lost in concern with and for others. It has no message, but summons the self to

the primary task of its *"potentiality*-for Being-its-Self."[103] Heidegger, as Ricoeur points out, ducked the moral issue of *praxis* even though his version of Conscience was reportedly based on the Aristotelian notion of the good or "right" life.[104] Ricoeur, on the other hand, departing from the same notion of attestation, redefines Conscience pragmatically as Aristotelian *praxis*. To open myself to hearing myself called upon as beloved and to respond with the promise to be there is, Ricoeur argues, the Aristotelian and pragmatic undertaking "to recognize oneself as being enjoined to *live well with and for others in just institutions and to esteem oneself as the bearer of this wish."*[105] As a result, my promise to you might destabilize my historically established and recognizable character (even for myself); it defers definitive characterization through time by holding it open. And I do this, or even dare this, for love. So from Ricoeur's perspective, in contrast to Heidegger's auto-affective *Dasein*, Conscience is in part the voice of the Other and self-attestation, ostensibly a variety of self-affection, but it is not made in a vacuum. It is motivated where I rub up against others and the Other. Thus, I promise as the consequence of implied competing choices and duties. Promising witnesses the morality of my conscience and my embeddedness in the voices of others and the Other: I cannot do, or be, otherwise.[106]

In a series of essays published in English in 1970-73, Ricoeur argued that texts or works realized in other media intervene or participate in negotiating my self, as events of self-understanding, rather than speech. For Ricoeur as for Jacques Derrida (a colleague and former student of Ricoeur), and as it was for ·Benjamin, the importance of a written text is that it is not the written mirror of speech or dialogue. Visual art, as a monument in another medium, likewise cannot transcribe speech. But if we take visual art as a text, then art must be something other than the mirror of a preconceived visualization. Ricoeur maintains that a text is the realization of language as a structured work or discourse, which allows him to argue that discourse is the event, preconditioned by the rules of language but surpassing them, where writers and readers are constituted *as* readers and writers around the task of meaning.[107] The same task, to make sense, confronts viewers of visual art, although the rules and conventions of art are notoriously less secure, so that the question of readership and the self circulate more fluidly. Agreeing with Derrida that a text abolishes the situation of speakers present to each other, Ricoeur argues that writing opens up or even necessitates the projection of a possible world in the absence of ostensive reality, in effect saying, "Don't pretend to tell me the truth of a situation; you can't tell me *the* truth because writing, painting or reading usurp given reality." Think of visiting the Art Gallery of Ontario with a friend and seeing Michael Snow's *Immediate Delivery* (colour plate 1). It's an explosion of colour and holds forth many of the tools and conventions of photography and picture-making, wittily disassembled and reworked. "What a hoot!" you exclaim. Now, what does that

mean? "Colour gels gone wild, and what's the liquid in the jar?" your friend replies, suspicious. Either response can express a whole range of emotions which can be clarified through tone, facial expression, gesture, and discussion. But if a description of my visit is written, the scene must be laid out more specifically so that a reader can make sense of responses to *Immediate Delivery* in order to project an imagined world beyond the page. Anyone who can read is a potential audience for texts like this one or works of visual art, but since the agreed-upon world of "here" experienced in conversation is absent, what "here" or this world is becomes literary or artistic and must be interpreted, which requires an active, questioning self of "I want, I move, I do" to surface.[108]

Since a work becomes autonomous from the intentions of the author or artist when it is being read and interpreted, she or he can't place limits on meaning even if present, so that Ricoeur further argued that "henceforth textual meaning and psychological meaning have different destinies."[109] The question is, how could you climb inside the mind of Michael Snow, or of Artemesia Gentileschi in the seventeenth century, regarding what their work means? Their work *might* present evidence of their interests and passions, but it is also fictional and perhaps made to a patron's specifications, so that the artists' fully intended meaning is always in question. Furthermore, if we understand ourselves generally as psychological beings with conflicting, hidden desires, the intended meanings of work by others become opaque beyond certain agreed-upon representations. Consequently, the task of the reader remains not to enter the mind or passions of the author or artist, but to make sense of the text or work. Ricoeur argued as well that at the same time that a work escapes the psychology of authorial intention, it also escapes the limits of the sociological conditions of its production.[110] So, as a critique of the simplistic view that a work's historical conditions of production must be retrieved, Ricoeur's theoretical stance would have us understand that these conditions are available only through interpreting other texts and artifacts as well. Consequently, since the meaning of a text or monument is neither limited to the author's intentions nor exchanged between mutually present speakers, but abolishes their mutually present and agreed-upon world, and since context is also under interpretation, the "ground" has shifted beneath our feet. An artistic or literary work brings me face to face with irreducible otherness with which I must negotiate.

Now, instead of seeing this massive intervention of objectification and mediation as a "fall" or "decline," Ricoeur, much in the same way as Benjamin values the "lost" body and gestures of forgotten meaning as potential, sees mediation as the profoundly hopeful and necessary ground for the emergence of the reader who must take an interpretative stance in the world. Freed from authorial intention, the reader's understanding is destabilized by reflecting on the meaning of the text which, Ricoeur, argued, can come about only by a detour through self-

understanding: "In contrast to the cogito...it must be said that we can understand ourselves only by the long detour of the signs of humanity deposited in cultural works. What would we know of love and hate, of moral feelings, and, in general, of all that we call the *self* if these had not been brought to language and articulated by literature [or visual art]?...The text is the very *medium* in which we can understand ourselves."[111] This is a radical rethinking of both the self and meaning in artistic and literary work: not only is there no true hidden meaning to be discovered in or behind a text or work of art, the revelation of a true, hidden, core self is neither the task of the work nor guaranteed by the promise of self-constancy made before it. Our deepest feelings and conscience, how we feel ourselves to be or "what we know of love and hate, of moral feelings," are born to us only through the mediation of external texts or documents: "to understand is *to understand oneself in front of the text*."[112] So, the question to my self by art or texts is not "Who is she?" to which I await a single and truthful answer, but instead how does this destabilizes any final self-understanding? It demands submitting to the injunctions of the work and entering the worlds opened on its basis. Ricoeur terms interpretation an act *of* the text, not *on* it.[113] He reminds us, too, that attestation and promises are inhabited by falsity. It is not that being-false is the opposite of being-true, but that the false haunts the true as part of its condition.[114] Because of the conflicts internal to promising, while attestation appears to secure the self among others through time, it is also inherently unstable. Attestation and the otherness of visual art or texts defer the closure of my self and only promise its "redemption" over and over, differently, with love, maybe. The hermeneutical or interpretative position does not rest on possession of the singular sight of "I," myself, but assumes competing moments of self-dispossession and refiguration: a critique of the self and the cogito.

While there is an obvious relationship between Ricoeur's and Jacques Derrida's theories about writing, Derrida purports to take a more radical view, claiming that writing is not discursive and can never fully be understood even by its intended, unique reader. The "complete message" never arrives. Derrida, like Ricoeur, is concerned with the legacy of Heidegger's thought. He is profoundly mistrustful of Heidegger's project of returning to the meaning of Being through language, and of the unquestioned genealogy of thought handed down in the Western tradition.[115] If the Western philosophical tradition were freed from understanding its destiny transmitted through the textual genealogy descending from Socrates to Plato and on through Nietzsche, Freud, and Heidegger (particular targets), Derrida reasons, one could love oneself.[116] To find love for oneself depends on redemption from the direction of this received legacy of philosophical thought. Derrida's epistolary short "novel" of ficto-criticism, "Envois," seeks to unravel this tradition of philosophical and psychoanalytical discourse by its strategically chosen form which lies beyond philosophical

discourse. "Envois" purports to be a correspondence by postcard between the author and his beloved correspondent, although the number and gender of writers remain unknown.[117] To add to the confusion, given the statement that if his project is successful, one will be able to love oneself, then maybe the postcards are to himself. Derrida refers to a reproduction on a postcard of a medieval drawing that presents Plato dictating to Socrates: Plato who came later and who could write, dictating to his predecessor Socrates who supposedly could not. The order of writer-message-addressee and the integrity of intentional messages have come unglued. All that we know of these personages (Plato and Socrates, but also Derrida and his correspondents), is through texts.

"Derrida's" correspondents agree with Ricoeur that writing, reading, and even visual art are recorded in a more or less codified form that can be understood by a total stranger, and that prevents guaranteed exchange of unique, personal meanings between a unique writer and reader. Ricoeur and Derrida also agree that words—let's extend this to marks, gestures, and even objects—have no absolute meaning. To be meaningful they must all be reiterated in larger complexes. In the text of the postcards, the presence of the medium shows itself by white spaces fifty-two characters long in the midst of the print, which introduces an otherness into what circulates as "postcard," as well as suggestion of the possibility of loss or erasure. It is as though these writers have finally understood what artists who work without a secure grammar or reference system have long known. In addition to these characteristics, visual art makes a direct kinaesthetic appeal.

For example, every element of Snow's *Immediate Delivery* (colour plate 1) is visible and comprehensible as pre-existing "units" which can be used in assembling photographic images. The transparency image and total light box installation, like a text, depend on repetition and inclusion in a larger complex to make sense. And undeniably, *Immediate Delivery* appeals to my embodied responses. However, like a book, *Immediate Delivery* is not addressed just to me or to anyone else. The meaning of writing and especially works of art does not "stop" with a unique addressee because there isn't one. So just as "Plato," the unique receiver with a capital "P" in Derrida's reading of the medieval postcard, is undone by writing, the properly named writer, "Socrates," is equally destabilized because he becomes a mere transit point in the circulation of the text. He cannot be the solely founding author because his pen is dipped implicitly in several sources in the necessary reiteration of writing and culture to make sense. The logical consequence of the text freed from authorial intention, a claim on Derrida's part which Ricoeur did not make, is that there remains no distinction between what is written, "you" the reader and, by extension, the writer who "receives" writing in advance. There is no discourse: the message never arrives (is not an event), there is no "understanding" or fulfilled meaning between you

and me, and so the singularity of event (saying), meaning (the said), and "to someone" or "who?" have all been dissolved in the circulation of writing.[118]

Derrida is making the distinction that while discourse as traditionally understood leads to understanding (a key word in Ricoeur's writing), and thereby secures positions of mastery of discourse, *writing* abolishes discourse and the security of those positions. "We are the worst criminals in history," Derrida claims, "and right here, I kill you, save, save, you, save you run away, the unique living one over there whom I love. Understand me, when I write, right here, on these innumerable post cards, I annihilate not only what I am saying but also the unique addressee that I constitute, and therefore every possible addressee, and every destination. I kill you, I annul you at my fingertips."[119] This statement unburdens writing of the legacies of the Cartesian philosophies of the foundational "I," even though it means placing discourse over on the side of securing subject positions, mastery, and traditions of debate and Western philosophy.

Ricoeur seems to have had a different notion of discourse than Derrida's. Ricoeur argued that spoken and written discourse had common ground in the dialectical constitution of discourse: "Writing [fixes] not the event of speaking, but the 'said' of speaking, i.e., the intentional exteriorization constitutive of the couple event-meaning."[120] Discourse is "the dialectical unity of event and meaning in the sentence. The event character has to be stressed over against all attempts to reduce the message to the code....*If all discourse is effectuated as an event, it is understood as meaning....*The semantic autonomy of the text which now appears is still governed by the dialectic of event and meaning....Writing is the full manifestation of discourse."[121] So, a work of art or text must be already understood as a saying about something to someone. It is not simply a coded message linking separable end-points, writer to reader, but an integral field of representation which already includes an idea of "you" and "me," even if not exactly you and me, because the field is autonomous. Derrida, according to Ricoeur's critique of 1977, chose mistakenly to overlook the dialectical constitution of discourse.[122]

However, you and I over here happen to read this postcard, one side or the other (drawing and text). The viewer or reader of an autonomous work of art or text is "textual," while the work is an attestation of love, for in writing the postcards, "Derrida" sends love letters. A text is simultaneously "bed" and "the read" in French (both *le lit*) and confuses the boundaries between writing and reading in declarations of love. However, remember that the postcards as love letters involve death—but exactly of what? Derrida laments that loving you and writing literature (note: what is usually taken to be structured works, or discourse according to Ricoeur) at the same time were impossible: "No literature with this, not with you my love. Sometimes I tell myself that you are my love....And then you no longer exist, you are dead...and my literature becomes possible."[123] So

the beloved and literature can exist only in a state of mutual absence. The problem is the coding of writing, genre, and language itself. As a result, literature is a death sentence.[124] But wait; perhaps all is not lost: "The condition for me to renounce nothing and that my love comes back to me...is that you are there, over there, quite alone outside of me. Out of reach. And that you send me back."[125] You, over there, irreducibly other than me, an other whose site and flesh I cannot appropriate, have the capacity to make literature and love possible, and finally one will be able to love oneself, but only if I don't write to or for just you. This would mean that writing, which is also love, serves to keep "us" apart but alive. Nothing needs to be surrendered, nothing collapses, and the writer can keep on both writing and loving. Writing conceived outside of the normative circuit of discourse, which never "arrives," prevents the authoritative consolidation of an "I," an eye, a single site or destination, where everything would clog up with no further possibilities. While Derrida is famous for saying that "There is nothing outside the text," or representation is the limit of our world, he still sends texts, not just to me. He just sends them, which I read or not by chance, or chance my self to read. Since writing circulates, he sends them to everyone and all the world is the concern of writing, so that his phrase can be understood as inclusive rather than divisive. Meanwhile, "Derrida," writer, makes his promise to be there, a promise haunted by falsity: "Know that I am always ready, this is my fidelity. I am a monster of fidelity, the most perverse infidel."[126] He gives his word, although warning that promises might be false, that his site is very precarious, that he might be unreliable, and that he doesn't even know who is writing or to whom (there might be several of each), or that he might be writing to himself.[127]

So Derrida addresses the problem of representation as if the implicit sense of "I am writing about this for your sake, or making this video for your sight" were abandoned: hence the epistolary form of unaddressed postcards. He took "speculation" as a modus operandi, not just a metaphor. He got the idea from Freud: Freud borrowed "funds" (terms) from other specialized discourses and moulded them, along with empirical description, into the language of a new theory. While Freud initially set the standard of empirical observation as the limit on meaning, this standard collapsed when he had to admit that, without the help of his syncretic theoretical language, he could not even *perceive* the processes in question.[128] It seems that language does have the capacity to refigure the "real" world and that Heidegger was right when he said that it holds things forth and shows them to us, perhaps for the first time. So Derrida speculates, joyfully: "*To borrow* is the law. Within every language, since a figure is always a borrowed language, but also from one discursive domain to another....Without borrowing, nothing begins, there is no proper fund/foundation [*fonds*]. Everything begins with the transference of funds, and *there is interest in borrowing*, this is even its ini-

tial interest. To borrow yields, *brings back*, produces surplus value, is the prime mover of every investment. Thereby, one begins by speculating, by betting on a value to be produced as if from nothing."[129] The example is there even in the Freudian model: the Pleasure Principle is a drive (*Trieb*), purportedly an instinct (also *Trieb*) in a transfer of terms by which a universal notion (the PP) is capitalized by terms from an external discourse (biology). From this perspective the notion of borrowing never dreams of reconciliation or final redemption. Rather, it is always a risky game of chance and pleasure. To be indebted is to be called to account. But in speculating on the transfer of "funds" (e.g., the transfer of notation from one discourse or medium to another) the debtor relationship can be endlessly deferred, because in speculating in language or visual notation, I can gamble on even avoiding indebtedness. Writing by detour can become so convoluted that the path and return can be neither mastered nor retraced with certainty. So the proper names of creditor and debtor recede from sight. Being indebted just slides by. It's more like the stock exchange; I leverage more. Refiguration becomes a transfer point, a practice which appears to produce from nothing. It's sexy, and I love it. This process Derrida calls simply the sending principle, which Michael Snow had been practising as framing and transferring images between many mediums at least since 1962 with the inception of the *Walking Woman* series.[130] Derrida provisionally decides that the only possible "redemption" is the promise to accept all mediated transfers. In a movement of voluntary self-dispossession and misappropriation, he promises to read under an improper name: "*J'accepte*, this will be my signature...don't worry about anything....Take this word literally, it's my name, that *j'accepte*, and you will be able to count...on it,...from you I *accept* everything."[131]

Let's think of speculation another way: one way to capitalize on otherness in reading comes from a reconsideration of mimesis. Like Benjamin, Derrida was interested in the possibilities of mimesis as a "writing" or gesture which has no original model. In the long history of mimesis, Derrida noted several generally accepted attitudes: there is "good" and "false" mimesis; that which tries to reproduce its model faithfully or at least in good faith, and so serves the cause of truth, and that which distorts the relationship whether by incompetence or intention and displaces the faithful copy with a false one. Although neither type is the original and neither has value from that perspective, both types were engaged in making likenesses of life, and thus served the interest of truth and were traditionally tolerated on the side of the productive arts and *poiēsis*. These types, even the faulty one, would arguably fall under Aristotelian *praxis*: to live well and for others in just institutions, and to esteem oneself as the bearer of this wish. On the other hand, there is non-productive and non-poetic mimesis that is not based on life, but simulates its likenesses. It produces production's double, a mirror-effect that seduces its audience and so belongs to the "acquisi-

tive" arts.[132] As Derrida points out, all mimesis as well as *poiēsis* are "different" to the extent that all kinds of writing and reproduction cross out the "is" in saying "this is that." Demonstrably "this" is not "that," no matter how faithful the intention or reproduction. In the end, mimesis imitates nothing because there is nothing prior to the writing or sketching of the mimetic gesture. Even oral language cannot be intelligible unless it belongs first to the concept of writing or iteration.[133] So Derrida finishes by reversing the *poiēsis*/mimesis relationship. The mimetic is neither outside nor subordinate to the system of truth (*alētheia*), but comprehends it.[134]

Starting from the fact that the mimetic doesn't illustrate or follow a prescription, and given that mimesis crosses out the "is," Derrida takes the strong position that in mimesis there is no drama, no narrative, no history, and therefore, no Oedipus; no discourse, either. The mime makes present only what is performed in embodied notation and does not reveal any pre-existing or ever-present truth. The mime, mimesis itself, escapes destination, and presumably *poiēsis* and *technē*.[135] Because of this the mime mimes reference itself, mimes imitation, but is not an imitator per se.[136] But still, I read. Am I the acting subject ("I want, I move, I do") who can master reading and the read after all? This is by no means certain; I want, but what, when I read? "*La question du texte est—pour qui le lit*," which has loosely undecidable translations: "The question of the text is for the one who reads it," or, "...for whom it reads," or even, "The question of the text is: for whom [is] the bed?"[137] *Le lit/le lit* (the bed/the read) as Mallarmé had said in the text "Mimique" which Derrida reads; between the sheets of the pages the eye reigns in intimate silence, which is the delight of reading.[138] So the mime and reader not only read, they are read in a movement of self-dispossession, as Ricoeur had also suggested. Mimesis does without the "truth" of fixed reference and offers other possibilities. Imitating nothing, producing nothing beyond the mirror of reading and notation, nothing "truthful" happens, and it is delightful. And so, are you saved over there, the unique one who I love and who sends me back? Are life and love sheltered by this folding over of *poiēsis* into mimesis? I can only promise to read whatever you send, but it might not work out.

As Derrida plays out in the postcards, as Ricoeur finds in reading as complex, ongoing events of self-understanding, as Benjamin finds in dumb mimetic gestures or in reading outmoded commodities and photographs, the work of art or literary text intervenes in my site, the sight of my self-understanding, by transferring funds from multiple sites of otherness. As artists and computer users, bankers, and entrepreneurs all know, mediated transfers are full of opportunities for corruption by mistake or design, for misreading by the "wrong" readers, and consequently for illegitimate outcomes. And I love it; "I" promise to *accept* it with all of its possible corruptions, contaminations, missed addressees, or

whatever. So, does the desire for redemption—to accept it all in advance from "you" who whispers "Be there for me!"—does this subvert the notion of reconciliation or justice as a moment of final reckoning? Are the mimetic capacities of visual art and the promise to accept it all a hopeful wager on the possibility of illegibility and illegitimacy, to get the rush and pleasure of more? Is Derrida telling us that historically we have been coming at the question from the wrong angle? As the words in one of Snow's films flash in succession across the screen: "This / is / where / you / come / in."[139]

The *Walking Woman*

FIELD TEST

"Be a *tracer of missing persons*."
—Michael Snow[1]

Michael Snow's *Walking Woman* series is built around the silhouette of a female figure striding parallel to the picture plane, looking straight ahead, arms swinging. Appearing in hundreds of variations in different mediums from paint to film to cardboard or stainless steel, in places ranging from art galleries to a taxi door to sites abroad "claimed" for art by her appearance, she is strangely abstract, lacking individuality. She doesn't look at me—I watch her. Or that is how the situation appears at first glance. However, things are rarely as they appear in the contested sights of Michael Snow. Striding again and again across my sight, haunting my site, do her multiple returns mark the reappearance of my sight? If so, then how was my sight, and by extension my seeing self, invisible in her absence? Do her multiple appearances return more than my sight; let's say, my sight plus interest? And what would the interest of the interest be?

Well-dressed in a bright floral print on the upper panel of *Duet* (1965; figure 1), this *Walking Woman* has medium-length bobbed hair and a mature figure which is readily apparent in her rather tight, low-cut dress with short sleeves and knee-length hem.[2] She is sexy in a conventional style familiar from 1950s and 1960s

Notes to chapter 2 are on pp. 178-81.

advertisements for household products. The lower panel of *Duet* unveils her struc-
ture: a beautiful construction well fitted to her panels through a proportioning sys-
tem of squares and rectangles used to measure her off. Yet, the lower panel is just

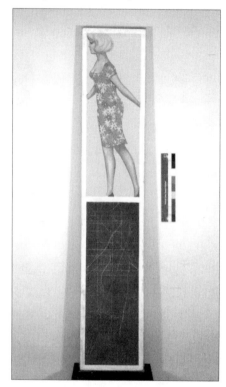

another painting, a line drawing
"unveiling" nothing, however
indistinct, especially when repro-
duced. What shows is her con-
struction as drawing or painting.
As is customary, a grid of horizon-
tal and vertical lines blocks out
areas of ankle, knee, stomach,
bust, jaw and eye line, central ver-
tical, rear and frontal limits, and
so forth. While her clothes and fig-
ure, fair hair and skin lead me to
first understand her as represent-
ing a stereotypic, middle-class
white woman, such a limiting
determination is subverted further
by *Mixed Feelings* (1965), where she
makes many different appearances
through manipulations of colour,
pattern, chiaroscuro and other
techniques of painting.[3] The top
of her head, her legs, and forearms

Figure 1. *Duet* 1965. Polymer, acrylic, and enamel are cropped, suggesting that the
on canvas, 173 x 33 cm. Canada Council Art Bank, prior intervention of a frame is a
Ottawa. Photo courtesy Michael Snow. condition of her appearance. In

both works and all the rest of the series, there is not a hint of reference to biologi-
cal or organic structure, or to a woman's context. Empirically, "she" is a series of
colour and pattern studies in a cleanly delimited closed contour, a variety of sub-
divided circle, a figure-ground problem. We can see this being worked out in the
earlier oil paintings *27 Ladies (Women)* (1962) or *Clothed Woman (In Memory of My
Father)* (24 February 1963), and the ink drawings of *Encyclopaedia* (1964-January
1965), where she returns numerous times through "simply joining shapes to find
new shapes," as Michael Snow himself put it.[4] Inside-outside relief-like construc-
tions such as *Torso* and *Gone* (both 1963) extend this type of formal development
of purely two-dimensional figures into three dimensions.[5] Canvas stretched
between the *Walking Woman*'s contours reversed on opposite sides of the structures
create a new, non-biological interior developed from the outside in, instead of
according to an unseen, deep regulating core such as a skeleton.

Other *Walking Women* are cut-outs from which the silhouetted figure has been removed (e.g., *Carla Bley*, June 1965, figure 2; *Negative Figure*, 1967).[6] In *Carla Bley* and *Negative Figure*, her outline remains as a frame, the boundary layer conventionally constitutive of art and which separates art from life, through which fragments of the world appear and disappear. Yet, when I look through these frames, something other than representation of reality takes place. In *Carla Bley* and stills from Snow's film *New York Eye and Ear Control* (1964), photographed and filmed women partially fill the framing cut-out of a *Walking Woman* as they walk behind it. In all their variability, their very realist images disrupt how I look through the silhouette: these are not what the frame is "looking for." In contrast, the flat colours and comic-strip-style profiles of *Cry-Beam* (1965), *Hawaii* (1964), or *Morningside Heights* (1965) seem more natural, convincing, and real in the self-sufficiency of their framed autonomous planes and colour fields.[7] Consequently, lacking references to the organic structure of real bodies or to a woman's social context, I am led to conclude that the *Walking Woman* does not represent or refer to prior contexts or people from real life.

As some critics have understood since her early appearances, and as I have sought to demonstrate from example, the *Walking Woman* consistently re-fuses to fulfill the conditions of a first-order representation of a woman out there in the world. In the cases of *Duet*, *Mixed Feelings*, and *Encyclopaedia*, the most obvious references are to processes of representation itself. After the first show of *Walking Woman* at the Isaacs Gallery in Toronto in March 1962, Toronto critic Robert Fulford

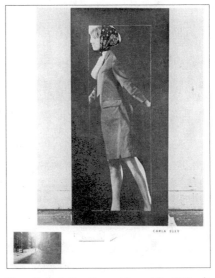

Figure 2. *Carla Bley, Toronto 20* portfolio 1965, edition of 100. Photo-offset print and line block, black and blue ink on paper, 66.2 x 51.0 cm. Gift of the Jerrold Morris International Gallery, 1966. Art Gallery of Ontario, Toronto. Photo courtesy Michael Snow.

wrote about their formal concern: "She exists in two dimensions only; there is not even a hint that she might have substance. This is a clue to the artist's intentions. He apparently wanted, for these pictures and assorted curiosities, an image that would remove his work from total abstraction and yet not interfere with the picture-making which is his real purpose."[8]

Reviewing the *Walking Woman*'s first appearance in New York City at the Poindexter Gallery in January 1964, Donald Judd commented on how the over-

all project turned the Western classical and realist tradition inside out: "Depicting a single thing in different ways is potentially interesting. Snow makes his subject, and in addition one pose, the constant part of his work; the style and technique vary widely. This is something of a point-to-line relationship, and it is the reverse of the old idea of a permanent style depicting everything."[9] Toronto critic Elizabeth Kilbourn agreed, but also argued that the *Walking Woman* stripped the female subject matter of its historically sensuous content: "By obsessively using a female form rather than a table [one of Snow's earliest subjects—T.K.], Snow immediately starts talking about every representation of woman from the Knidian Aphrodite to a Matisse Odalisque. But Snow has taken the female form, not as a sensuous object of desire or an ideal form, but as a cardboard cut-out...the female image at its most banal."[10] However, Kilbourn also had the intuition, which she did not develop, that the *Walking Woman*'s interest might lie in conceptual relationships beyond the frame that could be explored or tested though picture-making: "But the longer one looks the more the paper doll becomes an abstract form, a philosophical device, a laboratory instrument for dissecting and probing the components of space."[11]

An earlier text by Snow partially corroborates these insights into the *Walking Woman* as a formal device: "My subject is not women or a woman but the first cardboard cutout of W.W. I made. A second remove depiction. Always use it same size as original. 5 ft. tall. W.W. is not an idea, it's just a drawing, not a very good one, either!...Art is an addition to life not only a quote....I *don't 'believe'* in representation."[12] However, his constant usage of the *Walking Woman* argues that images are as much part of art's material base as paint, paper, or film. Realizations of the *Walking Woman* undergo a loss of context or biological reference which would support conventions of "this stands for that out in the world," because that is one of Snow's points: "she" is an addition to life, not a substitution. As an addition to life, in the outdoor scenes of Snow's early film, *New York Ear and Eye Control* (1964), and in other dispersed works, she appears outside of the context of art galleries; for example, on a breakwater, on street corners, in subway stations, and among the crowds of Expo 67 in Montreal.[13]

Snow understood images, especially the human female form, as an enigma at the core of Western art, an enigma which makes that tradition problematic: "Woman historically as subject in art. Women 'characters,' 'types,' 'actresses' designed by artists....'Abstract' *this* element of painting....No distortions of figure itself. W.W. always same contour....But we really look and say 'it's a woman!' Passing through."[14] He also thought that the real-world relationships that the *Walking Woman* posed were problematic, but a problem that contemporary critics were busy ignoring: "W.W. is detached from her background or 'she' is in reciprocal relations to it. If 'she' is cut-out (no depicted background) alone on the wall the relationships might be just internal or just with the real environment."[15]

While one might agree that the various versions of *Walking Woman* are not sensuous objects as realistic representations of women, they are sensuous in terms of colour, line, sound [in the two films, *New York Ear and Eye Control* and *Wavelength* (1967)], and time (e.g., the films).[16] And while the unavoidable connotation of live women might be a core enigma, it points out that the problem lies not in the images but in us, in our social history of images, and our individual interpretations. Some of the most insistent questions raised by the *Walking Woman* pertain to fields beyond representation's frame but connected to it by framing. For these reasons it is worth asking, what if the *Walking Woman* is understood primarily as neither object nor representation, but as experiments for a way of seeing? What if she is a gamble that the sight of you and me is loaded with sensuous potential which "she" takes out on loan, and returns with interest?

When you or I look at *Duet*, "she" borrows our sight with no promises of returns because "she" frustrates the assumed priorities of the biological organism and at the pictorial level, surface/depth and original/reproduction. Our expectations that "she" is a substitute are not met, so that the traditional return of interest at the sight of a painting of a female nude is denied. *Duet*'s short-circuit of the depth/surface model demonstrates how the couple clothed/unclothed is homologous to a major metaphor of Western metaphysics, veiled/unveiled and, by extension, to the other binaries just mentioned. These parallels tantalize by suggesting that even in the abstract domain of processes of representation, what lies beyond the eye is part of what meets the eye. *Mixed Feeling*'s title and colour variations explicitly experiment with the linkage between colour, form, and sensual response. In the panels of *Test Focus Field Figure* (1965), the successive views "zoom" in like a camera to the figure's rear curve. Given that the subject of the third panel is identifiable only in the context of the previous two, the figure tests responses to colour and form as syntactical (linked one after another) and sexual in a pre-rational manner. The curvaceous figure of the *Walking Woman* appeals undeniably to a heterosexual male response to the silhouette of a woman, as well as to women's sense of what counts as attractiveness, and there is no doubt that unveiling, penetrating, and uncovering appeal in different degrees to both predatory and sexual instincts of viewers such as you and me. So the sight of the *Walking Woman* returns interest by revealing another pair of binaries found within our reactions and so within ourselves: nature/culture.

Duet tests more profoundly the possibilities for my sensual responses bound up in "cool" reading. In the lower panel, the lines of construction include an X through the space of the heart. X marks the spot. It is there for me to read, like a treasure map. I'll say that she has been figured out and named under a sign of love. Snow had been approaching this configuration in several earlier abstract paintings. In *Theory of Love* (1961) and the folded paper collage *Title* (1960), he associated crossings with love and naming.[17] And on the fiery red, green, blue and white

surface of *Self-Centered* (1960), the crossing figures the shifty point where self-referential, nonobjective painting, naming, and potential identification between artist and painting intersect.[18] The *Walking Woman* yearns, passionately; but isn't it really me, refracted at the same time through a male heterosexual point of view which was at one point the artist's? With reference to substitutions for reality frustrated, "centred" by these crossings and working through multiple couplings of veiled and unveiled, *Duet* tests me, standing here, for sensuous potential—regardless of my gender or social context. Suddenly, I am in the picture. So, rather than testing the reference function of signs or the essential conventions of visual representation appropriate to their medium, the simple figures of *Duet* and *Mixed Feelings*, and tens of others in the series, test and violate conventional borderlines between the fields of art and life, object and viewer, by returning interest of a different kind. The question returns: she doesn't watch me, but does she figure my watchful sight, returned to me with interest by a different route?

These kinds of questions were not confronted in most contemporary art of the late 1950s and early 1960s. The international context for the *Walking Woman* was the legacy of Abstract Expressionism, concurrent colour-field painting and Post-Painterly Abstraction, and the critical paradigm presided over by Clement Greenberg's celebrated dicta regarding modernist visual art: "A modernist work of art must try, in principle, to avoid dependence upon any order of experience not given in the most essentially construed nature of its medium. This means, among other things, renouncing illusion and explicitness. The arts are to achieve concreteness, "purity," by acting solely in terms of their separate and irreducible selves."[19]

Elsewhere he claimed: "The essence of Modernism lies, as I see it, in the use of the characteristic methods of a discipline to criticize the discipline itself—not in order to subvert it, but to entrench it more firmly in its area of competence. Kant used logic to establish the limits of logic, and while he withdrew much from its old jurisdiction, logic was left in all the more secure possession of what remained to it."[20] Clearly, with its female figure and a variety of mediums and styles often enclosed within one work, its physical and illusory projections into three dimensions, the *Walking Woman* series violates Greenberg's standards for quality modernist art. Yet, grounded in formal exploration, the series departs from the same premise. The *Walking Woman* is an insider's challenge to Greenberg's prescriptions.

At other points of the contextual spectrum for the *Walking Woman*, objects which would become identified with Pop art and Minimalism were just emerging in the United States and in the pages of *Art News*, which Snow was reading. Snow wanted to learn specifically from the latest New York art, but he preferred the Abstract Expressionism and colour fields of Willem de Kooning, Mark Rothko, and Barnett Newman to the Pop art of "Rauschenberg...things like that."[21] Robert Rauschenberg had been making his riotous combine paintings

since the mid-1950s (e.g., *Rebus*, 1955, Hans Thulin, Sweden; *Bed*, 1955, Mr. and Mrs. Leo Castelli, New York), in which junk scavenged from street and studio, along with text and found visual images, were collaged on panels and modified with drawing and painting. These cast-offs and reproduced images from a consumer society were placed together in a new context so that they accumulated meanings other than what they had individually and previously. In new relationships, they produced a tangle of verbal-visual puns, historical references, and a refutation of the notion that art is separate from life. These are some of the effects and concerns emerging from the *Walking Woman* series, although Snow engaged them with very different means. Some of Rauschenberg's comments also resonate with Snow's project: "A picture is more like the real world when it's made out of the real world," so that "there's no reason not to consider the world as one gigantic painting."[22] This statement finds its framed analogue in Snow's *Four to Five* (1962, figure 3), where the world reappeared as picture when the *Walking Woman* was photographed around Toronto in rush hour; or when people rushed between the eleven stainless steel *Walking Women* at Expo 67.[23] So one has to acknowledge certain conceptual similarities between Rauschenberg's work and the *Walking Woman*.

Snow was also thinking over issues from the painting milieu surrounding artists such as Jasper Johns and Claes Oldenburg.[24] Johns declared his own working strategy as:

> *Take an object.*
> *Do something to it*
> *Do something else to it*
> " " " " 25

Snow's program for the *Walking Woman* is similar: "A representation can be used for something else....Lady fence, lady table, lady chair, lady lamp, rubber (balloon) lady, water bottle lady, fur lady, stained glass lady, lady road sign, lady shovel, lady car, lady dart board, lady hat rack....What are the differences in 'meaning' in comparing the same form (W.W.) in sponge rubber, in plastic, in sand, in light."[26] Jasper Johns had begun his flag series in 1954. Like the *Walking Woman*, the flag series includes many images of an image (or things like a thing) produced in many different ways. Johns approached seeing as problematic and as a site of difference in *Target with Plaster Casts* (1955; Mr. and Mrs. Leo Castelli, New York). Like the flag, a target is a pure image from popular culture; it does not represent anything else. Johns framed that realization in encaustic, showed it in an art gallery, transferred it to the context of art history and the discourse of specialized aesthetic appreciation. The targets contrast with small, gaudily coloured plaster casts of body parts of friends and himself, which are lined up in cubby holes across the top of the target. As a result, sight focused on a single point coupled with univer-

sally understood meaning (i.e., ⊙ marks the spot) competes and contrasts with furtive, voyeuristic seeing "behind" the object, provoked by the body casts. As with *Duet*, my sight is targeted in the possibility that the unseen or still-to-be imagined fantasy behind the spot is as much part of the object as its substance.

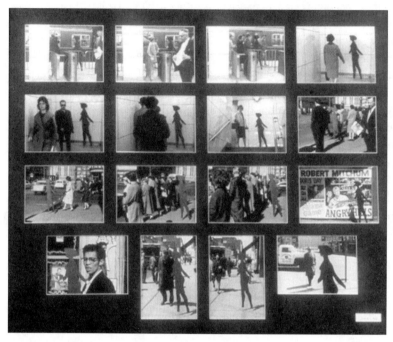

Figure 3. *Four to Five*, 1962, edition of 3. Sixteen gelatin silver prints mounted on cardboard, framed, 68.0 x 83.3 cm. Purchased with donations from AGO members. Art Gallery of Ontario, Toronto. Photo courtesy Michael Snow.

Claes Oldenburg was also making flags out of torn cardboard, plaster, and wood scraps (e.g., *The Old Dump Flag*, 1960, artist's collection) in order "to reveal the actualities of life and to assert an exuberance for living, to encourage a more open and open-minded way of seeing," to test the perception and definition of art.[27] In 1961-62 Oldenburg set up and ran *The Store*. In an old shop at 107 East Second Street, New York, Oldenburg became entrepreneur, factory worker, food store clerk, tailor, cook, etc. His line of products in painted plaster and stuffed cloth reproduced the mass-produced commodities, including food, that he saw all around him in shops or as garbage on the streets. Oldenburg combined these with his role as an artist. Simultaneously, the work of art, artist, and viewer in the context of consumer society stood revealed as consumer products—Heidegger's standing-reserve—even if presented with high irony. At first sight, they became resources available to the capitalist system which they apparently could not escape as an art practice. Snow performed similar tests with the

Walking Woman when he used her as his personal trademark and as his line of consumer goods that were both custom-made and mass-produced. So, is it possible that the *Walking Woman* and Oldenburg's project produce a different kind of viewer than a unit of standing-reserve? Circulated through the ironic practices of artists such as Oldenburg and Snow, I can no longer "believe" in or respond to their injunctions as a static target. Instead, I've been sent on a detour which might just get me around this problem.

Andy Warhol also submitted images of banal objects and iconic images to mass reproduction processes (e.g., *Soup Cans*, acrylic on canvas, Irving Blum; *210 Coca-Cola Bottles*, silkscreen, Robert E. Abrams; both 1962), but with a different purpose. While Johns and Oldenburg made stylistic references to the history of painting, sculpture, and assemblage, Warhol adopted slick styles of commercial advertising from his professional background, a short-circuit which denied that the references of art to hallowed values of originality, authenticity, or spirit were still available or even viable goals in contemporary society. The *Walking Woman* falls both ways: some versions refer to the history of Western art and contemporary art criticism, while others (e.g., *Cry-Beam*) seem as purely contemporary as Warhol's images. Snow, however, does not use found images, which gave him the more interesting ability to test the viability of older values and perspectives rather than simply denying their possibility or viability today.

There is no doubt that many of Johns's, Oldenburg's, and Warhol's pieces are ironic, but they also report the story of victorious American consumer culture and patriotism, McCarthyism notwithstanding.[28] As cultural treasure and as the story of the victors, American Pop art revealed that a political bias for an art of mass-production was possible, as Walter Benjamin had hoped, but it was just as possible to use art to silence history's losers. (That is, victors often appropriated unique, traditional art works associated with ritual.)

Although these artists had been working with popular imagery since the mid-1950s, and although Pop art had been a recognized phenomenon in London through the Independent Group's exhibitions—*Parallel of Life and Art* (1953), *Man Machine and Motion* (1955), and especially *This is Tomorrow* (1956)—exhibitions bringing together and theorizing Pop art in the US did not open until September 1962 with *New Paintings of Common Objects* at the Pasadena Art Museum, and *New Realists* at the Sidney Janis Gallery, New York, in November 1962. The recognition of Pop art came to Toronto with *The Art of Things*, held at the Jerold Morris International Gallery 19 October-6 November 1963, and included work by Andy Warhol, Tom Wesselman, Claes Oldenburg, James Rosenquist, and Robert Rauschenberg, among others. Against this exhibition history, it needs to be re-emphasized that Snow's first *Walking Woman* exhibition was held at the Isaacs Gallery in Toronto in March 1962, months before these other shows.

Snow himself distances his work from Pop art: "Mainly pop art didn't exist at that time," Snow said in 1970. "It was perhaps within a year before the first notice of what Warhol and Lichtenstein were doing. The main influence which triggered it was partly knowing about Oldenburg and Kaprow. I hadn't experienced their work, but hearing about it triggered some problems in my work which I'd been approaching."[29] His show at Isaacs Gallery in 1962 included the paradigmatic *Venus Simultaneous* (colour plate 2).[30] *Venus Simultaneous* makes visible the most obvious differences between Pop art and most of the *Walking Women*. Rather than bringing a found popular image into art, Snow chose what he understood to be the general historical subject of Western art, rearticulated his own figure in many mediums, and then resited it for new possibilities. As he also clarified: "Women historically as subject in art....One subject, *any* medium....I'm not so interested in making a lot of paintings, sculpture etc. as finding out what happens when you do such and such a thing."[31]

The woman's many continuous and overlapping painted and drawn silhouettes, shadows and contours of her figure, collage attachments and a freestanding element—all in blue—thoroughly confound boundaries between medium, figure/ground, the "space" of art versus my space in the real world, myth and reality. And she is named for love, right now, between you and me. Snow realized early that if he cut his figure out of its surround (or vice-versa) it was by default set loose for his use and our reception as a consumer item and as a representative of art in non-art environments, thereby testing the separation between the two.[32] Long before Keith Haring, and at least three years before Dennis Oppenheim and Robert Smithson, Snow dispersed her in the non-art world as a mailing piece, bookmark, stencil on clothes, posters on telephone poles, construction hoardings, in bus stops and subway stations, as well as in art exhibitions and galleries.[33] In contrast, most Pop art was made for and shown in the unquestioned context of art and its institutions. In Toronto, as Dennis Reid has discussed, significant differences between the *Walking Woman* and Pop art were immediately understood by local critics and artists.[34] However, in New York, where Snow produced the *Walking Woman* after the summer of 1962, Snow was considered a tangential Pop artist by as prominent a critic as Lucy Lippard on the basis of Snow using mass production techniques and fielding the *Walking Woman* as a personal trademark.[35]

Prior to leaving for New York, Snow was part of the circle of local, radical artists brought together by Avrom Isaacs at his Greenwich Gallery (which opened in 1955; later it was called the Isaacs Gallery). Gallery artists were united by an interest in what was happening internationally (multi-media work, return to figuration, happenings, performance), and several played jazz (including Snow), but as a group they did not subscribe to any single theory or ideology. They included Graham Coughtry, William Ronald, Gerald Scott, Dennis

Burton, Richard Gorman, John Meredith, and eventually Joyce Wieland, Gordon Rayner, Greg Curnoe, Robert Markle, and Ted Bieler, among others. Along with Snow, fellow artists Wieland, Curnoe, Markle, Coughtry, and Bieler were concerned with the female figure as the subject of Western art. Curnoe painted flamboyant, funny, and satirical versions of the female form, or of feminine clothing, in the smooth, brash, and flat style of commercial advertising. Bieler's *Female Wall* (1963), a free-standing room partition of *ciment fondu* deeply worked as a two-sided relief, proposes the female form as an organizing principle inseparable from sculpture and the built environment. In a parallel fashion, Coughtry's paintings embedded the figure as the apparent basis of painting. Although his paintings are always called Figures (e.g., *Emerging Figure*, 1959; *Two Figures*, 1962; and *Reclining Figure Moving #1*, 1974-75), as were some of de Kooning's *Woman* series, their positions and veiled indistinctness call upon the tradition of the female nude in Western art. Coughtry and Snow were friends when they were students at the Ontario College of Art, and they both worked after graduation at Graphics Associates, a film company that made animated commercials. Snow and Coughtry had their first public exhibition together at Hart House in Toronto in January 1955.[36] Like Snow, Coughtry admired de Kooning, and was particularly interested in how de Kooning turned the female figure into the basis of painting: "The thing about de Kooning that has always been important to me is the way he turned the image into an actual way of painting, spread it all over the canvas, and still retained traces of what the image was to begin with; it's a marvellous combination of seeing and then having an emotional response that is translated into a way of painting."[37]

Unlike de Kooning, who attacked conventions of how to paint and simultaneously attacked the biological integrity of his figure (without obliterating it), Coughtry started with photographs of film stills from which he made many drawings. His figures were already products of representation and refracted light. During the drawing stage, the figure changed considerably. Although the figure looks as though it is buried under numerous layers of paint, it functions visually as the radiating source of both colour and paint. Figure-painting, the figure "at the back of the picture" (i.e., metaphoric foundation), looking at figures as the basis of painting—all of these find correlates in *Venus Simultaneous* and others of the *Walking Woman* series, although they look quite different.

The *Walking Woman* does bear a relationship confirmed by Snow to Willem de Kooning's *Woman* series, dating from the mid-1950s, as well as to the modernist paradigm for painting. As Snow himself said at the time, "Revelation of process as subject in Pollock, de Kooning continues. Scientific method. Experiments."[38] Many of Snow's abstract paintings prior to the *Walking Woman* were part of this investigation. They show him isolating and analyzing the effect of elements of painting in the Abstract Expressionist style that he admired. For

example, in a series of work and sketches including two *Sketch(es) for Painting* (both 1959) and *Blue and Purple Drawing* (1959), Snow experimented by isolating and laying out elements common (but not exclusive) to Abstract Expressionism—the splashing strokes, dribbles, calligraphic lines, flat colour planes, thin contour lines, and brushy patches of colour—separating and rebalancing them in the acknowledged presence of surface, edge, and a visible or implied grid.[39] In *Blues in Place* (September 1959) he included collaged items and imported a visual-verbal pun on the rhythms and harmonies of blues music and the placement of colour.[40] In *Secret Shout* (January 1960) he returned to a traditional subject, the human head in profile, although the figure is playfully ambiguous like the hidden figures in children's visual puzzles.[41] In 1960, Snow returned to the problem of the female figure as both figure and ground, the "field" of visual art, which he had explored earlier in 1955-56 in a beautiful series of paper collages coloured with Kodak dyes and cut to shape with a knife (e.g., *Reclining Figure*, 1955; *Enchanted Woman*, 1956).[42] The large, floating, abstract figures of *January Jubilee Ladies* (1961) sum up much of this work and, to the historically minded, gesture towards antecedents such as Picasso's *Les Demoiselles d'Avignon* (1907; Museum of Modern Art, New York), Cézanne's nude female bathers, Matisse's reclining nudes, as well as de Kooning's *Woman* series.[43] The figure for the *Walking Woman* emerged during this reconsideration.

No one can look at the *Walking Woman* series without thinking of rules-based processes and of Minimalism, where production is distanced as much as possible from the private taste, touch, and decisions of the artist and is brought into public intelligibility as the articulation of an objective order (e.g., the Fibonacci number series, geometric or logarithmic progressions, "whirling squares"). In an un-dated issue of a Toronto magazine called *evidence* 2, which appeared probably in the spring of 1961, Snow published a handwritten page covered with aphoristic phrases: "I make up the rules of a game, then I attempt to play it. If I seem to be losing I change the rules."[44] Although paradigm-setting Minimalist exhibitions and criticism did not emerge until 1965, Snow's first show at the Poindexter Gallery in New York took place 28 January-15 February 1964, opening two weeks after a show of Donald Judd's new work at the Green Gallery closed. Judd's new work engaged a sculptural and painterly vocabulary of surface and plane on wall reliefs and box constructions; the interiors of the boxes were opened to display a perfectly regular, additive construction process. In Judd's review of Snow's exhibition, he praised especially the emerging new relationships of surface contour to interior when two-dimensional figures are expanded into three dimensions, and the strategy of using one simple, apprehensible form (the *Walking Woman*) in numerous ways.[45] Judd clearly found issues in the *Walking Woman* sympathetic to his own emerging Minimalist practice. However, Judd did not write about what would become Minimalism's cen-

tral concerns, objecthood and presence, until 1965 in the article, "Specific Objects."[46] Mel Bochner wrote his influential series of articles on self-evident structures and seriality even later, "Art in Process–Structures," "Primary Structures," "Serial Art Systems: Solipsism," and "Systemic" in 1966-67.[47]

While objects of holistic and non-subdividable form (having good gestalt) as a perceptual route to self-consciousness in the immediate moment was not the *Walking Woman's* problem, tracing "missing persons," or jolting you and me in the real world out there into questioning where and how we find ourselves can be considered a parallel project. The last painted *Walking Woman* (*Test Focus Field Figure*) appeared in 1965, while the stainless steel *Walking Women* commissioned for Expo 67 can be considered retrospective. Nonetheless, "she" returns at times in other mediums to test Snow's scene and ours, for example in *Projection* (lithograph, 1970) and *Adam and Eve* (colour photograph and other mediums) in 1997.[48]

Since the interplay between process, materials, and sight in any *Walking Woman* is always part of the issue, materials—their application and how they work together—are emphasized rather than disguised in a seamless construction, with the result that "her" final appearance as a virtuosic objet d'art fails as a generalized description. Furthermore, often there is not a lot given in a single piece, so that the *Walking Woman* tends to take on more significance in groups, one playing off the other. They are like phrases, or sentences of a paragraph, testing how pictures with their sensual charge might come to mean something. These characteristics, combined with Snow's tendency towards systematic variation, leads one to consider the context of rules-based art-making, a category generally described as Conceptual art. As described by Robert Morris, "the detachment of art's energy from the craft of tedious object production has further implications. This reclamation of process refocuses art as an energy driving to reshape perception."[49] The *Walking Woman* is not like Conceptual artworks whose material properties were theorized as secondary and dispensable or through which "the overall ideational development of an artist has more value than any instances of his artwork," but the series does participate in the shift performed by Conceptual art after Marcel Duchamp. As two artists explained, "the redefinition of artwork as syntactical indicates...that art's manner of operation can move from the myriad permutations of iconic hardware into a study and application of the category itself, where the category is interpreted as being a context of rules and conditions."[50] It is in performing this shift that Duchamp's readymades exploded the traditional functions of art because the readymades, based on contemporary mass-produced and found objects, assume that contemporary viewers are historically disconnected. The completely modern task of twentieth-century art was to challenge art's viewers and institutions to rethink and revalidate the practice

of art each time because they were disconnected from the historical tradition that delivered art as a protected concept. With Duchamp, art's concept became a primary issue.

Duchamp initiated his readymades in 1912 with the *Bicycle Wheel*, two years before Europe started to blow itself up in World War I. But thinking through the readymades as a paradigm for Conceptual art practice was not taken up in North America in a major way until 1969 with the first exclusively Conceptual art exhibition, *January 5-31, 1969*, organized by Seth Siegelaub at Simon Fraser University (Burnaby, BC), followed by the *Information* show at the Museum of Modern Art in New York City.[51] Of course, there were individual precursors: Robert Rauschenberg's 1961 "portrait" of Iris Clert (a telegram stating "This is a portrait of Iris Clert if I say so"); Yves Klein's performance pieces; Joseph Kosuth's *One and Three Chairs* (1965) and *Art as Idea as Idea* (1966); and Sol Lewitt's theoretical essays, "Paragraphs on Conceptual Art" (1967). The British-American Conceptual art journal *Art-Language* began publication only in May 1969, and Kosuth formalized Conceptual art for the New York art scene in "Art After Philosophy," published in *Studio International* in October 1969. In the light of this context, it is significant that Snow had consolidated the *Walking Woman* as a project prior to its first exhibition at Isaacs Gallery in Toronto in 1962.

Shortly after his first show and *Venus Simultaneous*, a unique painting-construction owned and frequently shown by the Art Gallery of Ontario, Snow turned the *Walking Woman* loose on the everyday world of offices and commuters, framing the addition of art to life, which he photographed and returned to art in *Four to Five* (figure 3). This photographic piece is not a unique work, but an edition of three. A grid of sixteen black and white photographs records commuters' interactions with a cut-out figure of the *Walking Woman* placed around Toronto on subway platforms and corridors, on busy street corners, and in front of storefront ads for popular films. All of these are urban spaces designed to hasten people on their way, rather than centralizing spaces for pause and contemplation or for reaffirming relationships of family or authority.

In some of the photographs, the *Walking Woman* finds her counterpart in solitary women striding purposefully by. In others, people pass by in crowds. Most ignore each other as well as the female figure in their midst, with the exception of two pairs of women in the top row of photographs. These commuters are the Toronto equivalent of members of Benjamin's crowd who surge along urban streets and become aware of things through momentary distracted glances while on the move. The *Walking Woman* is framed multiple times by windows of the subway cars, large tiles in the corridors, and movie ads on storefronts. These "natural" frames of urban life keep views orderly. The view gets messy only on street corners, where frames appear in the pavement around her feet rather than in the vertical position of pictures.

Commuters and shoppers hurrying home are hard at work fulfilling their roles as human resources, units in the standing-reserve of capitalist consumer enterprise. They do not seem to be concerned with the limited and unique time of their lifespans rather than the clock-time of the workplace; they are not following a schedule organized around their unique personal circumstances rather than that of their commercial masters. And for most of the passersby in these photos, the intervention of the *Walking Woman* is not an unscheduled pause where they stop, puzzled by how to read the figure or what to do next. If they look at the *Walking Woman*, it is only with a passing glance. Maybe they will remember and think about her later.

But for me, to whom these photographs return in an art gallery, it's quite a different story. I come to them in a room designed for stopping and looking although, because this is the Art Gallery of Ontario, not always designed for sitting and prolonged consideration. I have to admit that I have passed by these unassuming photographs many times in unconscious mimicry of their subjects. I am, however, asked to pause: in the top left print the *Walking Woman* strides by on the subway platform, head clearly framed by the car window behind her. In front of her is the turnstile to the platform with instructions clearly marked for me: ENTRANCE. Yes, I am invited into the picture. Over in the fourth print I can follow the back of the staffage figure of a woman preceding me down a tiled corridor towards the *Walking Woman* already turning the corner. A man and a woman walking towards me close to the wall pass on my left. I join a crowd ahead of me, and later hurry to follow a crowd of women stopped at a street corner who are ignoring the *Walking Woman* hurrying to catch up with them. I stop suddenly, confronted by the hard stare of a young man, himself framed with the *Walking Woman* by entertainers' ads behind them. Finally, on another street corner, the *Walking Woman* turns to walk down a side street, intersecting the line of sight between me and a man in dark glasses walking towards me. Passing through, she holds us together, our gazes pressing on either side of the picture plane. Below the last print and a bit to the right, Snow signs for his sightings—SNOW '62—and makes space for me at the same time. Having found myself mimicking its subjects in the past, and having accepted the invitation into the picture this time, have I been incorporated into the standing-reserve or given other connections?

Four to Five can be viewed as a plotted story with beginning, middle, and end. It has a cast of characters of different qualities: commuters, the *Walking Woman*, the ambiguous presence of Snow through his signature and trademark, and me. It tests different ways of seeing again and again. Through the prints, *Walking Woman* figure, and signature, Snow's sight permeates the world. It could be anywhere, turning the world potentially into one giant picture. Despite differences of time, history, and gender, the work generates a certain empathy

between the owners of different eyes, so that I can somewhat see *as if* I were Snow, just as he, much earlier, undertook to see *as if* he were me. As the last print suggests, they are traces of a crossing point of lines of view (remember *Duet* [figure 1] and *Self-Centred*). Together, we hold this site and sight in place, a sight in which I am not addressed as a unit of the standing-reserve. Rather, the photography has reopened possibilities of seeing that I hadn't considered before. Having crossed Snow's gaze *as if* I were a character in the photographs and again in an art gallery, in the everyday world and in the designated space for art, then shouldn't I be ready for this event to happen everywhere all the time? Time and space become pregnant with this possibility.

Just as Walter Benjamin hoped, the future can be saved from being the homogeneous, empty time of capitalist production and utilitarian efficiency: "For every second was the strait gate through which the Messiah might enter."[52] However, while Benjamin's project was to free the arts of reproduction for political use, Snow's project appears to be more about testing for aesthetic emergence in the banalities of everyday life—which could have ethical and political import indirectly, as Ricoeur suggested.

The radical shift of framing in *Four to Five* made art and life mutually enframing, and directly questioned their priorities. In work like *Four to Five* and the *Walking Woman* bookmark series, the two domains become impossible to consider separately; they are co-dependent. Such interdependence suggests that the most radical proposal by the *Walking Woman* is arguably not that she is "about" looking at women, or images of women as objectified male desire, or even about processes of representation. Rather, she is a way of seeing that challenges categories of seeing and being seen in art and in life, and between visual and verbal domains, a conception that is useful to approach through another major resource for Snow and the earlier source for Conceptual art, Marcel Duchamp. As a delay of the glance in paint, paper, steel, or film which renders the domains of "representation" and "real" insecure, what follows from proposing that the *Walking Woman* is Snow's version of Marcel Duchamp's *regard* (gaze/look) as a *retard* (delay) in figuration, figured and enframed by the ready-maid?

Thierry de Duve has argued for a more discerning interpretation of Duchamp's readymade: in technical terms, the readymade sets forth the enunciative paradigm rather than the linguistic (structural) paradigm. Previously, structuralists had enclosed the enunciative paradigm and the readymade within the linguistic paradigm. Now, de Duve wants to separate enunciation from the operations of structural linguistics. There is a good reason for this. Although de Duve agrees that the readymade was the point of departure for Conceptual artists in New York during the 1960s and early 1970s, he argues that Conceptualists, particularly Joseph Kosuth, mistook conditions set by the work of art for causes, and so strayed into logic.[53] De Duve argues that the enuncia-

tive paradigm distinguishes between conditions and causes, which keeps the work of art from collapsing into deterministic causal explanation and propositional logic (i.e., if x and y, then z; or, a statement in which something is affirmed or denied and can then be characterized as true or false) associated with history, technology, science, or philosophy, or which determine the subject (you and me) as an effect of language structure. Consequently, the subject of enunciation, "I," takes up a powerful critical position: neither the Greenbergian subject of taste invoked by material-based essentialist aesthetics, nor a decentred effect of linguistic structure, nor the conscious and objective agent of science, technology, progress, and consumer economics.[54]

As de Duve sees it, the readymade sets out four conditions for the work of art taken as enunciation, and which are basically the same as Ricoeur's conditions for discourse:

a) there must be an object as reference;

b) there must be an "I" who says or sees something;

c) there must be a viewer or spectator who sees or reads the same thing;

d) there must be an institution which records the enunciation and response and disseminates the resulting entity now called art.[55]

According to condition (a), a statement has to be about something (an object) that remains recognizable over time. This is necessary for enunciation to make sense pragmatically, if not grammatically. As we have seen, once Snow fixed his female figure he used it arbitrarily as found material, as ready-for-consumption as Duchamp's readymades had been. It became its own reference through multiple repetitions (which suggests as well that reality is present to us as a condition of reference rather than an empirical discovery). De Duve's conditions (b) and (c) enlist artist and spectator as co-respondents in a particular relationship. Once you (the artist) state, "This is art," you are defined as practitioner in relation to this object. The situation for me as a viewer is more complex. As viewer or listener, I implicitly repeat the artist's statement second-hand, coming later, after the frame. Even if I disagree, in responding I validate the statement as a test of art's conventions. While I engage and join the artist's practice, nonetheless I can reproduce that statement only "unfaithfully," because I am in a different time and place. This is a major shift in spectatorial identity, away from transparently filling the artist's shoes, towards recognizing his or her dreams of desire for me as audience. Finally, recorded public reception such as exhibition or acquisition by an art gallery and critics' reviews institutionalizes the statement. The entity called art, in consequence, is now a practice and a cultural formation constituted by judgement which circumscribes a triangle of participants: artists, viewers, and institutional recorders.

Contrary to what one might believe, the enunciation invoked by Duchamp's readymades is not "This is a urinal," a snow shovel, or whatever, but specifically, "This urinal is art." None of the readymades, including Duchamp's urinal, *Fountain* signed by R. Mutt (1917; lost), was designated as sculpture, so that prior to Greenberg, Duchamp's project denied that art was a self-critical and self-defining, medium-specific, convention-jettisoning object. Duchamp's deployment of readymades in exhibitions provoked people into recognizing that the statement "this is art" could apply to any object, whether urinal or great painting. In de Duve's estimation, Duchamp's implicit enunciation was crucial in changing what counted as Modernist art. From art described by objective properties specific to a medium it changed to certain kinds of *activity* regardless of medium. Consequently, medium-specific, object-bound conventions were bypassed in defining the aesthetic domain. The essential issue was judgement about art practice, made first by an artist, then repeated and validated or denied by individuals and institutions. The category of artist was broadened from painter, sculptor, musician, or whatever, to persons who test judgements pertaining to the field of art rather than conventions of a medium. It is on these grounds that an art work does not have to be handmade; it has to be signed (chosen) and countersigned by viewers and institutions, which means that not everyone is an artist.

In de Duve's argument, participants in the judgemental enunciation "this object is art" are specific to the aesthetic field. You and I arguing about Duchamp's snow shovel are not the consumer/producers of economics, the inventor/users of technics, the sender/receivers of communications, or the addressor/addressees of the pragmatic field, because the audience of these categories does not have to make a judgement about the category of art.[56] The *Walking Woman* aims a little differently and more radically, I think. The subject who judges "this is art" in effect saves himself from being a subject in the arenas of economics, technics, communications, etc. But the *Walking Woman* challenges not only what is art but the priority of "life" to art. That is, do we understand life through the frames of art of whatever mediums (e.g., poetry, music), or vice-versa? And how do I "find" my self in such a confusion? So, setting out from the path opened by Duchamp's readymades, on a route ignored by Abstract Expressionism and its descendants, somewhat probed by Pop, and long before the debate over simulation heated up, the *Walking Woman* had already arrived.

Duchamp's readymades had four additional criteria: (1) a readymade was not handmade; (2) it was not produced by Duchamp; (3) he had to stumble over it; (4) he had to be aesthetically indifferent to it; there could be no stirring owing to lust or hate, no libidinal investment based on notions of beauty or creation.[57] Kosuth frequently repeated these criteria in his version of Conceptual art in New York in many of his essays, including "Art After Philosophy."[58] In Kosuth's

version and Duchamp's readymade, neither artist nor spectator could judge and experience pleasure at the same time; the pleasure-body—the animal?—had to be left behind.

The *Walking Woman* series departs in certain ways from Duchamp's conditions: they are handmade; they were produced by Snow; and they are deeply involved in the allure of looking. While most if not all the series are handmade, Snow employed means to subvert the filiation of the handmade. Many were made using mass production materials and methods, even if they were done by Snow in his studio. For example, the panels of *Test Focus Field Figure* (1965) were painted with readymade spray enamel, so that neither surface nor hue owes much to Snow's private touch or an unreachable private taste in colour. Anyone can choose and use the same paint. The "ready-maids" went further, however, by elucidating the structure of visual meaning. Duchamp's readymades, while manipulated, were not elaborated as variations on a formal theme. Yet Snow's typical manipulation was to choose particular parameters from the material basis of his medium, such as black and white, solid contour/blank ground in *Encyclopedia* (1964-65), or primary colours (mutually exclusive categories), and partial contours (as figures on ground), as in *Switch* (1963), followed by apparently systematic variations of those variables through a range of possibilities.[59] Snow himself has attributed his process of working out variations to his "other job" as a professional jazz musician.[60] A set of variations could become a *Walking Woman*. The improvisational character of jazz, and especially Snow's jazz, suggests that the *Walking Woman* depends on and returns Snow's private sensibility. The *Walking Woman* variations, however, were structured as binaries (e.g., black/white, inside/outside, primary colours), mutually exclusive but related categories which also structure language, granting works of visual art a structure of public intelligibility parallel to that of verbal language. At one level the binary strategy for the *Walking Woman* also unburdens painting of creativity or originality peculiar to the artist in an unspecifiable and unrepeatable way; it deploys "impure" media in repeatable, legible structures of meaning that explode past the individual into the social domain, intelligible to more than two. Intelligible rules of variation are inherently public rather than private or irrationally creative, so a logic of variation was another means of bypassing Duchamp's ban on the homemade handmade. Furthermore, because of its public intelligibility, the "ready-maid" fulfills the requirement that I "stumble" on it. Through its strategies, the *Walking Woman's* status as intelligible convention satisfies Duchamp's conditions that the readymade be found, not made.

Stumbling, Duchamp found objects in the world to which he was aesthetically "indifferent" and which he and others tested as art. In a departure from Duchamp but in the context of Duchamp reception, the *Walking Woman* suggests that the readymades' criteria of selection can be approached by different

means and are certainly not objects of indifference. In an intentional reversal of Duchamp's found objects, Snow carried series of *Walking Woman* figures outside the studio and gallery to "lose" in the real world of subway stations, newspapers (the *Village Voice*), lamp posts, construction hoardings, a breakwater, a car door, record jackets, etc.[61] For one series, he "lost" small sheets of coloured paper printed with a *Walking Woman* rubber stamp as bookmarks in the general stock of the Eighth Street bookstore in New York.[62] At a preliminary level, the bookmarks were a whimsical gesture testing the inhabitants of non-gallery contexts for their aesthetic response. Which comes first, aesthetic object or viewer? What is the context of an aesthetic object? The bookmark juxtaposed the *Walking Woman* figure in its simplest form with text, so that the test for art became a reading test similar to that of Jasper Johns's *Target with Plaster Casts*. The hypothesis of the bookmarks' juxtaposition of figure and text is that both figure and text are governed by conventions or codes of reading, so that I don't just see the figure, I read it as much as I read print.

Since both pictorial figures and text return mental images, theories that deny any contiguity between reading print and looking at pictures falsify a real and productive connection between visual and verbal images. As I scan figure and page, the text leads me inexorably on to the next word from which it structurally differentiates itself, and which as a sign has a reference function. But it's the sentence as a whole that opens a world, remembered or imagined. I pause at the figure of the *Walking Woman*. I haven't a clue what comes next, especially if I am unfamiliar with the series. She is the shape of a delay in my seeing, a disturbance of my other kind of reading, the shape of a certain kind of site and sight, a breakdown in the flow of sign structure, a mark where I stop. The first reference for the *Walking Woman* is others in the series. Secondly and more broadly, she opens the imagined world of seeing and reading as problematic. She tells me that Snow's sight is implicitly here in the pages of a randomly selected book in the commercial institution of a New York bookstore, haunting my sight by chance, the possibility of everywhere. Why am I browsing in this bookstore? Are the shelves of books haunted by allure? The bookmark generalizes from the aesthetic domain to reading any text while asking the question, is this kind of reading the same as that? Do they have the same possibilities for desire?

So, in a departure from Duchamp but in the context of Duchamp reception, Snow's *Walking Woman* suggests that the readymades are certainly not objects of indifference, and questions whether aesthetic indifference is different from other kinds. Surely it is possible to question whether Duchamp's readymades were objects of aesthetic indifference, even to him. As late as 1961 he explained that "the choice of these readymades was never dictated by any aesthetic delectation. Such choice was always based on a reflection of visual indifference and at the same time total absence of good taste."[63] Doubtless Duchamp

was taking aim at conventional European definitions of the beautiful (the true, the good, the well-composed). Nonetheless, much of his production was based on establishing the connection between desire and looking at works of art. Objects like the rotating *Precision Optics Rotary Demisphere* (1925; Museum of Modern Art, New York), and the 1912 series of paintings *Passage from the Virgin to the Bride* (Museum of Modern Art, New York), *The Bride* (Philadelphia Museum of Modern Art) and *Virgin No. 1* (Philadelphia Museum of Modern Art), culminating in the glass-sandwich construction (and its spin-offs), *The Bride Stripped Bare by Her Bachelors, Even (The Large Glass)* (1915-1923; Philadelphia Museum of Modern Art), all pun on the theme of masculine desire in looking at art.[64] They define aesthetic spectatorship as a viewing machine for desire. With regard to the readymades themselves, while approximately fifty objects have been designated as unassisted, assisted, or aided readymades or imaginary projects for them, the readymade which set the model was *Fountain*, the urinal signed "R. Mutt" and submitted for the Independents' Society exhibition in 1917 (New York).[65] Although the exhibition rejected the submission, art practice and criticism immediately repronounced it "art" as the questioning of art, even the deferral of art, and institutionalized it.

It seems undeniable that Duchamp's selection of a urinal must have been conditioned by an alleged indifference informed by an excretory body socialized by the *pissoirs* of Paris, their public viewpoint on the city's sidewalks, and pleasure associated with the inevitable jokes. Within the context of his other aliases such as Rrose Sélavy (*Eros, c'est la vie*) Sélatz, Marcel Douxami, Duchamp's signed pseudonym, R. Mutt, revises easily to *mutter, tu mère, tu mer(de)*, perhaps an association of something like *tu m'erres*, and maybe *der Mutt* of the field (*du champ*). Through this series, name as well as its object don't simply reverse conventions associated with high art; they descend to a combination of mother, excretion, the animal, and a transgressive pleasure arising from turning "art" upside down (not just figuratively; the urinal was tipped over on its back). De Duve points out how the "tr" syllable is repeated in the readymade titles *Trébuchet (Hat Rack)*, and *Sad Young Man in a Train* (1912; *triste* and *train*), and was singled out by Duchamp himself as "very important." The syllable in all three cases calls readers to stutter or defer completion in pronouncing his titles.[66] In French, Duchamp's assisted readymade snow shovel, *In Advance of the Broken Arm* (1915; lost) is *Pelle à neige* which, de Duve points out, transposes to *elle a peigne* (she has [a] comb). *Comb (Peigne)* (Philadelphia Museum of Modern Art) appeared as a readymade in 1916.[67] From shovel to comb not only opens traffic between masculine and feminine object, but between utilitarian objects as subjects of art and one of the classic subjects of oil painting, the woman combing her hair, which also stages the syntagm, I (male) look at (and touch) her. On these grounds, not only are Duchamp's readymades highly suspicious

as objects of his (or others') aesthetic indifference—they claim blends of desire with irony and punning as aesthetic vehicles.

Before making too large a claim for irony, how is the *Walking Woman* ironic? Linda Hutcheon has argued that the strategy of "*refusal* to fulfill the expectation of closure or to provide the distancing certainty the literary tradition...has inscribed in the collective consciousness of Western readers," is the basis for postmodern irony.[68] The General Idea collective in Toronto, which followed Snow, described in 1978 this strain of irony which their female figure, Miss General Idea, shared with the *Walking Woman*:[69] "Hints of flesh-and-bone content are framed by beauty's-only-skin-deep context. We are surfacing on the surface of our desires defined by the intersection of differing points of view. Elevated she reigns; idealized she contains; artfully she maintains; dominantly she sustains our interest."[70]

The most fundamental ironic structure found throughout the *Walking Woman* series is the refusal to fulfill expectations generated by various modes of framing. The contrast between the visual disruption felt when Carla Bley appears photographed behind a *Walking Woman* frame named in her honour, and the satisfaction experienced when the surface-bound expectations of the frame are answered by the flat images of *Hawaii* or *Test Focus Field Figure*, satirizes realist representation and the viewer's culturally educated expectation that representation imitates the world. *Duet* and *Torso* function similarly, satirizing our expectations that realism is based on representing the biological body—a tradition lodged in figure classes where students learn to draw starting with the skeleton, then muscles, then the skin; or the Renaissance and neoclassical technique of underdrawing all figures as nudes (not nakeds) before painting on drapery or clothes. Rather, following the model of Duchamp's *Nude*, the *Walking Woman* celebrates the *bricolage* nature of construction rather than smoothing it over with a beautiful and seamless technique. And these pieces reflect back to us the voyeurist hope with which we as viewers gaze at even magisterial history painting, hoping to see traces of nudes below the clothes.

Snow did not stop with painting technique: *Olympia* (1963; five figures "dematerializing" from chiaroscuro to crude nude, to pure contour, to pure silhouette, to dotted line) satirizes the contemporary revival of Hegelian theory in the trend of modernist criticism which would terminate logically with the dematerialization of the art object. However, the piece doubles as a centenary homage to Edouard Manet's *Olympia* (1863), itself an outrageous satire on what the male gaze wanted in a picture figured by so many of Manet's contemporaries in the Paris Salon exhibitions (e.g., Cabanel, Bouguereau, Baudry, Schutzenberger, and Lamothe).[71] Snow's *Olympia* also jokes that with no artwork and perhaps no image, there is no art; idea alone is not enough. Some further expectations around the legacy of Western painting are raised by titles (e.g., *Olympia*) or a

combination of title and image, such as the reference in *Stairs* (1963, where one-half of the figure is lowered stepwise to a lower stair) which playfully recites and revises Marcel Duchamp's *Nude Descending a Staircase No. 2*. But these two examples fail to fulfill an expectation of closure ("I understand that") and distancing ("Understanding, I am in control through knowledge") that historical reference can disseminate. Snow's historical allusions, coupled with his refusals to fulfill historical conventions, place his practice in a contested relationship with tradition, but this is what gives it an ironic and critical edge.

A strategy that places stereotypes in the context of current theoretical concerns is the deadpan, dumb literalness with which titles describe work but fail to fulfil the metaphoric-allegorical relation between title and work that Western viewers have been conditioned to expect. What springs forth as a result is the duplicitous ambiguity that inhabits interpretative codes, which themselves are often silently charged with improper allusions. *A Falling Walking Woman* (1961; oil on canvas) places two *Walking Women* head to toe horizontally on a panel, daring us to find impropriety or hidden meanings while playing on the stereotype of "loose" women. *Half Slip* (1963; oil on canvas) rotates a *Walking Woman* dressed in a woman's half-slip by 90 degrees (rather than a full 180 degrees) and jokes that painting's surface is literally and metaphorically slippery. Together they visually play on a major point of Heideggerian and poststructural theory, that our lives find meaning in visual and verbal transactions which have no secure reference as ground, and that our birthright is to be initially "thrown" into this place which is not of our making or choice. Visual puns on slang expressions seem to intervene in *Rolled Woman I* (1961), a canvas figure rolled on cardboard tubes, and *Touched Woman* (1961), an ink drawing overlain with hand prints on folded and scrunched paper.[72] These two also make complex formal puns on work by Snow from 1960 such as *Quits* and *Shunts*, sculptures that enact falling from wall to floor, and to foldages such as *White Trash* and *Blue Monk*.[73] The titles coupled with technique also bear witness to the dark side of puns and some versions of the *Walking Woman* which can be ambivalent in their intimation of (dis)figuration coupled with touch and desire.

Snow satirizes the invisible conventions of seeing pictures and their received meaning by making those conventions concrete, and by invoking the unreasoned space of punning. For example, *Seen* (1965) plays on "scene" and the implied primal scene by placing a tiny *Walking Woman* on the small end of a rectangular pyramid (the shape of pictorial perspective rather than the circular visual cone), which projects from the viewer's place in the room onto the wall. Her intervention mocks the viewer as the conventionally objective and detached subject of painting's window on the world or television's (then) "cool" screen. *Register* (1964; a mechanical arm attached to the wall which apparently imprints a hazy reproduction of a painted female nude on a small panel) stages representation as the

machine-like reproduction of the desiring masculine gaze: a parody of poststructural and psychoanalytic theory mixed with popular pin-ups. There are too many plays on received forms in all of these pieces for them to be taken seriously. These examples of plays on words, parodies of historical images, historical genres, exhibition history, popular culture, poststructural and psychoanalytic theory, slang, the fabrication of images, show how many of the series cite, negate, or make ridiculous conventions rather than jettison them. This is the work of irony.

The relay through Duchamp's work insists on the question of desire in initiating the enunciative "I." Although de Duve cited Duchamp's practice as a route to the enunciative subject and a detour around the logical causation of structuralism, the resulting judgement is a pronouncement which does not take account of the desire that so evidently drives much of Duchamp's work. Rosalind Krauss has tried to account for desire in the enunciative subject from within the structuralist perspective. By taking Jacques Lacan's "L-diagram" of the linguistic subject and placing it over a diagram of the deixic subject (whose place is held by pronouns or "shifters"), she has analyzed how the subject of desire is introduced into the system. Theoretically, this accomplishes a slippage from the deixic to the deictic, which takes account of me, standing here, as irrational, psychological, ahistorical, one of the "missing persons" of whom Snow's bookmarks and pieces like *Stereo* (discussed below) were seeking traces.[74] What Lacan's diagram subsumes through the psychological process of introgression is narrative, and the narrative genre implied through psychological explanation is very similar to that for redemption. The model for the subject of desire proceeds from the premise that at some earlier time, she or he became a subject through the mother's look which named the child to and for itself. For this reason, the child or subject fears withdrawal of the look above all else, as it will lose the basis of its identity. Terror, Krauss argues, is prefigured in the withdrawal of the look, and so we must consider it as woven into identity.[75]

Identity or self-recognition, then, is initiated from outside and from "above," has a terrifying component which we probably don't want to know about, and is a situation into which we are "thrown." We suffer this initiation and terror, and we long for a sense of wholeness or redemption even if we are blind to our terror, our indebted position, or the link between "fallenness" and redemption. Following Krauss, these links are revealed by narratives of faith (which demand submission to the "look" of God) but are subsumed as the work of the unconscious by psychoanalysis. Remember that according to Ricoeur as well, narratives of faith (such as redemption), and the structure of the testimonial lie at the foundation of ethics, the desire to live well with others in just institutions. Ricoeur, Krauss, and de Duve were all looking for a theory of written discourse that would take account of an "I" that was not simply an empty effect of language; they all came up with subjects of desire.

Given the insistent reappearance of the *Walking Woman*'s female form, desire was clearly part of the problem of figuration for Snow. He proposed that the sight of art was desirous historically as well as biologically when he wrote, "women historically as subject in art....Art as a form of mummification....Tits and arts."[76] Earlier, Snow had coupled the historical with the contemporary in the painted relief, *Venus Simultaneous*. Decades later he repeated his point about contemporary viewers with the ironic relief, *Stereo* (1982), a pair of photographs of bare female breasts, with crude cones of black paper ("binoculars") suspended before the breasts almost as their extension.[77] A small projection from the wall between the black cones emphasizes that *Stereo* refers to biological, binocular vision, not monocular, illusory representation. In the binocular vision of human mammals, as Snow makes us see, sight and sex are closely related. So, as we see through these and other works, the acculturated aesthetic sight of Western art has a shape, direction, force, and emotion that are biologically contingent on female anatomy as the object of attachment and desire mirrored into the present moment.

In her often-cited article linking seeing to power and gender in film, Laura Mulvey argued that film conventionally represented woman as type or icon, which was "displayed for the gaze and enjoyment of men, the active controllers of the look."[78] However, is domination of or by the image so straightforward? Mulvey argued that active control of the look "always threatens to evoke the (castration) anxiety it originally signified," so that the icon becomes a fetish object: private, pleasurable, seamlessly constructed, and under control. The *Walking Woman* does not represent anyone out there in the world; she is already an abstract formal construction. The abstracting and objectifying processes of first-order representation have been left out. And there is no question that the *Walking Woman* figures were under Snow's formal control, but he did not leave the matter there. In fact, he courted the risk of losing control, as might many viewers.

With *Venus Simultaneous*, Snow obviously did not follow academic painting method to achieve academic composition and finish which seamlessly effaced material evidence of painterly work. On the contrary, construction, process, allusion, and borrowed sources are many self-evident points of departure that are displayed rather than smoothed over in beautiful appearance. The paint strokes of *Venus Simultaneous* are so obvious and refute so emphatically academic *belle peinture* that attributing them to the controlling private touch and sensibility of Snow seems questionable. Emerging beyond his private domain, they pass into the field of figuration to add touch to sight, a public site which is given the originating Western name for love (Venus) and coloured rich, deep, blue (traditionally a spiritual colour). So, while *Venus Simultaneous* seems to be a site objectively out there, it lies uneasily in sight over here, on my side, which I re-cite and

test, and which questions me as spectator, although with love. In pieces such as *Projection* (a black *Walking Woman* silhouette with a white penis grafted onto it) and *Adam and Eve*, the possible fusion of desire between the unnamed artist as maker and his practice becomes visible to me. Both of these works are blunt in their exposure despite the outrageous sexual verbal-visual pun (in the first) and gentler humour in the second. Puns and irony, which destroy realist reading, however, can also open how a piece works. They are reflexive processes on one hand and distancing devices on the other.

Reflexive processes can open an intimate space within them where "he looks at her" leads to the artist looking at work and practice. Our gazes cross as I see this and "he" sees "me," because of course "he" is visible only as traces to be read, and although I am as yet invisible, he as artist yearns towards my place. Coming later, I become witness rather than voyeur, a witness to art done possibly for the love of art, for the love of reproduction's double which opens me, and "him," to the desire of distance, which brings us wanting to be close once more as intimate listener for the other: "Here I am!" as one to the other. The brain, both *Projection* and *Adam and Eve* remind me, is also a sexual organ, spurring on the fracture of my sight to seeing and hearing an imagined world and imagined or remembered others. Always arriving late, I respond and become involved, with love, rather than as a voyeur. In understanding that double appeal and loaning it my sight, love for "you" infiltrates a love of art, on both the artist's part and mine, along with a love of play and of these elements being acknowledged, no matter how gendered. There is no way to master this figuration, and given its multiple viewpoints, no way for it to master me. Together with *Stereo*, these pieces make it very plain that Snow's sight in art is in no way singular or determined; it is conditioned by a visual legacy of attachment and desire. Once named and sent into the public domain, illusions and puns spin out of control for any single viewer. If the controlling gaze is understood as a symptom of anxiety, then a practice which opens constructedness and gambles on the "illicit" returns of chance allusions is not a site where control is a covert, anxious issue. Consequently, the *Walking Woman* subverts the controlling gaze.

My attention is focussed on the processes of image fabrication and seeing as a double-ended construction that argues without words that everything is already socialized and symbolic, and that there is nothing natural throughout the field. A final image and final subject position, a final language of self-description, are always out of reach. Obviously there is no end to the possibilities of the series, no upper limit, no restored, resolved, vision of plentitude. The endless potential of abstraction frustrates desire for a final order or resolution. The numerous references made with insouciant indifference to "high" art, art history, and popular culture prohibits any sentimentalizing or yearning emotion. No latitude is given to halt identification with the images as either my past or my yearned-for utopian

future, and thus no latitude for an expressive, subjective, psychological, and regressive subject. There is no possibility for authenticity or nostalgia in such a field. Even in those which possibly bear homage, their abstract recitation destabilizes any sense of founding image, to say nothing of belief in a founding truth of representation or possibilities for identification or desire. Unquestioning belief, even in the alleged truth of negation, has a short life in all this jostling. The *Walking Woman* is relentless and remorseless. Ironic recitation and puns are a great loan operation. Liberated from exhaustion in the finality of literal meaning, they generate outrageous and unlimited returns.

Now that I as a subject have been found in irony and desire, in judgement between art and real life, between reading and looking many times, hence beyond the limits of any of them, it seems that I have been redeemed from subjection to conventions of the image or from the circumscription of plenitude. So, have I been freed to return again and again with unlimited interest? Has Michael Snow?

Framed

THE RETURN OF SIGHT, SQUARED

By using sculptural framing devices, Snow made the circulation and returns of sight problematic both immediately after completing his celebrated film, *Wavelength* (1967), and again after making the landscape film, *La région centrale* (1970-71).[1] While neither cinema, photography, nor painting, the post-*Wavelength* group of sculptural frames share some concerns explored in the two films and in the *Walking Woman*: the destabilizing effects of framing and transferring events as images, and the expressive returns from these transfers which place the security of my self in question. This production emphasizes again that Snow's object was not an isolated formal entity, but the domain of art practice—including its viewers and practitioners. Of particular interest is the flow of disappearance and reappearance of my positions and sights which are put into play by the sculptural frames, and what negotiations become necessary or seductive in the framed circuit of seeing and being seen.

As discussed in the first chapter, "enframing" sight was also a central concern of Heidegger's. Heidegger speculated that when one's viewpoint was enframed by the demands and equipment of technology, alternative ways of seeing and interpreting the self and other people as subjects would disappear for seer and seen alike. What technology demands is rationalization and efficiency. These criteria justify that all subjects and objects alike be treated as standing-reserve—deployable at the whim of higher authority and for profit. At the larger

scale of commercial institutions, there is no doubt that much of the Hollywood film industry was already organized in this manner with regard to its entire production teams, methods, and audiences in the 1950s when Heidegger's essays on technology and enframing were published. Similarly, other disciplines that use photography have been criticized for displaying their human subjects as enframed specimens to be scrutinized, labelled, and analyzed or romanticized; documentaries of aboriginal groups are obvious examples.[2] While Heidegger condemned the transformation of human subject into specimen, Benjamin, remember, thought that such an artificial and constructive process had critical potential. So do Snow's frames scrutinize the subject the way that Heidegger condemned? Or do they have the sort of critical potential envisioned by Benjamin?

Snow's frames emerged in New York where Minimal art was being articulated in a substantial body of work. Minimal art had been institutionalized through a barrage of critical writing and exhibitions in major museums of modern art by 1967. The Minimal art project met its fiercest written critique in Michael Fried's controversial article "Art and Objecthood."[3] In support of Greenberg's dictum that the task of modernist art was to free itself of all conventions not essential to the viability of its medium, Fried denounced Minimal art for being anti-modernist by breaking down the traditional categories of Western art and weakening its traditional areas of competence.

Minimal art subverted the history of art as previously constructed through Greenbergian standards of medium and method, and through art historical terms such as originality, taste, individuality, authenticity, self-expression, and style. Dissatisfied that the private masterful, originating, differentiating touch and sensibility of artists engaged with the abstract expressionism of colour field painting and Post-Painterly Abstraction, the immediate concern of Minimal art was to deprive viewers of access to intimate or private aesthetic appreciation. The favoured form was the simple geometric solid that was apprehensible immediately (that had good gestalt) rather than geometric abstraction which relied on hierarchy within a bounded whole (e.g., Piet Mondrian's abstract planes). To find compositions and structures immediately apprehensible by the general public, artists such as Donald Judd, Robert Morris, Frank Stella, Carl André, Sol Lewitt, and Robert Smithson turned to systematic orders like grids, permutations, and serial progressions because they were non-biomorphic and non-anthropomorphic.[4] Whereas much earlier twentieth-century avant-garde sculpture had been "about" the process of transformation of a specific raw material into art object (e.g., Constantin Brancusi, Auguste Rodin, Henry Moore), or surrealist effects of assemblage (e.g., Joan Miró, André Breton), Minimal artists used the standardized and anonymous materials of industry, which removed sculpture from the epic arena of grappling with nature or the romantic representation of inherent vitalism mediated by touch and sensibil-

ity. Minimal art materials and structure were completely visible and undisguised, so that there could be no mysterious cores, no veiled allusions, no place to ascribe subjective content to the object.[5] Open, a priori structure becomes information, as available to the spectator as it is to the artist, subverting the artist's intentional authority.

This notion of information works against the traditions of Western art history where art depicts history or myth (origins), spiritual illumination, an organic integrity with nature and/or divine plan, or manifests the artist as gifted. In Minimal art objects, "the picture-object [or sculpture] stands...unconcealed before the spectator in its quality as a *thing*, and thus asserts its immediate presence in his life-space on the same terms as the other things which populate it, and which engage him on the primary existential plane," argued Sheldon Nodelman in a frequently cited statement.[6] "Presence" was the key concept. Loosely related to human size, Minimal art objects were entities parallel to the spectator, but not open to metaphoric identification.[7]

An exhibition by Robert Morris, which took place at the Green Gallery in New York between 15 October and 2 November 1963, included what would become central to the vocabulary of Minimal art objects: big plywood box constructions painted monochromatic grey. As early as 1961, Morris had used a grey-painted plywood box (8 ft. x 2 ft. x 2 ft.) as the primary actor in a stage production where the curtain opened to show the box upright for three and a half minutes before it fell. After another three and a half minutes, the curtain closed.[8] The box was translated later into various versions of *Columns* (1961-73), made from painted aluminum. Morris's later exhibition at the Green Gallery in December 1964 showed "primary" forms, simple geometric structures which had a theatrical quality and could be understood in an instant even though the viewer could see them from only one side. These forms became the lingua franca of Minimal art objects. Morris's show preceded a show at the same gallery by Donald Judd, which closed two weeks before Snow's first show opened. Judd's work included geometric boxes, like Morris's, but his were red rather than grey.

Snow's first show at the Poindexter Gallery in New York took place 28 January-15 February 1964. Snow's exhibition consisted of versions the *Walking Woman*. Judd's new sculptures, reliefs, and paintings worked with an abstract vocabulary of surface, plane, and additive construction. Judd reviewed Snow's exhibition and was particularly sympathetic to the strategy of formal variations on one image, including expanding two-dimensional images into three dimensions with no debt to a regulating central or "deep" core.[9] Clearly for Judd, much about the *Walking Women* resonated with his own emerging Minimal art practice.

Snow's second Poindexter exhibition took place 27 January-16 February 1968, well after the important "Primary Structures" Minimal art show at the

Jewish Museum (27 April-12 June 1966), and after Michael Fried's attack on Minimalist art in "Art and Objecthood" (June 1967). This time Snow included the framing pieces *Scope, Blind, First to Last,* and *Sight,* all made in 1967 after *Wavelength* was finished, but before the film was shown. Later, at the Isaacs Gallery in Toronto, 15 January-3 February 1969, Snow exhibited *Portrait* among other pieces, but it had also been made in 1967 immediately after *Wavelength.* Like Minimal art objects, Snow's framing devices are unadorned, self-evident objects made from industrial materials, and they stage the viewer's consciousness of her physical and perceptual engagement here in this place. Rather than confrontation with a non-anthropomorphic object, however, Snow's concern with relays and interventions in the field of view argues that what is at stake is the assumption and fate of what I understand about my sight and self-image as it is returned to me—presently and when delayed indefinitely in my imagination. More along the lines of Duchamp's work which delay and charge the viewer's perception with desire by relays through images in glass or other mediums (e.g., the installation *Etant donnés,* 1946-66, or the windowpane *The Bride Stripped Bare by Her Bachelors, Even,* 1915-23; both in the Philadelphia Museum of Art), Snow's frames cast doubt upon the aspirations of Minimal art: the possibility of my body as a site of immediate perception. Rather than orienting myself to isolated, holistic, and nonobjective objects, I am challenged to locate my self and self-image in a crowded, bustling field of real and imagined relationships: who else is here? For whom do I present or see myself? Who might implicitly give permission for my appearance? At issue is not simply my presence here and now, but my self seen traversed by the sight of the Other and of others. It seems that to find my self in this crowd forces me to surface by answering, Here I am! I promise you! as Ricoeur suggested.

Sight (first called *In Place,* later *Site;* 1967 but post-dating *Portrait*) explores the site of the viewer by reporting on the differentiating function of framing on two sides of the frame.[10] The work's succession of titles suggests that Snow's thinking had shifted from the view from a specific place to seeing already framed as a problem. *Sight* is a panel that was originally set into the window at the bottom of the front stairs of the Poindexter Gallery, where it was first exhibited. It was not parallel to adjacent storefronts, but in the angle where a gallery-goer turned from the street toward the gallery stairs. From inside, the panel's interior surface is black plastic engraved with a pattern of white lines (figure 4), an abstract notation of the figure-ground structure of pictorial space, framed by the gallery's white walls. The largest scale element of the pattern is a four-by-four grid which divides the panel evenly but could extend theoretically beyond its limits onto the walls without interruption. A secondary pattern of more closely spaced lines is engraved within the grid commencing in the third row from the left and the third row from the top. The lines intersect in a grid inscribed in the third rectangle from

the left and third from the top row. While the principle of division in the smaller grid repeats the four-by-four division of the whole, its asymmetrical insertion into the larger grid effectually limits the larger grid to this panel.

Figure 4. *Sight* (detail: one side) 1967. Aluminum, engraved plastic, 142.2 x 106.7 cm. Vancouver Art Gallery, Vancouver, British Columbia. Photo courtesy Michael Snow.

Using the same distance between parallel lines as the smaller grid, Snow inscribed an X through the centre of the smaller grid, extending the "arms" of the X to the edges of the large panel. From bottom left to top right in the smaller rectangle, one "leg" of the X has been replaced by glass, giving a diagonal window slit onto the world of the street, framed by design. A temporal sequence emerges: this, then this, and finally, the opened leg of the X. The large grid performs the reflexive function of mapping a plane which conforms to it. The smaller grid identifies the panel itself as a whole, restating its reflexive and

autonomous character. The X refers to its rectangle alone, and the glass inserted into one leg traverses the panel at the design's place of maximum density and intensity, the point where things come together and the part cannot stand for a divisible whole. As in *Duet*, X marks the spot. It completes the preparation of a design which points on the side of good order to *this* scene.

From here inside, I am framed by the hope that good design will hold everything together and by the desire to see from an exclusive enclosure or blind into the street. However, forget about a paradisiacal totality. Everything out there is ephemeral, fragmented, always at odds with the stability of frame and design and questioning its authority. No matter that the view draws outside towards the inside, the passing scene is radically heterogeneous and escapes all reduction to the orderly aspirations of frame and design. The "difference" comes into sight.

On the other side, at the foot of the stairway, the panel presents the blank face of an aluminum sheet dotted with a grid of bolts, punctured by the diagonal slit. As an armoured section of wall, it announces something which must be defended—the aesthetic sight of art galleries—against threats from the everyday commercial world. Since the slit from outside also invites voyeuristic viewing, the view through *Sight* from both sides supplies imaginary roles of predator or prey and their concomitant emotions of desire or fear. An uncomfortable body is designed for spectators because they can see from both positions. Opening a transitory site between the self-consciously organized world of an art gallery and the disorderly street cannot master that irreducible, proliferating disorder even when framed, because the frame itself maintains a constitutive difference. As *Sight* reminds us, we see and are seen from both sides, so there is no comfortable place, no equilibrated "wholeness" to attain, no self-possession possible. The self-possessed and possessive subject of representation is only a dream of illusion.

Snow's most basic frame is *Portrait* (1967; figure 5), first exhibited at the Isaacs Gallery in Toronto in 1969.[11] Only a frame with no image (despite its title), the missing image and conditions of its appearance or disappearance become problematic. In good Minimalist style, *Portrait* is a plain, collapsible aluminum frame of adjustable and replaceable sections that can be set up anywhere that has either vertical or horizontal supports within its reach. But completely unlike Minimal objects which serve contextually as a critical viewpoint *Portrait* cannot stand alone. It is explicitly a frame within a frame, an insertion into view, that picks up a visual theme from the *Walking Women* (e.g., *Morningside Heights*, and *Sleeve*; both 1965).[12] As a dependent structure that is also an intervention, it acquires the story of its insertion into a prior context and its discourse. *Portrait* gives its contextual space as architectural, informed by human occupancy, and announces the proposition that "picturing space" is pried open within a larger surround. Consequently, inhabited space is first understood as a force field organized along certain values of dwelling; framing of any sort depends on these

values and organization while working against pressures that those values exert. As an interruption in a force field, the framed can have no neutral context. So, a portrait imagined in the space of *Portrait*, including a self-portrait, depends on the values of its context even while working against them. It is not clear whether I am talking about a rationalized equilibrium, because this portrait frame is mobile, with the consequence that if there is no frame or architectural support for the frame, there is no portrait. On the other hand, if I am going to see any portrait, the space, a space of difference, must be pried open.

Figure 5. *Portrait*, 1967. Aluminum, approx. 60.9 x 91.4 cm (adjustable). Private collection, Ottawa. Photo: Carlo Catenazzi, Art Gallery of Ontario, Toronto.

For Heidegger, inhabited space ideally meant dwelling, which meant building, which in turn meant taking things under human care—a poetic task. Poetically caring for things as they were lets the connectedness of their contextual relationships appear.[13] So dwelling has the all-important power to redeem dwellers from instrumentality and the standing-reserve: to save them from the calculating and rationalizing view which has become the principal organizing axis of contemporary life. For example, Heidegger's verbal image of two stream banks joined by a bridge is most immediately a utilitarian scene of rapid access to the far bank. However, when seen poetically as part of a landscape constructed for dwelling that's under human care, a bridge gathers stream banks

into a spiritualized architecture of sky, river, banks, and bridge composed and maintained in unity by human poetic dwelling. Heidegger argued that while utilitarian need homogenizes space (computed as standing-reserve), poetic dwelling *differentiates* space and objects because each component plays a unique role in maintaining unity in poetic balance.[14] This argument is rooted in notions of cosmic design, which is automatically hierarchical. Heidegger's verbal image also constructs a conventional rural landscape painting or photograph which binds things together through hierarchical techniques of composition, and which is consistent with the notion that visual art or architecture consists of and reveals the epic transformation of nature.

Like Heidegger's bridge, *Portrait* opens a passage in a space that its own presence identifies as occupied by human beings. However, unlike Heidegger's pictorial view of a bridge which is organized from one side only, *Portrait* is two-sided but cannot be approached from both sides at once. Although *Portrait* joins while differentiating space into here and there, it questions whether one is framed and the other unframed. Lacking a structured, realized image, *Portrait* opens a space that is impossible to face objectively as a subject up against an object to be touched, measured, described, or objectified. So the frame of *Portrait* frustrates utilitarian or objective viewpoints that could size up their subjects and objects.

By its intervention in architectural space, *Portrait* acquires a story and the tradition of the Western Renaissance picture frame, which Leon Battista Alberti described as a window encircling a view: "First of all about where I draw is considered to be an open window through which I see what I want to paint."[15] However, unlike the changeable non-image framed by *Portrait*, the window of perspectival illusion is stage-like, coordinating frame, transparent front plane, solid ground, and back planes by means of orthogonal lines and colour gradations to contain a consistent space of representation. The historical need was for a setting for *istoria*, narrative painting. The labourious program of calculating and laying out the perspectival grid and the subsequent methodical building of figures and ground with layers of contours and colours presuppose in concept and technique a pre-existing container waiting for something to happen. Some Renaissance paintings incorporated the action of the frame into the scene (the *veduta*), while for others the frame became pure exterior, the demarcation between art and life.[16] The Renaissance frame replaced the medieval frame which was frequently irregular and overlapped by represented figures. The medieval frame did not try to maintain consistent spatial or temporal relations within it, as William Dunning has shown, because perceived relationships between objects were not important: "Medieval painters felt as if they existed in, and were a part of, their pictorial world, while during the Renaissance, painters of perspective stood outside of the world they represented and observed."[17] So, medieval painters and spectators considered themselves already dwellers of a

spiritualized and poetic environment; they assumed that both inside and beyond the frame were included in a cosmic whole. The final order of the cosmos was everywhere present, beyond representing but intuitable if one could recognize correspondences. Correspondences were represented by allegories or images considered as symbols which had to be interpreted, rather than the truth to be discovered empirically by looking from a single viewpoint.[18]

When Renaissance painters adopted a framing technique that aspired to spatio-temporal consistency to generate an illusion of here and now, the framed illusion also generated a viewer out there in a specific, verifiable position necessary to see the illusion. Alberti was an empiricist, holding that "all things are known by comparison" by a dispassionate and objective viewer.[19] But to compare things "truthfully" in painting, a definite distance had to be established for a viewpoint, and the intervening space coordinated.[20] Greek and Roman painters had previously established perspective techniques which generated realistic images, but in their representations, each object was given its own vanishing point and perspective, so that each had its own space. The space between objects was inconsistent, and the viewer's place not specified. The great difference between Greek and Roman illusionism and Renaissance perspective is that in Renaissance painting, things appear to me as I see them standing right here and now.[21] The truth of this viewpoint is the truth of my singular visual experience at this point, not the truth gleaned from past scrutiny, or a priori from a book, or by interpretation. I no longer look to confirm what I already know from theories set forth by faith, nor do I look at my world through painting as an assemblage of symbols. Now, when I look at painting, I discover what is evident from here. The transparent front plane is the unseen hinge on which this kind of illusion is staked, a membrane drawn across the frame between spectator and scene which ties them together while keeping them apart. As I look through the frame and frontal plane, the whole construction points my sight away from itself giving me the illusion of autonomy. Suddenly, a totality like heaven appears within my reach and understanding, and the age of securing a world picture, or "Vorstellen" (setting in place before), is secured. *Portrait* empties the frame of these contents, but not of this discourse.

Materially, *Portrait*'s replaceable, standardized aluminum sections recall the emergence of balloon framing and standardized mass industrial production which together made early mass housing and industrial projects possible—the all-rationalizing "technique" so lamented by Heidegger—whether in the North American subdivision, the apartment blocks and "domino" houses of Le Corbusier, or in projects of De Stijl and Bauhaus architects such as J.J.P. Oud and Mies van der Rohe. Mass production of prefabricated and interchangeable elements favours building designs that can be called nomadic, bearing no necessary relation to specific place or local tradition. These materials and building

practices express instrumentality and an enframed vision, certainly, but have been paradoxically associated with the utopian dream of a life free from suffering. Much ink has flowed over the fact that utopian universality allows for little expression of the personal and local, the desire for which is assuaged by consumption of styles ("choice"). Nonetheless, from within rationalized practices of enframing, does the consumerism they enable reveal a desire which subverts interest in making everything balance in a well-ordered, rationalized account? Surely, what we really desire is more. In fact, let's ask whether the enframing vision of technologically empowered consumerism serves to ignite and preserve temptation. What could this mean for notions of redemption as liberation from enframing, of being metaphorically paid-up, or as a vision of plenitude? And who wants to stop at that point?

When I approach *Portrait* to look through it, I can see how it pushes open a transparent plane in my surrounding, inhabited space. It exists through compression and stress: the frame itself is made from pieces clamped together and held in compression against nearby walls or supports. I can also look around it inside the room. Grappling with already-designed space rather than apparently unformed "nature," the relationship between space inside the frame and architectural space is unlike that described by Heidegger when he argued that a Greek temple vitalized primal elements of the earth as the ground of human dwelling or "world."[22] Nor is the relationship comparable to Heidegger's later notion of poetic language which incorporates the human body into a circle of auto-affection. *Portrait* is about engagement between others and my self, who asks the question "who?" by loaning my sight to this empty frame. Neither position on the two sides of *Portrait* involves seeing concerned with the minutiae of daily life. Instead, any move to see through the frame is coupled with questions about the desire to be seen. When I am drawn into the intervention of *Portrait* in the room, I respond to a prior framing intention. I double the artist's and enact my own desire to see through here, but I arrive later, asking who else is here; who wants me here; whom do I want to see; with whom am I negotiating? From this approach, *Portrait* tests whether the disguised condition of pictorial space *and* architectural dwelling space is one of call and response, a place exposed by the desires to see and be seen. This moment is foreseen in the past and redeemed for the present by our crossed gazes as I name myself to myself through the delayed refraction of desire through "Snow" (absent artist) and "architecture."

Given that *Portrait* is standardized in parts and construction, it mimics and refers to the rationalized architecture and space of industrialized society. Since it is mobile and collapsible, this opening requires investment to construct and maintain by artists, viewers, and institutions, so it must offer interest on this effort. Perspectival structure holds everything in its place, at the proper distance and in its proper size, both within the picture and between picture plane and observer.

As the historical antecedent of *Portrait*, this and other regulatory framing practices ground speculations through *Portrait*. Now arrested by the frame, seeing is delayed and relayed through this history, which is at least part of the return from play with the view in the room (one return). Meditations such as my writing and your reading generate further discursive returns (three times, and counting). As a final return of interest, if internal framing structure is removed but the frame itself retained, everything potentially within its view from either side, and the framer have an equal chance at visibility, flattening the implicit hierarchies of intention and attention that illusion and similar devices implicitly enjoin.

Portrait doesn't deliver on its promise of rationality; it doesn't mean what it says. It quotes, ironizes, and subverts its surrounding rationalized space. When illusion and perspective hold everything in place, even though the construction moves me to the best place to see it, we are still held safely and properly apart, which means that I can still come and go in the illusion of mastering each picture in turn. Now equally available without the regulating structure, seer and the seen run the danger of collapsing into one. With *Venus Simultaneous* (colour plate 2), the pictorial field in Snow's practice was named the site and sight of love, but this does not seem to be an anxiety-free affair of resolved harmony or plenitude. The title of the piece calls for a portrait, but the rivalrous possibilities of whose portrait is literally wide open. You and I, real or imaginary, are framed by choice or by chance, without precedence being granted to one position or the other. The seductive and dangerous interest may be flirting with the possibility that you or I will not be seen, or will see "nothing," or see something forbidden.

I step up to the frame. I choose to commit myself to its machinations and accept its chance. Since the frame sends you or me as scene, suddenly you or I are one image among others at this juncture, and while seeing "nobody" is no longer possible, our destination is possibly unknown. At this moment I am here as this particular kind of self, an unsettled image, a fictional proposal. And so are you, who set this frame. I chance my image, for sure; even more, chance myself as image, so that chance itself is my wish, and the only thing certain at this moment. Framers and framed are joined by conditions imposed by the frame, blurring the boundaries between you and me, loved and lover, present and imagined, here or there, even performance and critique.

Set inside the field of *Portrait*'s frame, I am unprotected by the plane of illusion in some relationship of desire with an other to whom I loan my sight. The seduction of illusion witnesses a desire to behold the other in its proper place. But if illusion *is* a seduction, then is my desire—all desire—automatically improper? Is the civility of the frame a representation of the potential for an improper assimilation of the other? The primary law of the Other, the figure of the Ancestor, according to Ricoeur, is "Thou shalt not kill!"[23] Now that the beholding glance in

Portrait has been improperly unleashed, is my desire for the *impropriety* of the other, already framed as the same as my self? There's a rhetoric of violence in these questions, but if the other is already myself, what violence happens?

Ricoeur points out that one's flesh is both comparable to other fleshly beings, and completely foreign to them, so that "I" slide between, undecidably neither I nor the other. Alternatively, there might be an escape from the rhetoric of violence through thinking about mimesis. In this case, concomitant with desire considered inherently improper, I mime assimilation of the other in seeing suddenly as other. In coming blindly to the place of the other who is not radically other because I have already specularized myself in her, it could be said that desire incorporates. But is this necessarily a violent mimesis? Am I necessarily hostile towards the desired other in me? This theory is governed by the notion that someone else must be stealing my pleasure, but is desire so determined? More importantly, if I *mime* this appropriation, then differentiation is held apart by circulating my sight through notation on the plane of representation, to be read. Benjamin, remember, considered mimesis a retrieval and reading of gestures based on a radical forgetting of the other inherently in one's self, others encompassing a wide range of possibilities, so that play rather than inherent violence was the source of mimesis. The intersection between questions raised by *Portrait* and by Benjamin elaborate possibilities that my wish to be a chancy image cannot be assumed to be desire predestined for a forbidden object, but for my place in a mime of being seen, or of seeing, or of both at the same time in a space opened by object or text. So, we should turn to the possibilities conferred by the frame and interrogate the invisible front plane or membrane which splits the open.

In *Membrane* (figure 6) the front plane is replaced by an enigmatic space of reflection.[24] Materially, this sculpture consists of a shining sheet of chromed steel with a narrower snow-white rubber sheet wrapped around it. A piece of wood slipped between the sheets holds steel and rubber apart at the centre, opening an interior space of reflection. Here, the glittering rear mirror surface makes itself evident as the physical and conceptual ground of the piece only where the wooden bar touches its reflection. The rubber sheet and its reflection enclose the reflective surface while the mirror, duplicitous to the core, "appears" only when it reflects something else. Reflection—appearance itself—incorporates or consumes this agency. While I might think of myself and my mirror reflection as an enclosed scene, securely mine because it disappears when I turn away, here it is evident that reflections require an intervention to hold open reflective space, and that reflections incorporate distance. So, between the sheet of steel and the sheet of rubber which or what is the membrane?

Slipping verbally between the sheets of latex and steel, a most improper mix of mediums and domains from a modernist perspective, we can experi-

ment with words that Jacques Derrida used for membrane such as veil and hymen. Derrida's remarks recall the organic model for biological integrity and propriety which also ground Western metaphor: " ʹγμήν [hymen] designates a fine, filmy membrane enveloping certain bodily organs...a white pellicle over the eyes of certain birds....A tissue on which so many bodily metaphors are written."[25] Of course, hymen refers most commonly to "the continuity and confusion of coitus...the fine, invisible veil which, in front of the hystera, stands *between* the inside and the outside of a woman, and consequently between desire and fulfilment. It is neither desire nor pleasure, but between the two. It is the hymen that desire dreams of piercing, of bursting, in an act of violence that is...love and murder."[26]

Figure 6. *Membrane*, 1969. Chromed steel, wood, rubber, 49.3 x 67.6 x 8.7 cm. Purchased with funds from an anonymous donor, 2001. Art Gallery of Ontario, Toronto. Photo courtesy Michael Snow.

Yet, while Derrida apparently confirms the notion that desire is based in violence, what he seems to be after is the interpenetrability between language and what Westerners understand as objective reality and, pursuant to that, writing or representation itself as a passional relationship:

"Hymen"...is first of all a sign of fusion....There is no longer any textual difference between the image and the thing, the empty signifier and the full signified, the imitator and the imitated....But it does not follow...that there is only one term, a single one of the differends....It is the difference between the two terms that is no longer functional....By the same token, it elimi-

nates the exteriority or anteriority, the independence of the imi-
tated, the signified, or the thing. Fulfilment is summed up
within desire; desire is (ahead of) fulfilment, which, still mimed,
remains desire, "*without breaking the mirror.*"[27]

Derrida questions the notion of desire preceding its object. Consequently, the
notion of writing or representation as a mimesis of appropriation seems to be a
way of either negotiating peace in the murderous vision of mimetic simultane-
ity, or of skirting this definition of it.

When I return to look at *Membrane*, its pristine snow-white sheet and crys-
talline surface do not seem so sinister as metaphorical murder; rather the surface
yawns open to reveal a gap between the dual existence of object and reflection
which denies priority, solidity, and centrality. Well, even if it wreaks "violence" by
dissolving all of these, has anything actually happened? When Derrida talks about
the hymen, he might just as well be describing *Membrane*: "What takes place is only
the *entre*, the place, the spacing, which is nothing, the ideality (as nothingness) of
the idea. No act, then, is *perpetrated*...no act is committed as a crime."[28] The artist
has only inserted a wooden bar to open the space between the sheets which allows
reflection to take place and then shelters it: the visual space of mimicry.

Now, *Membrane* lies in wait on the floor, reflecting my full body as I bend
over, Narcissus that I am, pretending to masterful objectivity while examining
this self-evident, self-reflective, self-enclosed object. The notions of Vorstellen or
Vorbild suggest that the observant, rational subject of representation is secure
in the mastery of his completely contingent reflection. *Membrane* apparently
meets these conditions—it is an autonomous object set up for viewers who stand
outside and above it—but then it ruptures these notions on the lowdown. First
of all, the "real" and its reflection abyssally mirror their mutual dependence.
Furthermore, as I bend over the mirror, its reflections from below are indiscreet
and distorted, destroying my self-image of composure and mastery. Much as the
voyeur at the keyhole exposes himself from the rear to a possible rival whom he
simultaneously and improperly solicits, my anticipated sight into *Membrane* is
ruptured from below by a reflection which denies my expected pleasure of
reflected composure and mastery but which I, too, have solicited. It is hilarious,
and I dare another peek, another chance, maybe from a slightly different angle.
Later I sneak a look at others engaged in the same game. Looking into a mirror
conventionally refers to narcissistic pleasure—an intimate and private experi-
ence. However, it is becoming apparent that I also solicit the appearance of an
improper specular other. There could be a lot of them. So this particular "nar-
cissistic" gaze into a mirror is hardly self-enclosed; it flirts with being improper
with a crowd, dragging intimacy into the public domain. Having been tempted
and puzzled, perhaps made foolish before others also standing around whose
experience must go through the same straits as mine, is this murderous, or do

we just laugh? As a woman I find Derrida's metaphor and play upon *antre/entre* disgusting, but his interpretative dance quite funny. Disgust with metaphor—only metaphoric disgust?—ejects me at some point from his representational field into my reading and female self right here. I laugh at the amazing rhetorical contortions of Derrida; I laugh alongside Snow's mind and sensuality, finding amusement in its puzzles and traps. No doubt, *Membrane* disperses my sights and thoughts widely.

If we laugh, then this act of materializing reflecting sight might be an act of saving grace and love, as Derrida proposed with regard to Stéphane Mallarmé's poem, "Mimique." *Membrane* preserves the site of sight, my sight as an embodied, passionate subject, from metaphorical violence by reversing violence into the eros of laughter. Its circuits and detours compound hilariously, threatening to slide out of control. I cannot decide whether these puns and jokes mark my arrival or my dispersion as a viewer, but as embodied, impassioned, speaking—a subject—certainly.

Membrane seats my sight in a desirous but socially disciplined eye which reflects consciously on injunctions of living well and among others. I am careful about others involved in these indiscretions, while we share them with humour. *Press* (1969; figure 7), a photographic installation, however, is more literal about the appetitive eye. In a methodical and offhand way, it makes a joke out of squeezing the "real" into the representational plane held between the sights of the artist and my self, and between ours and the walls of art galleries which back up work such as this. *Press* is a grid of sixteen black and white photographs of spaghetti, eggs, dead fish, cigarettes, rubber gloves, and other detritus which have been squashed onto square polished steel plates, clamped under Plexiglas, and then photographed. The photographs were then mounted in a grid and clamped behind Plexiglas with the same kind of clamps used in the photographs. Not only is the compression of three dimensions into two emphasized, but with the exterior clamps and frame, *Press* emerges again as a three-dimentional object which exerts force. To what extent do I eat with my eyes, and how does the sight of food and other sensually stimulating elements feed my senses, all of which play in desire? Thinking back to Duchamp (and *du champ*), is desire augmented when relayed through mediation in a way that the direct sight of food or cigarettes cannot match? Some of the photographs include faint reflections of Snow and his tripod "behind" the main image, and in one photograph his reflection is the only image. The grid and layers introduce the scene's players one after the other and bring the fourth dimension of time into the frame. Snow, art galleries, and I are all holding this site together. Clearly, Snow foresaw and imagined me and others standing in front of this grid, and his anticipation is reflected into the present as a reflection from "behind" the image, or as a trace "at the back of the picture." I redeem and fulfill the view-

point that he foresaw, but cannot fulfill his desire for this viewpoint. He is "there" and "then," while I am "here" and "now." The reflections stage the conflict that he cannot represent without my collaboration, but my sight can never be the same as his, owing to obstructions of time and flesh, and I remain irretrievably other. Nonetheless, held apart, we both can desire and circulate the equivalent of love letters. So, we firmly clamp open this site between us. The framed still life or *nature morte*, food for the appetitive eye, the hungry aesthetic soul, propose that everything seems detritus after the intervention of the post and sending machine, but you and I can go on feeding our desires as long as it is only in pictures. As with other pieces, *Press* defuses rivalry and charges the relationship between "Snow" and my self by reversing rivalry into the eros of laughter served up on the plane—maybe the plate—of representation.

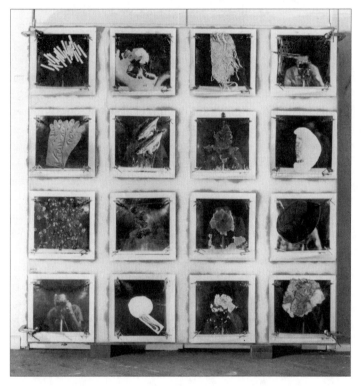

Figure 7. *Press*, 1969. 16 black and white photographs mounted on cardboard, plastic, metal, 182.9 x 182.9 x 25.4 cm. Dr. and Mrs. Sydney L. Wax, Toronto. Photo courtesy Michael Snow.

Continuing the possibilities brought into play by *Portrait*, Snow projected the imageless frame into a three-dimensional tube furnished with reflections in *Scope* (1967; figures 8 and 9), exploring other effects of desirous sight. Inside a gallery humming with visitors, a serpentine, rectangular stainless steel tube

mounted at chest height and open at both ends fills the centre of a room.[29] *Scope*
is like a periscope or viewfinder lying on its side, both surveillance machine and
toy. A polished steel panel juts out from the wall opposite each open end of the
"scope." I have to walk between them to get around this awkward, jostling thing
which is installed in a fairly tight space. That *Scope* shares Minimalist concern
with staging the body and perception is obvious, and in 1967 in New York,
where Snow was living when he made it, Minimal art was probably at its most
popular with avant-garde artists and critics. But *Scope* has other concerns.
Pushed close, I look into the tube in passing by. Disappointment: there doesn't
seem to be anything to see. The image in the tube may be just the reflection of
the opposite wall, or a reflection of the tube's interior reflected back into itself
by the steel panel mounted opposite the tube's other end, making *Scope* a
machine for swallowing its image whole. What did I expect? Suddenly the inte-
rior frame is filled by the reflected image of a lovely teenager: I am struck by
relief. Someone is there! This reverses quickly into, "Here I am!" followed by a
feeling of hollowness and longing. After a pause the girl bursts into a huge
smile, exclaiming as she sees my image at her end, "Oh, now I see!" We both
laugh at the crossed-eyed circuit that unites us, scrambling our well-trained nar-
cissistic expectations. We are united in expecting and yes, desiring to see our
own reflections, and united again in a narcissistic wounding since each of us can
see only the other. However, the truth staring us in the face is that each of us
can be "present" only if our appearance is set before others and recognized by
them. Contrary to Minimal art's private self-consciousness, *Scope* lets me see
that I am present here and now only insofar as my image is dispersed and rec-
ognized, or made legible and distributed. Verifiable presence, presence where I
recognize myself, depends on a compact with others. If that is the case, individ-
ualism as a solitary achievement does not make sense; it is granted by others. So,
why do I feel frustrated and annoyed faced with this teenager's reflection? Do I
really want her out of the way so that I can see my own reflection? After she
leaves, emptiness.

So, why do I look in a mirror if not to see myself as another sees me? In his
discussion of his grandson's game of throwing a spool of thread into his crib
and then pulling it back out to the joyful shout of "Da!" Freud remarked how
his grandson must have assumed his mother's point of view of himself, and con-
cluded that Ernst's shout represented both her joy at finding him and his hap-
piness at being joyfully found. Freud thought that the little scene compensated
the child for his feeling of loss when his mother left him alone for awhile, and
started him on a road to self-mastery through representation, for the game
required him to represent seer and seen: his mother's view of himself and him-
self as the object of his mother's sight.[30] Does the experience of *Scope* reclaim in
adulthood a child's joy in the circuits of Freudian recognition, and see this at

the same time? Or might the mixed emotion of joy and frustration suggest that, joyful at being found, I might be an other (my mother, or even strangers) before myself? Consider too that as women, both the adolescent girl and I have endured long training in looking at mirrors to scrutinize ourselves for faults, and to fantasize. It's a private sight and time but one of self-dispossession. Upon reflection, there can be no doubt that when I see myself in a mirror I want to see myself with another's eyes. As a teenager I desired to be the target of the gaze of some adolescent male, or my peers, teachers, and parents, and I wanted their approval. Today the gaze still belongs to a crowd: my husband, colleagues, and children, and to you, whom I shall never know. It gets even worse; none of these gazes coincides. Each sees and wants something different, so that I cannot look to my reflection for a consistently acceptable image.

Figure 8. *Scope*, (installation) 1967. Stainless steel, mirror, installation space: 8.4 x 5 m approx; two elements, 68.5 x 68.5 x 37.5 cm each; one element, 305 x 69 x 36 cm; two wall elements, 137.5 x 71 x 26 cm ea.; two bases, 106.5 x 84 x 37.7 cm ea. National Gallery of Canada, Ottawa. Purchased 1977. Photo courtesy Michael Snow.

Upon reflection through *Scope*, the apparently private act of looking in a mirror is a time and place of great exposure and vulnerability. It reveals to me how my image is always implicitly refracted through others and is anything but stable and secure, anything but a self-enclosed, self-possessed "reflection." Self-reflection is, as explored through *Membrane* and *Portrait*, routed through some hunter-lover's eye, real or imagined, which keeps the reflecting plane open. "See it my way," Snow suggested.[31] But there is still the question of whether or not my sight, now also my site here at the other end of *Scope*, is in possession of

Snow in particular or the artist in general. Inasmuch as the place and traces of the biographical and authoring artist are conspicuously absent, the hunter's loving sight must be mine delayed out there, relayed through another by my own desire, so that I dispossess myself of the enclosure and security of my reflection. Millennia before the danger of becoming part of the standing-reserve as the technological unit, the basic processes of human recognition and my desire for it, both of which have "natural" survival value, seem to have already fractured my sight in order to process me as a social being, given in shape-shifting images to myself through the eyes of others.

Figure 9. *Scope*, (detail) 1967. Interior reflection. Photo courtesy Michael Snow.

Snow's visual jokes in these sculptural frames hold us out to seeing that is appetitive, belonging to an ingesting, corporeal body. His practice of framing challenges the security of the picture plane and its structures, and chances the exposure of seers and the seen to a seductive scene of improper collapse. So desire may not be so much for another person but for the gaze of others. Moreover, since the scene is no place in particular, my desire could be for *being*

the scene of the lawful Other. However, sight redoubled through representational reflections and refracted through puns and irony keeps "Snow," "you," and "me," and others apart, saved by the distance of delays and relays and by laughter. Together the frames return an investment in eros, two-sided in its danger and humour. As a subject framed, what is returned to me is that I see from here and am my self seen, an embodied point of view located in a dialogical and psychological context with others; and I am always shifting, sliding in and out of sight through the different levels of this site, my subjectivity, with love and laughter.

Returns on Self-Effacement

THE SELF-PORTRAIT

From exploring how Michael Snow's sculptural frames return sights of my self by relaying my acts of looking through others, I'd like to turn to his self-images as a subject framed. Snow himself does not consider these to be self-portraits: to him they are images of a man with a camera and nothing more. Nonetheless, the combination of method, title, and signature of *Authorization* points towards the autoportrait, and on that basis, together with published photographs of Snow and the well-known documentation that these are self-portraits, I will consider them from the perspective of the self-portrait made problematic.

Two of Snow's well-known versions of the self-portrait, *Authorization* (1969; figure 10) and *Venetian Blind* (1970; figure 11),[1] have been frequently analyzed in art criticism as tautological works in which form or process becomes content: they document the process of their own making[2] or are so self-enclosed that conditions of production are the same as those of presentation.[3] They present the self-realization of a generative principle;[4] or present the event as its documentation and the whole returned uniquely to the mind and hand of Michael Snow who alone can authorize it.[5] Implicit in these analyses are concepts of the return of form to the idea, the immanence of the enlivening idea in form and matter, and the origin of the idea as the genius of Michael Snow. Gene Youngblood made this idealist materialism explicit in his discussion of *Authorization*: "Increasingly in Snow's work, icon and idea are one," he asserted, and then

Notes to chapter 4 are on pp. 183-84.

quoted Herman Hesse: "Artists can't conceive of thoughts without images."[6]
While the cited criticism is idealist, the idea names the artist as either maker or
director, and so this modernist criticism veers into romanticism because it does
not take into account the subject matter in the images.

From another perspective, Amy Taubin discussed Snow's reflexive photo-
graphic process in the context of consciousness. She reasoned that if photographs
influence or interfere in how we see or remember events, then they change our
perception of the "real" world and so intersect thought. It's a process of pulling
oneself up by the bootstraps which leads to a meditation on consciousness and the
merging of image and reality.[7] In my view, this boot-strap or dialectical process val-
idates the notion that progress guides the path to consciousness. However, it is
questionable whether consciousness offers a determinable end. Rather, progress
may be towards something bigger and intangible, a capital letter term like God,
Spirit, Being, or Idea, as well as Consciousness with a capital C. Why is this "big
intangible" so continually attractive? If the achievement of consciousness always
recedes into obscurity, then progress toward consciousness defines the subject
(you and me) as insufficient and vulnerable but we're driving towards a more com-
plete, realized, and self-sufficient status. Yet, always invisible, self sufficiency takes
on a mythical status and is curiously similar to Heideggerian Being. Like the
notion of Being, Consciousness suggests that there is something higher or deeper
out of sight, toward which we must strive for self-completion and self-knowledge.
On one hand, our striving for consciousness can provide a storyline for victim-
hood. On the other, the heroism of progress towards consciousness can be used
to justify acts of domination in the quest for higher knowledge or law. Insofar as
consciousness, higher knowledge, and similar goals remain unverifiable, the con-
sciousness argument from this perspective contextualizes Snow's work as a retreat
into interiority or metaphysics. However, the self-evident constructions and puns
of Snow's work do not support the notion of such a withdrawal.

Addressing the problematic issue of interiority, Peter Gidal situated Snow
with contemporaries such as Steve Reich, Andy Warhol, Jasper Johns, and Alain
Robbe-Grillet as the heirs of artists like Paul Klee, Franz Kafka, and Samuel
Beckett who, Gidal maintained, refashioned consciousness as a correlate of
material relations:

> To begin with, radical art, an art of radical form, deals with the
> manipulation of materials made conscious, and with the inex-
> pressible, the unsayable, i.e., not with content....The subject is the
> material, not an idealized viewer's consciousness....What is
> expressible is a process of dealing with what is materially there. A
> film, a drawing, a sculpture, a novel, a piece of music, can divulge
> its own process of having been made, it can record its own attempt
> at being made, thus recording an attempt at consciousness per se.[8]

In Gidal's terms then, the manipulation of materials made conscious can refer only to the artist, so that the model repeats the return of form to the mind of the artist. Second, consciousness of concrete material manipulations still drives toward the mysterious unsayable not yet there: an "attempt at being made" is still a sign for "an attempt at consciousness per se." In an *attempt* at apprehending manipulations of material as the trace of consciousness, doesn't consciousness still recede to a hazy, telic end of progress on the part of the viewer? Can viewers such as you and me, as part of art practice, be so easily written off? How is retrospectively apprehending manipulation of material relationships, or a system of ordering, significantly different from retrospectively apprehending the dialectical progress of the Spirit? Gidal admits that consciousness reaches toward totality, defined as early Derridean *différance* rather than an internal mystery.[9] In this case, consciousness is the self-announcement of a system of differences (e.g., a sign system such as language) graspable as an intelligible whole. Gidal maintains that this whole, a system of differences, separates itself as not-I from the spectator (an echo of the concurrent Minimalism).[10] If conscious of the system as legible, I can read English sentences or maps, for example, at different scales with different systems of legends. The language of English or of maps "announces" itself to me as a vehicle of making sense.

In remaining grounded in questions of process, Gidal actually seems to be arguing in favour of a theory of action whose questions, as we saw analyzed by Ricoeur, refer always to "who?" even when obscured and relayed through concealment by the pair "what?-why?," or "how?"[11] Ricoeur argues that a too narrow focus on the material relations of "what?-why?" or "how?" events serves to separate an event from "who?" It also detaches an event from the consideration that it has a reason-for which leads from doing to trying, to wanting, to an agent such as myself.[12] Despite his insistent reference to the concreteness of self-evident and logical material relations, Gidal enters this chain at the point of trying ("an attempt" at consciousness), and follows it in the direction towards structure rather than action. Doing so closes off the possibilities for consideration of how material relations in art practice relate to the world and to finding its viewers, such as you and me.

Gidal's argument that self-evidence of the medium in its operations and the critique of illusion is the proper subject of radical art points to similarities between the concerns of Russian formalism and Minimalism. North American familiarity with either Russian formalist criticism or related Russian experiments in abstract visual art of roughly 1915 to 1930 was very limited, owing to the art's suppression in Russia and to the popularity in the North American avant-garde of Greenberg's criticism. Seeking to extract Snow's work from the context of Greenberg's criticism, Regina Cornwell argued from the perspective of Russian formalism in 1973 that Snow's literalness of process denaturalizes or

defamiliarizes realist construction and perception and makes perception prob-
lematic, which distances the spectator.[13] Cornwell couched her formalism in the
terms of Malevich, Schlovsky, and the later Alain Robbe-Grillet (Robbe-Grillet
was not translated and published in the United States until 1965).[14] In defa-
miliarization it is the experience that is important, not the object, and that expe-
rience is valued for being new, not for being identifiably aesthetic.[15] At first
glance this seems to be a nice way around the consciousness problem.
Nonetheless, however objective the work or new the experience, we as spectators
remain subject to an interior, indefinite progress—whether of consciousness or
newness, wherever that leads. While Cornwell's perspective is redirected
towards spectatorial experience rather than structure, analyses by both writers
suffer from primary concern with construction, which doubles the artist's view-
point, forgetting about belated reception by the non-artist.

However informative and worthwhile this criticism may be, it lacks interro-
gation of how process "thinks" the self-image of spectator, or of artist. For that
matter, on the surface, *Authorization* (figure 10) is admittedly a work of precise
filiation of procedure. The program to rigorously restrict the work to its own
generating process also makes evident Snow's aspiration to produce a self-defin-
ing, self-critical, autonomous photographic object following Greenberg's dicta
for modernist painting, and as a critique of photography's dependence on the
external world and the illusion ground into its lenses. Snow even wrote: "I am
working to use photography in a very enclosed way so that there is nothing out-
side the work itself that is used in the photography...as in certain kinds of paint-
ing which have an autonomy of their own."[16]

Authorization, in the mode of illustrative repetition that is specific to pho-
tography, records and transfers Snow's self-reflection again and again, each
image including and transferring its predecessor as well as Snow's reflection. In
the centre of a mirror (54.5 x 44.5 cm), Snow taped a rectangle the size of four
Polaroid prints. Focussing his Polaroid camera on his reflection within the
taped rectangle, Snow shot his reflection of himself taking the picture. He
taped the first print in the upper left corner of the rectangle, and took a
another shot which included the first print. The second print went into the
upper right corner. The process was repeated until four prints filled the rec-
tangle. A fifth and final shot is shoved into the upper left corner of the mirror.
Paradoxically, mirror reflections are in focus in depth, "behind" the surface.
Because the camera was focussed on Snow's reflection for each shot, the pre-
ceding prints taped on to the surface are out of focus. As each print is included
in the next, each becomes successively smaller and fuzzier with each reprint.
Snow's first-generation reflection in the mirror is gradually effaced while being
replaced by its image, the series clearly mapping the sequence of shots and their
placement. Reflexive, enframed seeing or perception is represented as re-con-

structing and following a temporal process of recording. While conventionally the portrait photograph is intended to be a true and faithful copy or likeness, in this work it is unfaithful to resemblance, whereas the portrait of "mapping" the process is precise. "Who" is Michael Snow? In the process of *Authorization*, the taken-for-granted equivalence between the unique, biographical, existent Michael Snow and the artist is effaced in favour of Michael Snow, author of this work, which endures through the work. The later audience for *Authorization* will see only this "Michael Snow." Michael Snow, recognizable through the reflection and first-order photographic capture of his features, is lost in the process of becoming the artist Snow, who foresaw my presence and authored this work. So *Authorization* takes account of the partnership necessary to "author" a piece, and to declare that the practice of this process with photographs, mirror, and spectators, and the National Gallery of Canada which purchased this piece, is art. Just to make sure, Snow signed it as his promise that this is so, and the National of Gallery of Canada guarantees the signature by its purchase and exhibition of this piece.

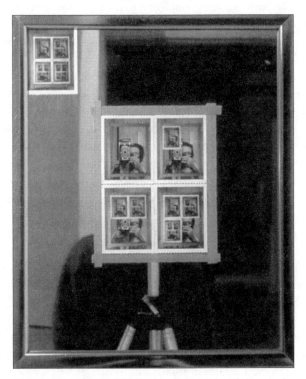

Figure 10. *Authorization*, 1969. Black and white Polaroid photographs, cloth tape, mirror, metal frame, 54.6 x 44.4 cm. National Gallery of Canada, Ottawa. Purchased 1969. Photo courtesy Michael Snow.

Since *Authorization* is a portrait, its form as a series of images rather than a single image, as in painting, raises many questions. Snow seems to ask, what if photography approached the self-portrait the same way as painting? How important is it that traditional portraiture is a construction that takes time but hides it? *Authorization* reverses the usual approach to looking at a realist portrait painting: rapid capture of the image as illustration, clear and whole. Instead, its primary concern is its construction as temporal, an aspect that is usually elided, especially in academic painting. Traditionally, a painted panel or canvas is slowly filled in by a methodical process of building up layers of colours and details, from the preparation of the ground to the final highlighted accents, and is finally given an overall unifying glaze. The finished work has its own rhythm of brushstrokes (if visible), tones, and colours. The process of the portrait can be considered a bildungsroman of figuration itself, an institutionalized method (e.g., approved and taught by members of a national or sanctioned academy) as story moving through time, space, material, and colour to deliver a figure-ground totality that lets the figure or subject appear. However institutionalized the process, the portrait subject emerges into the light having been distilled into recognizable characteristics that were chosen and encoded in brushstrokes by another. In the self-portrait, the position of the other is absorbed into the sight of self, a self-absorption renowned for producing strange and wonderful results (e.g., self-portraits by Gustave Courbet or Rembrandt van Rijn).

Both painted and photographed self-portraits begin with a reflection. A reflection, which is wholly contingent on my continued presence, takes no time and is not a portrait, for it neither endures nor adheres to the discourse of portraiture. However, a single snapshot can be considered comparable to a single brushstroke, a unique event. It takes many brushstrokes side by side and in layers to structure a portrait, and the structure exacts a tax or price. As Derrida has written more recently than *Authorization*, the subject is (re)claimed by painting. The rules and techniques of painting leave their trace in the portrait at the expense of resemblance. For the rules not only dictate what counts as a portrait, but in the course of painting, as is "recounted" to us in Jean Siméon Chardin's *Self-Portrait at Easel* (n.d., but one of a series dated 1771 and 1775; Louvre, Paris) or Velázquez's self-portrait included in the now-titled *Las Meniñas* (1656; Museo del Prado, Madrid), the artist cannot paint and look at his reflection at the same time.[17] He must pause, looking in the mirror while painting. He paints by conjecture, from memory, by means of abstract brushstrokes. As a consequence, Derrida argues, the portrait is a ruin: "Ruin is the self-portrait, this face looked at in the face as the memory of itself, what *remains* or *returns* as a spectre from the moment one first looks at oneself and a figuration is eclipsed. The figure, the face, then sees its visibility being eaten away; it loses its integrity without disintegrating. For the incompleteness of the visible monument comes from the

eclipsing structure of the *trait*."[18] Even though the traditional painted portrait gradually resolves into fuller colour and detail the more work is expended upon it, it cannot fulfil portraiture's aspirations to show the "all" of the self. In fact, Derrida argued, it shows nothing at all of the self because it is a conjectured construction from memory: "There is nothing of the totality that is not immediately opened, pierced, or bored through."[19]

Snow has remarked that the "click" of the camera isolates an instant, whereas the temporality of painting is cumulative.[20] In photographs, the time for memory between seeing and painting is lost; seeing and marking are collapsed into a single event. In each snapshot of *Authorization*, Snow can see and record at the same time, and the simultaneity of the reflection is the same as that of the single photograph. While he is unburdened from the risks of memory and conjecture, he is also excluded from the unseen intervention of the "other" wielding a paintbrush. When Snow fills in his immediate reflection with snapshots of it laid side by side, the accumulation of photographs might report a likeness of the process, but he and I must watch his reflection lose its integrity as resemblance to "the eclipsing structure of the *trait*." In both cases, disintegration exposes the fact that the desire and legacy of portraiture is built around the experience of "wounding" a seen reflection. Whether portraiture or self-portraiture, the genre is a search for affirmation by the gaze of the Other who first decides what counts as a portrait (discourse), and secondly the other who edits, distills, and marks my characteristics in a process that acknowledges the ethical primacy of other and Other over my self.

There is another aspect which must be considered: the mirror. The images of *Authorization* were both reflected from a mirror and then returned to it to cover their originating place. As I stand before the work, my body is reflected in the mirror while my head is replaced by the block of photographs, which means that I re-experience Snow's point of view of my lower body, but I watch his face disintegrate even as I watch his authority as artist emerge through the effects of an apparatus at work. That is, Snow makes the mirror evident, in contrast to the self-portraits by Chardin and Velázquez, where the mirror is not visible. Yet whether a mirror is evident or not, as Derrida remarked, the mirror's intervention must be assumed if we are to believe that these paintings are self-portraits, and if the artist is to believe in the self-portrait. But there is another layer: neither painter nor photographer can undertake a self-portrait without thinking in advance about our eyes there as witnesses. An image can never be authenticated without relying on an exchange of promises to be there, in sight on loan from us. Chardin and Velázquez appear to acknowledge this. For example, Velázquez stands erect, stiff with pride, while Chardin's bullet-shaped head is tightly wrapped and highlighted in a white scarf bound with a blue bow, or *bandé* ("erect" in French slang). He wears eyeglasses enabling him to see and do it even

better. To be fair, he was going blind late in life, yet he included them as char-
acteristic in his self-portrait, authorizing himself as artist before his easel, draw-
ing stick in hand. Before their invisible mirrors which reflect to them these
scenes of their mastery, Chardin and Velázquez pause, as does Snow, looking to
our place, we who see for them, as they deliver their sight and authority over to
us. Now included in the picture, my sight has been given increasing possibilities
opened by art, a potential delivered with love as the signature and final shot left
as a jaunty reminder in the upper corner of *Authorization* remind me.

Venetian Blind (1970; figure 11) extends play with the insecurity of portrai-
ture into the history of securing true images. The work is a horizontally oriented
four-by-six grid of twenty-four colour snapshots of Michael Snow's face in
Venice. In the background, sites familiar from other photographs and paintings
float by: the Doge's Palace, Basilica San Marco and the Campanile, the light-
house at the mouth of the Grand Canal, and famous bridges. While the type
reproduces millions of tourist photographs of "Here I am in Venice!" these are
different: only Snow's head shows (with an occasional intruding shoulder), he's
always out of focus, and he can't seem to get his eyes open. A challenge to the
credibility granted by the self-portrait of the artist in his historical "home"
domain of Venice, Snow's image is more like a pop-up getting in the way, annoy-
ingly, over and over.

Figure 11. *Venetian Blind*, 1970. Edition of 3. Twenty-four colour photographs, painted wood frames,
mounted in four sections, 126.0 x 234.0 cm overall. Canada Council Art Bank, Ottawa. Photo cour-
tesy Michael Snow.

The work generates many puns which are more than "just a joke," given
that so many of Snow's works play on visual-verbal switches. Punning enters
these photographs as "language"; they challenge us to accept visual and verbal
signifiers as an interdependent signifying system that transgresses the discipli-

nary boundaries implicitly drawn between kinds of signs (e.g., language, sculpture, painting) by semiotics or high modernism. Puns also introduce irony and humour to interfere with the relentlessly deadpan face of realism. While punning is an insider mode circumscribing a community of understanding, it also provides the occasion to take chances with newness as the intervention of non-understanding, misreading, and even offence.

As implied in these fuzzy photos of Snow on the move, and as an initial visual joke, snow in Venice is not a distinct or lasting possibility. It has to be ephemeral, just passing through. Nor are these photographs straightforward windows on the world. In a verbal-visual pun, blinded by the Venetian sunlight (as in "snowblind"), Snow closes his eyes as I close Venetian blinds on my windows against the sun at home. Past his fuzzy face, the photographs look back, just as the process of photography itself looks back, at this artistically historic city sinking into its own past (the marsh). Snow took these photographs when he was in Venice for a retrospective exhibition of his work, representing Canada at the Venice Biennale, four months after his retrospective at the Art Gallery of Ontario (opening February 1970) . His trip to Venice, of course, repeated that of many artists (think of J.W.M. Turner and J.M. Whistler in the nineteenth century) as well as tourists, and anticipated future trips by Canadian artists to look back again from the Venice Biennale. The series can be taken as a wry criticism of how Canadian artists achieve recognition: while in Venice, Snow makes himself visible as a Canadian artist in the typical Canadian mode of being reflected by the light of New York, Paris, Munster, or Venice. In fact, the process of *Venetian Blind* is very similar to the self-portrait process in the style of *Authorization*. However, *Venetian Blind* goes further. Despite signature and extensive exhibition, there is nothing secure about the process of answering "who?" through "how?"—the layers of punning point to meaning and self-image bouncing off the sight of an other, elsewhere, and in the artist's case, a long way away. This goes to the heart of the problem: how am I to know who I am or who "we" might be? Who decides what counts for recognition of persons or as knowledge, anyway?

Louise Dompierre claimed that a philosophical ground is the question of *Venetian Blind*: the work "is an inquiry into the parameters of the photographic process. More importantly, the work is a search for the knowledge that this same process can impart. This is the subject of *Venetian Blind*."[21] She found her answer in the work's index of a repeated action:

> *Venetian Blind* is a photographic essay attempting to capture time in its minute variations. Structurally, the work indexes slices of time in an attempt to bring out every nuance of a particular instance...the face tends to suggest one time and place. The background, on the other hand, shows distinct variations in the posi-

tioning of the subject. In fact, each photograph acts as a different memory of almost the same action. Within an instant of time, and by means of the simple act of self-portraiture, the complexity of time and the relatedness of its various constituent parts are here concisely represented within an almost simultaneous past, present, and future.[22]

Is this a defence against losing face through capturing time? There is an implicit pathos about loss of secure and long-term memory in this passage. While the world and real time shift and slip, repeated action remains constant. It's the act of holding time together by repeated action that is important in her text. But for whom? Dompierre posits an active subject-artist who focusses the "world" temporarily at one point by photographing himself in slices of time to be revisited in the future, however faulty and partial that record might be. Why must he be out of focus in each shot and why can't he get his eyes open?

To take the pictures, Snow faced the sun, set his camera's focus on infinity, held it at arm's length, closed his eyes, and then jerked his head and tripped the shutter at the same time: "This is the subject of *Venetian Blind*." As Heidegger remarked, the modern subject is always the subject of representation. But look, Snow is framed, shot, and printed—he doubled himself, in effect—from my point of view. There can be no "naked," natural being or sight; the subject must be reproduced, through some medium sent to others, to be a subject. The classical Greek poets or artists at the origin of Western history, Heidegger wrote, guided forth visibility from invisibility, but the visible was there already. The favoured medium of poetic speech or craft, in a pinch, is what releases or reveals.[23] The skills and knowledge of artist or craftsperson brings this about. However, Heideggerian poesy and *technē* also return the human body (speaking and hearing) to the home of human language. By these routes, the poet finds himself originally contingent with a somewhat mysterious power of language.

The modern subject of Vorstellung, by contrast, is one who grasps objects and sets them securely in place for observation. While objectification appears to deliver mastery to the observer at the point of origin or observation, Heidegger argues that this is deceptive. The medium of grasping, such as photography, while appearing to enclose and represent the object and to leave the observer outside, is always oriented *towards* the observer, gathering and projecting the observable as an intelligible image on a surface only when seen from the originating point of view: the grasper grasped. So "Snow," as artist, not only needs me as the audience of his photographs to see his artist-self, but I also need his point of view to see my self. Or has *Venetian Blind* made these relations unclear and we see but do not grasp each other?

In *Venetian Blind*, Snow surrenders to the medium to produce his self-projection. With closed eyes he allows the camera to frame the figure-ground con-

figuration. The camera composes the view in a way that a person framing a picture probably would not, for the horizon line is tilted in a few shots. A camera is indifferent to the horizon. For human beings, the horizon is the conventional baseline for the ninety-degree angle that orients upright posture and metaphoric rectitude. The camera also treats Snow in a way that self-portraiture conventionally does not: he is out of focus. Snow took the photos at arm's length, but his arm was too short for him to get "to the back of the picture." The problem of proper focus and spectatorial distance refers the photographs to Filippo Brunelleschi's experiments in Florence, circa 1420, which are commonly considered the origin of perspective (*perspectiva artificialis*, painter's perspective).

Brunelleschi's experiments were real enough, but we know about them only through sketchy and conflicting accounts written by Leon Battista Alberti in 1435-36, and others 140 years later, if not more.[24] These report that in Brunelleschi's first experiment, he painted a picture of the baptistry of San Giovanni on a wooden panel half a *braccio* (lower arm's length) square (maybe), as though seen from three *bracci* inside the main door of the cathedral, Santa Maria dei Fiori.[25] The vanishing point in this view is approximately in the centre of the lintel of the baptistery door. Allegedly, Brunelleschi drilled a conical hole the size of an eye at the vanishing point of his painting, which was also in its centre.[26] To see the effect, a spectator would look through the hole (with one eye) from behind the painting while holding a mirror at arm's length. In painter's perspective, although the spectator's point of view and the vanishing point appear to be symmetrically distant on either side of the projection plane, they are not. Hubert Damisch points out that "the *image* of the point of view should be inscribed on the painting—at a virtual distance corresponding to that separating the spectator from the plane of projection...the vanishing point being inscribed precisely opposite the eye within the frame of the baptistry door (or on its lintel)—it will on the contrary be thrown far behind the image of the observer, who will have it, so to speak, *at his back*." But when viewed through the hole and mirror, the reflection folds the vanishing point back on to the point of origin of the construction. The painting and mirror were simultaneously a showing (painting, construction) and a demonstration in which the rule showed itself. What was seen was not just a convincing scene of the baptistry, but the operation of a structuring gaze imposing itself. The real significance of the hole, Damisch argues, was to snatch the spectator back from infinity behind his head in order to secure him as a subject who could get his bearings at the origin of perspective (the "legitimate construction").[27] However, the price of the principle of a true appearance was the existent, mobile, changeable I. The body has to disappear. For a subject to find confirmation at the origin of perspective, it is necessary to abstract the self as only a single eye, a reflection, and a projection at the "back" of the painting.[28]

What is the significance of this for *Venetian Blind?* Damisch is adamant that Brunelleschi's experiments and painterly perspective have absolutely nothing to do with photography because the former are tautological; they exclude reality, including the body of the observer. It is all rule and construction, rationalized illusion. In contrast, he asserts, photographs *receive* reality directly through indexing the transmission of light.[29] So, for Damisch the role of photography is implicitly documentary, while the purpose of perspective is "to render visible not reality but 'truth,' or its semblance."[30] My argument is that the inner workings of the camera make not a whit of difference. Damisch himself admits that photography conforms to rules of perspective. In "straight" photography, perspective built into camera lenses guarantees a coherent sight. As a result, the insertion of the camera (optics, film, and frame) into the field of vision converts light and sight into a certain kind of pictorial field representing a mode of thought, a coherent doubling of which the principles can be deduced because they show themselves. The entire field, including subjects and objects, are thus guaranteed; and "showing" the rules and doubling the point of origin over onto the vanishing point make the spectator simultaneously producer and consumer, witness and voyeur.

To generate a coherent image which would integrate his figure with the background of Venice, in *Venetian Blind*, Michael Snow cannot get to his proper authorial and originary position behind the surface of projection. He remains seen, but he is not in the scene, not in an *istoria*, as the disjunctive scenes and shadows further inform us. Neither producer, hero of the scene, nor specular abstraction at the point of origin, he remains intrusive, shiftless, out of place. Blind and out of focus, he can be neither voyeur nor witness. The camera, a representational machine indifferent to what it "sees," cannot hold together Snow and Venice at arm's length, and he verifies its *impossibility* over and over again. However, is this to be redeemed from the technologically rationalized demands of representation (the camera and film), or erased by not fulfilling them?

With the background of *Venetian Blind* out of alignment and the foreground out of focus, even the lighting gives no sense of continuity; everything in these photographs is incoherent and in motion. What retains the character of portraiture—characteristics of the person? Dompierre pointed to the repetitious action of taking a picture over and over. In this and other pieces by Snow, what remains constant is the *practice* of photography as self-portraiture. The notion of practice gives meaning to Snow chasing around Venice repeatedly taking his own blurry picture, and then mounting a series of these snapshots in an art gallery to be seen and judged by you or me. A practice, Ricoeur reasons, takes into account the behaviour of others and is oriented towards their response. Followed over and over, it denotes preference, an evaluative choice, and judgement, although it may begin simply as rote procedure.[31]

Practice also answers "Here I am! I give my word, whatever else happens." While identifying characteristics are one aspect of selfhood persistent in time, Ricoeur argued that another mode of remaining self-constant is to keep one's word. It is on these grounds, in his account, that Heidegger distinguished the permanence of substance from self-subsistence.[32] While the self has sameness (character, attributes), the sameness of character attributes does *not* coincide with the same imputed by a promise. What Ricoeur is asserting is that the self is an always-open structure, never closed upon sameness even though you and I might feel the same and our friends treat us as if we were the same from day to day. The promise is of a different temporality and has something to do with "want-to" as a response, inasmuch as a promise answers an implicit demand from another.

Let's consider *Authorization* and *Venetian Blind* in the light of the conditions of a promise. Both works split "I" as the biographical Snow from the "I" of the photographic process, in that we learn nothing about Snow, the Canadian artist who works in many mediums and is a great jazz musician, is descended from both Québécois and English-Canadian parentage, and is a family man who summers out in the boonies, etc. We don't even learn that he was in Venice engaged in a high point in his career. While *Authorization* points towards being the self-portrait of the artist, a promise signed "Snow," such self-portraiture is literally not clear in *Venetian Blind*. What we discover in both pieces is Snow's absorption into his practice. The photographs narrate the passage from a "truthful" transference of Snow's biographical resemblance into artist-practitioner. The process reports itself as a repeated attestation: "I promise you that here I am, as artist, in the field of representation." A reflection on its own or even a single snapshot lacks the duration of practice. A single shot is an event, not an attestation by a witness. Attestation takes two, one independent of the other, as corroborated by two well-known paintings which constitute themselves as witnesses: Jan van Eyck's *Giovanni Arnolfini and His Bride* (1434; National Gallery, London) and Velázquez's *Las Meninas*.

Van Eyck, even though he signed the painting explicitly as a witness, painted next to his own image that of another witness to the wedding in the mirror reflection on the back wall. Velázquez playfully doubled himself by portraying the other Velázquez of the Spanish court, who was the keeper of the royal tapestries, in the doorway at the back of the picture. He placed the elusive vanishing point of the painting somewhere around the hand or forearm of this other man, who holds open a tapestry hanging across the door (unveiling the truth), and whose hand doubles that of Velázquez holding his paintbrush. In both paintings, the doubles are at the "back" of the paintings, doubling in gesture and position the unseen painter in front of the paintings but whose image returns in the paintings.

Authorization also reflects my self-effacement and reappearance returned in its reflection: the reflection of my head and shoulders is replaced by the taped rectangle on the mirror while my torso remains reflected. Despite the gender change between reflected torso and photographed face—which gives the piece an interesting twist—the work has clearly anticipated and incorporated—devoured?—my position and facial image, which seems to acknowledge how it cannot exist without my co-authorization, mirrored and thought. While *Venetian Blind* insistently inserts the artist's unfocussed image between camera and ground at an unrepresented arm's length, this repetition in twenty-four photographs also promises a "want to be there" which appeals to me. In each of these I see the image of Snow bound into his project head-on and by hand, the camera a prosthetic extension of his body. The process binds his sight and material body to the images and their subjects, and to the practice as a whole. Everything else is excluded.

While means differ, *Venetian Blind, Authorization,* and *Press* all make clear my necessity, anticipation, and incorporation as witness absorbed into Snow's practice of photography. Consequently, they relay Snow's answer first, "I promise you, here I am!" and they coax or coerce the same promise and response from me. Coming belatedly to a place that's been anticipated, I see Snow fascinated by the spectre of the spectator. Repeated so many times, is his promise an unwitting response to the unspoken injunction, "Be there?" Ricoeur felt the promise was a response to an intimate injunction such as "Thou! Be there for me! Love me!" Such an injunction would come from the Other with the force of the Law which must be obeyed. But in Ricoeur's view, the Law also demands, first, that "Thou shalt not kill." So in response to Snow, despite his specularization of me and other belated female viewers (which is a gender bender), here I am; I cannot be otherwise. But then, as the initiating artist, here he is, too, but the originality of his action is shown to be a repetition of and desire for the command of the Other, as much as mine is. His demand is pregnant with the desire to have his practice witnessed, while my identical response echoes the desire to be anticipated: we both desire and appeal to the other to be in a scene navigating the plane of representation. So what has happened?

"You must" has become "I want"; an injunction by the Other and by you over there has become my desire, but it is yours, too. Coming from the Other and you, my love, the source of my desire *as* a command is forgotten, and suddenly, I see as other, following Benjamin's model of mimetic identification or de-differentiation. Metaphorical murder: how does this stand up to the command, "Thou shalt not kill?" *Venetian Blind* and *Authorization* are part of Snow's practice, a practice which offers evidence over a long term for a desire to do something a certain way. If "Here I am, I promise you," answers and even incor-

porates "Be there!" in face of the ironies of *Authorization* and *Venetian Blind*, and I am suddenly other, has any violence necessarily occurred or, as Derrida suggested, does any intimation of violence reverse into laughter? *Authorization*, *Venetian Blind*, and *Press*, as well as Snow's other work under discussion, insist on the circulation of my sight through materialized visual discourse. A modification of mimesis as de-differentiation might be in order, that of notation to be read even though the meanings have been forgotten and which might, on the contrary, relay mimetic identification. In the blurry, wobbly, self-effacing images and reflections returned by *Authorization* and *Venetian Blind*, my sight is returned to me as a subject in relay, laughing, and desiring to be.

— • • • —

With eyes again lowered, Snow reinvested himself in the holographic self-portrait *Egg* (1985; figure 12).[33] With hands raised nearly to face level and holding two halves of an eggshell, his image emerges in green, ghostly, shimmering light while the raw egg is frozen in its tumble towards a real iron frying pan. The three-dimensional illusion of the hologram carves out a deep space from the shadows behind the plate, reciting the chiaroscuro tradition of Renaissance painting in which figures emerge from darkness as though from nothing. *Egg* is about seeing: Snow's hands, as he told Derrick de Kerckhove, mimic the shape of binoculars.[34] Just so I can be certain of the reality connection and get a handle on all of this, the handle of the frying pan protrudes from beneath the holographic plate. Reciting conventions of still-life, *Egg* also engages my body's real senses (touch, sight, taste, and satisfaction of the stomach), puns on the passage of time (many still lives are *vanitas* pictures), and tickles the mind, all at the same time. It at first seems that Snow has finally produced a spatially coherent present moment—that he has finally gotten to the back of the picture and taken a single-shot self-portrait of himself as the conjuror-cook of space/time in holography.

But the first warning that all is not what it seems comes from the ghostly lower edge of the holographic plate which returns as doubled in the image. A space opens within the hologram, between the real and virtual edge of the plate. So the hologram recites and spaces itself, now, from when it was made, then, returning to itself real time marked by the illusion of space. It asks what the real connection might be between time and space. Is all reduced to and lost in illusion, or is hard reality the fact that, as in scientific reporting, the past can return only as illusory abstraction, whether in pictures or numbers?

Holograms are an advanced form of precision technology in realist representation. The holographic image is suspended in mid-air, where light waves reflected back from the plate intersect each other in regular patterns. So unlike an oil painting, where the image sits directly on its support while its

colour and depth come from refracted light, the holographic image occurs some distance in front of the plate, suspended, like the falling egg. Holograms can mimic the suspension of the image in front of the plate by having some element project forwards, seemingly into the real space of looking. For example, in the "Zeus" panel from Snow's installation, *Redifice*, a broken classical Greek column juts forth at face-level.[35] This image is also a visual-verbal pun on toppling the prestige and assumptions of classical good order and composition, and the aesthetic of unveiling the truth, which holograms don't do: the wooden toy building blocks supporting the fallen column spell out "Fuck Zeus!" Playing between two and three dimensions, the illusion of the falling egg tumbling into a real pan, time frozen and time lived, Snow seems to be once again having it both ways, working two sides of the story, but there is no "behind" the plate.

Figure 12. *Egg* (installation) 1985. Hologram, iron skillet on base, 91.4 x 106.7 cm. Musée National d'Art Moderne, Centre Georges Pompidou, Paris. Photo courtesy Michael Snow.

De Kerckhove discusses *Egg* and Snow's other holograms in terms of technical progress: the hologram freezes an instant in time and holds what we cannot normally see up for our inspection. Now we really know what a falling egg looks like,

held up right at eye-level for scrutiny. We are also brought "closer to the root, the core, the essence of the instant. Pulsed-laser holography turns photographic recording into an epiphany of time....By digging into time, with today's available time-based technologies, we can expand the visible spectrum of objects and space," de Kerckhove declares.[36] A hole in our knowledge and experience is filled, and another hole in our spatio-temporal perceptual acuity is plugged; we are but lacunae. But now, thanks to technology, we are also more complete. Some day we will have made the entire invisible visible and be fully paid-up members of the cosmos, able to see and know the All. This is the discourse of progress buttressed by science and technology.

Louise Dompierre, on the other hand, cites *Egg* and Snow's other holography as evidence of the disappearance of reality in the age of the omniscient image (*Egg* and *Redifice* were part of Snow's installed environment, *The Spectral Image*, at Expo 86 in Vancouver):

> Through this play of contrast, reality exists only in denial and as
> a momentary, fleeting presence, its being emerging as magically
> as it disappears....In [much of Snow's work from the 1970s and
> 1980s], the space of representation tended to begin in an already
> transformed or re-constructed real, conveying an increasing sense
> of remoteness, of a world in fragments, and one that feels dis-
> tanced through mediation of the image and through other
> devices....In these more recent works, the body becomes a dis-
> embodied presence, at once objectified and the embodiment of
> traces of meaning.[37]

But wait. Holograms such as *Egg* are so precise that my breathing and blinking alone disturb their focus. Through breath, musculature, and sight, I am connected in the most immediate way to these intersecting light waves. Through other work, especially the film *Wavelength* and the soundtrack for *La région centrale*, I find my self strongly confirmed in my embodied reality through the sensing of wavelengths. Perhaps from the perspective of Snow's practice spanning the 1970s and 1980s, as a sensory self I am an intersection of light waves. Nonetheless, his practice demonstrates that through the mediation of wavelengths, images composed of light are as real as the rest of the world and the confirm the reality of my embodied self. And the wonder of this shimmering image is that it provokes my pleasure-body in many ways. Contrary to Dompierre's interpretation, I don't find that Snow's practice, even these holograms, requires me to leave embodiment and its link with self-recognition behind. For what are "Snow" and I looking at in the non-existent depths of the duplicitous picture plane? "Snow" holds up his hands to show how touch doubles sight and that we see with both hands and both eyes: this is the truth about embodied sight, doubled and witnessed from inside the frame, with his two hands and two eyes. He

promises, with love: ground zero. And what does he offer with this promise? *Ab ovo*, "in the beginning from the egg," as though from nothing, but eggs always come from somewhere else. As the egg is stopped in its fall, its image as real as the frying pan below, the possibility for inscribing the certainty of origin, character, and identity slips away again in the space between you and me, and I think that I shall "die" from laughing.

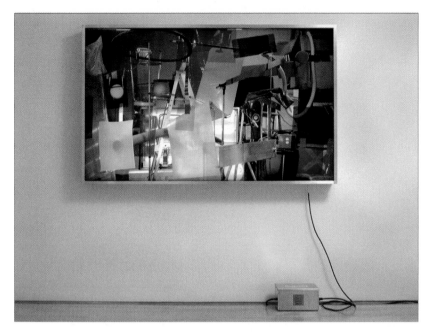

Plate 1. *Immediate Delivery* 1998. Backlit photographic transparency, light box, transformer box, 116.1 x 191 x 16.8 cm (light box). Gift from the Peggy Lownsbrough Fund, 2001. Art Gallery of Ontario, Toronto. Photo: Sean Weaver, Art Gallery of Ontario, Toronto.

Plate 2. *Venus Simultaneous* 1962. Oil with lucite medium on canvas, cardboard, and plywood, 200.7 x 299.7 x 15.2 cm. Purchase, 1964. Art Gallery of Ontario, Toronto. Photo courtesy Michael Snow.

Plate 3. *La région centrale* (detail) 1971, 3 hours, colour. The landscape cartwheels and strobes around a blue vortex when the camera rotates on the axis of the lens. Still photo courtesy Michael Snow.

Plate 4. *Plus tard* (detail) 1977. Frame-filling photograph of J.E.H. Macdonald's painting, *The Solemn Land* (1921). C-print, painted wood frame, Plexiglas, 86 x 107.2 cm. National Gallery of Canada, Ottawa. Photo courtesy Michael Snow.

Figuring the Field

THE MACHINE, THE "GARDEN,"
MY SELF

In Snow's film *La région centrale* (1971), you and I face the problem of "who?" relayed through cinema and a cinematic machine set in the "garden" of the specifically Canadian north.[1] The context for the film is not only concurrent experimental film practice in New York, but the argument that Canadian identity, or self-recognition, is grounded in fear before an empty and hostile wilderness. The visual representation of wilderness found in historical Canadian landscape painting and photography has been largely ignored in relation to *La région centrale*, particularly by non-Canadian critics, an ignorance which has obscured an important reference and a recurring theme in Snow's practice (see also chapter 6). Writers such as Northrop Frye, Margaret Atwood, and Gaile McGregor are well known for their analyses of the human recoil before hostile nature which they find in Canadian literature and painting. In 1989 Bart Testa extended this analysis into Canadian film with the exhibition and essays of *Spirit in the Landscape*, which included *La région centrale*.[2] Protagonists, in this view, implicitly or explicitly retreat to a defensive position (e.g., under the bedcovers, inside a compound, or before multiple framing devices) in the face of a threatening, unregulated environment.[3] Frye went so far as to include the irrational aspects of human nature in the category of threatening nature, and even what

he understood to be irrational and uncontrollable cultures, so that both Aboriginal peoples and the unconscious shared the category of threatening nature. It is no surprise that Frye's selected poets who chant of Canadian identity express their horror at the nature which surrounds and threatens them from inside and out.[4]

Frye's notion of nature runs contrary to the Western myth of bountiful nature as the garden in which humans formerly did and could still aspire to live harmoniously. The myth comes to us not only from the Paradise of the Bible but from Iacopo Sannazaro's revival of the Greek tradition of bucolic poetry with the publication of *Arcadia* in 1519. Etymologically, however, the Greek *parádeisos* refers to a park landscape or pleasure grounds, not to "uninhabited" nature. The Iranian *pairi-daēza* similarly referred to cultivated space, the walled garden. In the chaos of Rome just prior to the assumption of power by Augustus, Virgil turned bucolic poetry to polemical purpose. However, both in the Bible and in Virgil's first *Eclogue*, the myth of paradise and the story of the native garden landscape relate that nature will provide a livelihood for its dwellers without hard and punishing labour, provided that human inhabitants regard simple food and shelter as sufficient and don't disobey the law. The current rise of environmental consciousness and natural crises related to human activities make the same basic argument: there are natural limits which must be respected. Of course, whether in the Biblical garden or in today's world, people have always invented ways to make nature provide more of what they want. Today, more than ever, the potential of nature is harnessed by machine technology. In this context, *La région centrale* can be viewed as engaging Heidegger's pessimistic argument about the instrumentalization of nature in conjunction with the problem of self-recognition in the Canadian north of the boreal forest.

While some nineteenth- and twentieth-century Canadian writers and artists were undeniably fearful of nature, the most immediate defenders of nature as good came from the United States. There, moral benefits accrued from contemplating wilderness landscape—not nature used for forestry or agriculture—as the "sensuous image of revelation."[5] In contrast, the Frye argument goes, neither Canadian literature nor Canadian landscape painting, haunted as they are by the Franklin expeditions and similar disasters, offers much evidence for the popularity of Ralph Waldo Emerson's idea that an observer "should know that landscape has beauty for his eye because it expresses a thought which to him is good, and this is because the same power which sees through his eyes is seen in that spectacle."[6] From this perspective, regarding landscape, whether in the real world or in painting, was virtuous because in landscape the world expressed itself as created; in finding good and beauty in landscape, human beings confirmed their created status as parts identical to the whole.

For example, in the wilderness of a Hudson River School landscape such as Asher Durand's *Kindred Spirits* (1849; New York Public Library), transcendentalist poet William Cullen Bryant and landscape painter Thomas Cole have an animated discussion while looking out from a rocky precipice embraced by great trees. The rock ledge hangs over a river gorge, and the distant canyon and high hills are wrapped in Durand's typical hazy, atmospheric perspective. Artists, wilderness, and art are enfolded in the visible harmony of good composition and unified colour tonality. Many other of Durand's landscapes depict a golden, sun-drenched park landscape where man's domestic cattle find plenty and multiply (e.g., *The Babbling Brook*, 1851; Boston Museum of Fine Arts). They reproduce a pastoral, Arcadian ideal of harmony between culture and an abundant nature which provides enough for the yeoman and his animals. The Canadian attitude, in contrast, is represented historically as one of surviving the fearsome and fateful elements, and of the tragic attempt to escape from their evil. For example, George Back's watercolours of northern exploration, such as *Crossing the Barren Lands* or *Landing near Point Evritt* report precarious survival and the skill needed in an unaccommodating environment, although his sketches of Aboriginal inhabitants, their tools and clothes record some of their solutions to these problems.[7]

While the Canadian tradition according to Frye is about fear of nature, the Heideggerian debate over technology argues that through technology, human rationality has subdued and distanced itself from nature and thereby abandoned its "home" of poetic affirmation of Being present in everything and everyone. Consequently, technology itself is the threat today in a domain cleared of alternative languages capable of apprehending the connectedness of Being. George Grant, the Halifax philosopher, followed Heidegger's route. He argued that historically, the Canadian experience of nature historically has been interpreted through the doctrines of Luther and of Calvinism which interact synergistically with the demands of technology. Far from the later Emersonian ideal of regarding nature as the sensuous revelation of the divine, Luther and Calvin sought revelation of good and evil only through the suffering of Christ's crucifixion.[8] Calvinist faith excised any good from human connection to or empathy with nature. Facing nature stripped of divine design "left the lone soul face to face with the transcendent...will of God. This will had to be sought and served not through our contemplations but directly through our practice."[9] Buttressed by a Baconian empirical science and a Hobbesian view of nature as brutal competition, Canadians in a Calvinist cultural context were free—or constrained?—to approach nature through utilitarian rationalization. Like Heidegger, Grant argued that technology rather than nature becomes the threat because our faith in technology and the empirical science which supports it reduces nature and ourselves to object, depriving technological society of a

means to judge and set limits to its practical will.[10] Again like Heidegger, Grant warned against considering technology as objective and external to the North American mind. "Technique is ourselves," Grant wrote. "All descriptions or definitions of technique which place it outside ourselves hide from us what it is."[11] In a Calvinistic culture, "the external world was unimportant and indeterminate stuff (even when it was our own bodies) as compared with the soul's ambiguous encounter with the transcendent. What did the body matter; it was an instrument to be brought into submission" which included "the unlimited mastery of men by men."[12]

But such a perspective of nature as threat is not necessarily supported by Canadian art history. Maria Tippett and Doug Cole have documented a change in landscape painting in British Columbia where attitudes towards the landscape changed from eighteenth-century descriptions as "desolate," "dreary," and "monotonous" to appreciation in the late nineteenth century for the exotic landscape as picturesque, sublime, and moral.[13] Perceiving the landscape from a positive point of view occurred in conjunction with the completion of the transcontinental railroad and the spread of Emersonian ideas. The shift in attitude also accompanied the gradual overcoming of European realist and romantic painting conventions and techniques which had not been able to accommodate a land of largely coniferous forests, without traces of white settlement but which painters in British Columbia nevertheless wanted to paint.[14] What was paintable in terms of conventions and technique could have been an important part of the "recoil before nature," the equivalent of a lack of words, especially "poetic" words.

Some very well-known early paintings of Quebec offer a perspective of nature as benign rather than a menace. Thomas Davies's *The Falls of Ste Anne* (1790; National Gallery of Canada) depicts the falls and rapids in their narrow rocky gorge, tightly hemmed in by high, untracked hills cloaked with trees in fall colours. However, the miniature people on the rocks at the base of the falls are not overcome with fear or awe but are enjoying themselves, fishing. Robert Todd's *The Ice Cone, Montmorency Falls* (c.1845; National Gallery of Canada) likewise shows an impressive natural wonder visited by people gaily riding in sleighs, and hunters with carefully detailed equipment, especially snowshoes. Frances Anne Hopkins's paintings of her canoe trips with voyageurs between Lachine, Quebec, and Fort William, Ontario during the 1860s (e.g., *Voyageurs at Dawn*, 1871; *Canoe Manned by Voyageurs*, 1869; both National Archives of Canada), while dramatizing the dangers of shooting rapids, disorientation in thick fog, and the hardships of camp and portage, overflow with details of teeming activity, a bustle of figure and colour. Arguably these report her excitement on a long canoe voyage rather than defensiveness before a threat. Lucius O'Brien's luminist painting of a native *Fishing Party, Returning Home*

(1874; private collection, Toronto) rivals Americans Fitz Hugh Lane and Asher Durand for light-saturated harmony and compositional stability, while in O'Brien's *In a British Columbia Forest* (1888; National Gallery of Canada), beneath the shelter of an enormous spruce shrouded in undergrowth, an elderly man and a youth relax in attitudes that intimate an emotional affinity between the forest and themselves, rather than fear. The painting could be an allegory about generational renewal through youth, or of human nature through "wilderness." Even Back's watercolours, painted during Sir John Franklin's disastrous first Arctic land expedition (1819-22), have their luminist moments (e.g., *Holey Lake*, and *Canoes with Sails*).[15]

In the context of a central Canadian regard for nature, priority must be given to the twentieth-century work of the Group of Seven which added nationalist aspirations to their search for new conventions adequate to representing the Canadian shield. Although the group faced the question of Canadian wilderness very late relative to the onslaught of industry on nature, one has to remember that, for example, the road around the north coast of Lake Superior was completed only in 1960. Nonetheless, the area had been explored and exploited for centuries by boat and by means of the Algoma Railway. Like their nineteenth-century counterparts in British Columbia, the painters of the Group of Seven were concerned with the inadequacy of European conventions to deal with the facts of a less domestic and less atmospheric Canadian landscape, which they saw as a new kind of space. For example, in a review of J.E.H. Macdonald's 1911 exhibition at the Arts and Letters Club in Toronto, C.W. Jeffreys (a painting colleague) wrote: "In themselves...Canadian themes do not make art, Canadian or other, but neither do Canadian themes expressed through European formulas or through European temperaments."[16] Nature was not a threat to these artists who pursued sketching trips into the Canadian Shield, the Rockies, and rural Quebec in subfreezing temperatures. J.E.H. Macdonald, Lawren Harris, Emily Carr (in BC) and Frederick Varley were also influenced by Walt Whitman's transcendentalism. For these artists, as for nineteenth-century American Emersonians, there was a divine truth to be discovered in landscape and revealed in painting. However, as Ann Davis argues, since transcendentalism was literary, mystical, and emphasized individual intuition, it did not have a conventional iconography, so that Canadian artists influenced by transcendentalism could and did pursue their pictorial experiments individually.[17]

Quite contrary to the contained, circular vision of a defensive clearing in the trees, the standard repertory of Group of Seven conventions include wide-open views across hilltops and water (e.g. Frank Carmichael, *Northern Tundra*, 1931, R.S. McLaughlin estate; Tom Thomson, *The West Wind*, n.d., Art Gallery of Ontario, Toronto; Lawren Harris, *Lake Superior*, 1924, Art Gallery of Ontario), views through screens of vegetation which absorb the spectator right

into the colour and movement of the forest, or paint (e.g., Harris, *Beaver Swamp, Algoma*, 1920, Art Gallery of Ontario; Thomson, *Northern River*, 1914-15, National Gallery of Canada), and vertiginous views down waterfalls or on to streams (e.g., Macdonald, *Falls, Montreal River*, 1920, Art Gallery of Ontario; *Leaves in the Brook*, 1919, McMichael Canadian Collection, Kleinburg, ON). Overall, these paintings establish an identification between colour and form, paint and representation, and solicit a kinaesthetic response connecting spectator to painterly gesture to dynamic nature. Their expansive restlessness is enclosed and stabilized in strong surface design which can also be understood as an optimistic metaphor for the cosmic One.

THE *LA RÉGION CENTRALE* OF FILM CRITICISM

Like the Group of Seven artists, Snow was concerned to find a method or form appropriate to a different kind of space than that translated by received landscape conventions. He wanted to make "a real landscape film, a movie of a completely open space....I wanted to make a film in which what the camera-eye did in the space would be completely appropriate to what it saw, but at the same time, equal to it. Certain landscape paintings have achieved a unity of method and subject," a balance between doing and seeing.[18] He also wanted to make something non-coercive, which suggests a political undertone to this film.[19] Snow's statements indicate a commitment to an idea of film as an abstraction which must remain doubly faithful to two facts of its material: its capacity to record and represent, and its quality as a pure construction. Given its constraints as both construction and indexical record, the challenge seems to be that if a film is to avoid subjugating its subjects and objects, it should be ideally neither pure imaginative construction nor pure report, but remain faithful to both. Consideration of reception (i.e., "non-coercive") adds a third leg to the dialogue between representation and construction. Snow considers his films to be experiences: "*La région* isn't only a documentary photographing of a particular place at various times of day but is equally and more important a source of sensations, an ordering, an arranging of eye movements and of inner ear movements."[20] It's a very different perception of landscape than the genre would seem to allow.

Given that film orders sensory experience, can a "landscape film" be non-coercive when camera movement is matched to wide open space and apparently untouched boreal forest? W.J.T. Mitchell has pointed out that since the term "landscape" refers to and confuses the external world with a genre of painting or photography, our most conventional term for countryside constructs it as already represented and a place where cultural meanings and values are encoded and then found. Consequently, landscape is a medium of exchange expressing

both limitless symbolic value and the exchange value of commodities.[21] In transcendentalist terms, applicable to many Group of Seven paintings, landscape is a sensuous sign of God's presence, while in secular proprietary terms, it's a country garden. So as a genre, landscape is already imposed on the interpretation of the world, while film, any film, is admittedly a "rearrangement of eye and inner ear." Given these conditions, how is a "landscape film" going to be non-coercive, or even redemptive? "Wilderness," especially in Canada, has long been a medium of pictorial exchange. The project to rearrange image and eye and inner ear is saying that the received picture of Canadian landscape is one of subjugation, in some way, and that something is missing having to do with my embodied reception. Given that "landscape" is a received imposition which translates terrain to and through my self, then something in my self having to do with notions of landscape and wilderness has been subjugated and lost. Since the film's project is to change things on the side of my embodied sight, the problem is how I recognize and sight my self through cinematic images of northern Canadian wilderness. However, because the film is experimental, to redeem or "de-subjugate" eye and ear with the cinematic image of wilderness is not foreseen as a source of pleasure by confirming what is already familiar and culturally valued. So the film project relies on key terms in the discourses of technological progress and de-familiarization. As a result, one problem is how the film walks a fine line between liberation of the senses and understanding, and resubjugation to discourses of progress and liberating newness. Another point is that liberation of "wilderness," which might just be my wild side, depends on negotiation through an intervener, who remains problematic.

The forest needed a redemptive image just as much as the senses and understanding of my self. Snow made clear that he did not wish to perpetuate the received image of the northern forest. He said that he "wanted complete wilderness with nothing man-made visible....I feel horror at the thought of the humanizing of the entire planet. In this film I recorded the visit of our minds and bodies and machinery to a wild place but I didn't colonize it, enslave it. I hardly even borrowed it."[22] In a journey redolent of the Group of Seven's sketching trips by canoe and boxcar, Snow and his crew travelled by helicopter to a hilltop surrounded by land which looked untouched about 160 kilometres north of Sept-Îles, Quebec. Because wilderness records no story of subjugation to human activities, one way of redeeming wilderness means not making conventional Western movies about it. The Quebec hilltop is a possible site where film could remain faithful to its represented object and at the same time release camera movement and film editing from subordination to narrative construction and the rationalized space it requires. However, while places visually free of "landscape stories" might be both found and cinematically formed, as a cinematic entity this space can become a visual, literary, and possibly economic natural

resource—that is, there are problems in the social use of the film. On the screen, there is no question that *La région centrale* rearranges reception through eye and ear. The question remains whether wilderness landscape and my perception of it have been redeemed from subjugation or loss, especially from its account in narrative cinema. In terms of the Minimalist problem, what remains problematic is how a return to "naked" perception would be signalled and whether it is even possible.

In the opinion of Richard Foreman, New York theatre director and critic, and Gene Youngblood, Canadian arts writer, the answer to the question of naked perception would be a resounding "yes." These critics placed Snow in a group of artists including Philip Glass, Steve Reich, Terry Riley (music), Ken Jacobs, Hollis Frampton, Joyce Wieland, Ernie Gehr (film), Yvonne Rainer (dance), Ken Kelman, and Foreman himself (theatre).[23] *La région centrale* was made while Snow was living in New York, where his immediate working environment was comprised of the avant-garde filmmakers associated with Jonas Mekas's Film-Makers' Cinematheque, such as Stan Brakhage, Jacobs, Frampton, Wieland, and Mekas, among others. The avant-garde film scene operated in the shadow of ongoing work by Stan Brakhage and Andy Warhol (e.g. *Empire*, 1964). Similarities between Warhol's and Snow's films between 1964 and 1967, according to Snow, had to do with their similar interests in the painting of Oldenburg, Johns, and Duchamp.[24]

Writing before the making of *La région centrale*, both Foreman and Youngblood refer to its precedents including *Wavelength*, *New York Eye and Ear Control*, and most closely, <-----> (called *Back and Forth*), which was also a film based on panning.[25] Foreman understood these films as audience-oriented critiques: they challenge viewers to test how they derive pleasure from objects or films. His hypothesis is that, traditionally, pleasure from films derives from repeating confirmation of the familiar and expected character-sedimentation known as myself. Snow's films, however, bring to the fore a "being-present," which creates something new at the level of viewer consciousness.[26] Most traditional Western art, he points out, has channelled consciousness into the work, so that we "project into it what we were as individuals and 'persons' in the full Christian sense of the word." With recent art such as Snow's films, however, we run into a surface or space-time which will not accommodate this self-projection into the work and so we are thrown back upon ourselves. But this does not mean that we simply find our comfortable mirror image confirming what we already know, because we are in a collision with the unknown. The "spatial drift" of the film prevents a return to sender, so to speak: "The spectator, in order to simply *notice* the work itself, *must* replace himself so that he is no longer confronting an object, but 'putting-himself-as-self' elsewhere, so that naked presence is the mode and matter of the artistic experience."[27] Foreman's analysis remains with the idea

and language of consciousness, but it could also be called post-consciousness and post-Minimal, owing to its break with the notion that we're being offered "more" consciousness or progress towards Consciousness. Whereas Foreman also retains the language of a singularity of my (male) self, preliminary intimations of the notion that my self might have different, even competing temporalities and sites surface in the phrase "putting-himself-as-self elsewhere." It is this impossibility of repetition or confirmation of the familiar in the face of "spatial drift" in film experience that opens up being-present, for him.

The same notion guides Youngblood's idea of expanded cinema, which he explicitly calls post-Minimal and post-Warhol because it deals with pure filmic time (fragmented; *Empire*, by contrast, reports "real" time) and pure filmic space (two-dimensional and non-perspectival) which always compete in film with its capacity for illusion. The question of dimensional compression is frequently made problematic throughout Snow's practice, including *La région centrale*. Youngblood includes Snow's films in a new category, synaesthetic film, and he argues that synaesthetic film also tests the spectator, but in a more round-about way. Films like *Wavelength* and *La région centrale* produce a field of harmonic oppositions in continual metamorphosis which is received by you and me kinaesthetically (through embodied senses). Not a dramatic narrative, constructed from multiple superimpositions, this kind of field is not something for which we have been conditioned in terms of pleasure or pain, although this assumption might be more questionable in 2001 than it was in 1970. Analytic perception is bypassed; rather, reception of the metamorphosing field of harmonic opposites evokes kinaesthetically in "the inarticulate conscious of the viewer recognition of an overall pattern-event that is in the film itself as well as in the 'subject' of the experience."[28] My body and perception pick up or "read" signals which it repeats somehow. Pattern-events become recognizable through repetition. This leads me to consciousness of my own perception. Considering what might be the gain of pleasurable return, rather than obtaining pleasure from confirming my life experiences and emotions in a dramatic narrative, the emotional content is a function of the degree to which I become consciously aware of my perception or reception, so it is not predictable. My self is returned to me reconfigured because I find my self released from being bound in "object consciousness" to freedom in "metaphysical relationship consciousness," or being present. In the absence of this mode, or stuck back in known dramatic stories or object consciousness, my self as self-renewing in relationship to its context becomes entropic.

Youngblood points a way out of the Minimalist more-consciousness abyss by arguing that a viewer "invests the experience with meaning by exerting conscious control over the conversion of sight impressions into thought images," such as his writing and mine.[29] How this might be achieved lies in the notion

of a field of harmonic opposites and recognition of these as pattern-events in the film, because such patterns can be construed as a system of differences that can generate meaning, something like Derrida's *différance* but not as formalized as language, which has a grammar.

What seems important here is not only the idea of "harmonic opposites" (poetically unspecific), but the notion that pattern-opposites are picked up subconsciously through ear, balance, handedness—perhaps evocation relayed through the eyes of taste, flavour, and touch—all of which is very in touch with Snow's practice (e.g., *Press*, figure 7, or the film *Breakfast* (*Table Top Dolly*)) as well as *La région centrale*.[30] My whole body is discovered recording, reporting, and reading its relationships. I find this significant, for the task at hand is making sense, which gives pleasure through a transfer of funds, playing at translating from one medium to another. This is another definition of pleasure than the instinctual, Freudian model still so prevalent. My body is accounted for in the pleasure of making sense, but released from being chained to the instinctual concept of desire, or masculine crescendo and orgasm, by recognizing other plays, other overflows: redemption indeed.

Annette Michelson and R. Bruce Elder hold up Brakhage as the exemplary figure of independent film in New York in the 1950s and 1960s, situating his concern with optical spatiality, light, and the expressive effect of hand-held camera movement as the dominant paradigm and standard with which others had to contend.[31] While both critics call the nature of consciousness and related modalities of perception the primary concern of Brakhage and Snow, Michelson situates them in a linear passage from expressionism to a new objectivity.[32] Elder, on the other hand, couches their concerns in the contrasting phenomenologies of Merleau-Ponty (Brakhage) and Husserl (Snow). As Elder sees it, Brakhage's films proceeded from the primary principle that seeing involves the whole body and that, through entrainment effects, the camera can be a stand-in for the eye. Because every person has a unique body, therefore unique vision and feelings, Brakhage could only record what or how he sees, so his films characterize his own vision.[33] Elder describes the effect:

> His films are based upon—and are dedicated to the attempt to evoke in their viewers—a fascinated condition which involves a thorough-going identification of the viewing subject with the act and content of vision....So complete is the identification that for Brakhage any change in vision represents a transformation of the self....When we move, our *soma* is affected and these changes are registered as changes in the way we feel and see—or better "feel/see," since for Brakhage all emotional experiences involve the modification of our bodily condition and the way we see, and these alterations cannot be separated one from another.... Fascinated spectators of Brakhage's films are so absorbed in the

act of seeing that any change in what they see ruptures the con-
tinuity of the self. Every shift of attention involves a death of one
self and the birth of another.[34]

Since Brakhage's films had the effect of absorbing the viewer into the eye of the
camera/filmmaker, which means absorbing and collapsing the feelings of the
spectator into that of the filmmaker, the obvious conclusion is that the film or
camera "murders" myself from one instant to the next, although I am reborn
instant-to-instant as well. Brakhage's films are visually and temporally so frag-
mented that the limits separating perception and imaginary images, inside and
outside, or you and me, breaks down with the result that, as Elder argues, they
grant no permission for a self, a "transcendental self," that persists through its
experiences. As a consequence, the films produce an intense feeling of anxiety.
However, it is through this anxious sight that I gain access to the real and learn
about my self, because I learn through learning about things not-my-self.[35]

Brakhage succeeded in isolating the unavoidable effect of continuous re-
assertion of self in the present, a problem not well-considered by Foreman and
Youngblood. That is, my self (always-dying and being re-born) is divorced from
the past and remains without resources to anticipate the future. One has to
question why this condition is taken to be co-incident with a feeling of pleasure
rather than a feeling of subjection. If presence is pleasure, often associated with
a feeling of wholeness, then surely it involves "keeping it all together" which
implies the temporal dimensions of memory and anticipation, and surely some
decision that these are "mine." As we saw in chapter 1, Ricoeur argues that a
model of self expressed as "here," "now," and "I" simply cannot stand up
because it omits certain aspects of persistence through time.[36] Presence as this,
here, now, I, and even we omits the other half of the set of shifters: that, there,
then, or you (he, she, they), and furthermore deprives the self of its own histor-
ical dimension, practice, and remembrance. Further ignored in absorption into
Brakhage's camera-I is *my* fleshly self, one of the ways in which I am both like
an other and completely other, physically and temporally, and through which I
can designate my other. Consequently the self as purely present attributes
remains inadequate to the task of identifying the self.

Michelson and Elder hailed the use of the camera in films such as
Wavelength, <----->, and *La région centrale* to restore a sense of a consciousness
(i.e., a subject such as you and me) that could find reflected in film the experi-
ence of duration, "keeping it all together" in time. Snow himself remarked that
one of the key gifts of film, shared only by music, was the capacity for prophecy
and memory, a point which had been largely ignored in the avant-garde interest
to subvert narrative conventions.[37] Specifically in *La région centrale*, Elder and
Michelson found that, as Elder wrote, "the camera is a stand-in for the tran-

scendental subject which constitutes and rules the objects in the world which we perceive, for it is through the transcendental self that the discontinuous fragments of lived experience are integrated in a unifying meaning....Continuity is, then, an attribute—and product—of the subject."[38] Michelson also found it significant in Snow's films preceding *La région centrale*, especially in *Wavelength*, that they restored and remapped the space of perspective, the space of the transcendental subject. In her view it was from this point that Snow proceeded systematically to develop transformational analyses on this space.[39]

Elder and Michelson both read *La région centrale* through Jean-Louis Baudry's well-known text proposing the transcendent "eye of God" as homologous to the cinematic camera:

> To seize movement is to become movement, to follow a trajectory is to become trajectory, to choose a direction is to have the possibility of choosing one, to determine a meaning is to give oneself a meaning. In this way the eye-subject (which not only represents a larger effort to produce an ordering, regulated transcendence), becomes absorbed and "elevated" to a vaster function, proportional to the movement which it can perform.
>
> And if the eye which moves is no longer fettered by a body, by the laws of matter and time, if there are no more assignable limits to its displacement—conditions fulfilled by the possibilities of shooting and film—the world will not only be constituted by this eye but for it. The mobility of the camera seems to fulfil the most favourable conditions for the manifestation of the "transcendental subject."[40]

The first two actions (to seize and to follow movement) are folded into identification (to become movement), so that a previously reflexive and desiring subject becomes identified with the camera-I. The camera movement has the identificatory effect of absorbing the position of the viewer-subject, the "who?" of you or me. Baudry refers us back to Benjamin's contention that mimesis is not reflexive. It is a radical forgetting of the Other, who might already be my self, since Benjamin was speaking of everyone's animal and primitive capacities, including mimesis. Benjamin claimed that mimesis makes one suddenly an other who makes itself present through signifying gestures and imitative language, even when meaning or reference are unknown.

Mimesis provides a model for desire based on de-differentiation rather than differentiation, and so opens more possibilities to understand (later) how I might find my self in the domain of visual art. But mimesis is also, according to Derrida, an act of readership, in which the third person's position is held by the gestures themselves. Ricoeur's contrasting notion is that identification occurs both on the side of internalization of the external traits of others or social

norms, but it is also part of the structure of injunction interlaced with appeal and promise which supposes that "I" am already open to listening for you and am ready to respond.

With these notions of violence and mimesis, and of the effects of identification in mind, we need to consider how both Baudry and Elder first assume an active, independent free agent of choice (a conscious spectator) who must pre-exist and understand the trajectories of the moving camera across the landscape in order to seize the choice of following one or another. This passage seems contradictory: to seize movement as becoming movement while retaining the power to choose among them does not quite mesh. Furthermore, this viewer is assumed to understand all of these choices from behind the viewpoint of the camera rather than from in front of the image on the screen. So, as Elder said initially, rather than suffering de-differentiation, this subject-viewer divides into one self who experiences and one who remains unchanging and reflective, the first reporting to the second. There is ambiguity here regarding the effect of the continuous landscape movement which in no way mimics human sight, and the argument that "to choose" is "to become" is the choice of a mastering sight.

At the heart of this figure lies desire for mastery over appearances. In the Baudry proposal, the model and vehicle is the transcendental eye. Retaining only its will, the disembodied eye rises, like the spirit of progress, to master the world which now exists only to augment mastery. The spectator-subject of *La région centrale* might lose himself in the process, as Elder maintains, but he loses only impediments to his will, because the process is the imposition of mind.[41] Elder's position augments the transcendental eye by tactics of semiotic reduction and syntax: first transfer the world into image, then abstract and divide its continuity into intelligible units. Elder claims that the fleeting images which form the basis of many of Snow's films, e.g., *Standard Time* (1967), <-----> (1968-69), *Presents* (1980-81), *So Is This* (1982), *Seated Figures* (1988), as well as *La région centrale*, wrap the world irretrievably in a system of representation which exchanges the presence of a sign for its absence and replacement by a subsequent sign and which, in sequence, construct meaning.[42] This means that, in the pursuit of consciousness, we pursue disappearing signs of the disappearance of the real into representation. As a result, the achievement of consciousness—the mastery of representation as meaning—is also loss, which, according to Elder, is what Snow's work is about.[43] However, transcendental consciousness, the mastery of meaning, "saves" us from the maw of the disappearing real and its fragmentary images. Power is the stake for both Baudry's model and for the transcendental subject. The position of knowledge and power is bought at the price of losing a body or subjection to experience. In the eye of the transcendental interpretation, mind performs *aufhebung*, and the incarnated self watching *La région centrale* is left behind—perhaps in disgust yet again.

Michelson ostensibly takes embodiment into consideration, but reaches a similar conclusion. First, the omission of story and its structures collapses the camera into "character" and then disembodies the spectator, so that the spectator identifies with the camera as "character."[44] In Michelson's reasoning, the erasure of anecdote and the collapse of filmic agent into character remove the signs of mediation and the structures of storytelling that provide the third-person position, and which usually distance and protect the viewer from entrainment. Removing this framework and replacing human perception by patently non-human perception (i.e., the camera movement) trigger desire: the desire to see what is forbidden doubled by the desire to know what is forbidden (the instinctual model, again). It is "a fusion of primary scopophilic and epistemophilic impulses in the cinematic rendering of the grand metaphor of the transcendental subject."[45] So, while desire might be taken to stand for the embodiment of you and me here on earth, the possibility is snatched away by de-differentiation into the camera, and references to a theorized desire ("scopophilic and epistemophilic impulses") returned to the metaphor of the disembodied transcendental subject.

In subscribing to Baudry's metaphor for the camera, Elder and even Michelson surrender the fleshly eye to one whose powers are augmented by the technology of the lens, an eye made better than the body can provide because this is a systematic and rationalized eye, conceived and perfected by mind. When consciousness and identity are both identified with the camera and other technological products, consciousness becomes a rationalizing organizing principle. When the transcendental subject demands the surrender of obdurate realities such as my body and the world out there, it not only defines them as disobedient, finite substance from which the stabilizing, enduring, and formal powers of mind have been subtracted; transcendental consciousness has also excised the ground for selfhood and agency. As Ricoeur has argued, knowing how and being able to do things can be realized only in my body, and is the point where the linguistic subject (you and I defined by our place in the system of differences of the language system) surpasses its designated place to become an agent who lives and acts among others, as we all are. Saying "I can" marks a divide in the self and names it as a self (as discussed in chapter 1). One part is the self of introjected models or assumed norms resulting in persisting characteristics recognized by others; an other is the self who promises to be there for you, and so takes up the capacity to designate an other.[46] In light of Ricoeur's analysis, the transcendental subject is, in effect, a disempowerment of *my* capacity for selfhood.

The third immediate critical context for *La région centrale* was the very influential Structural/Materialist criticism of British critics, especially as articulated by Peter Gidal. British critics, in an effort to separate themselves from

Clement Greenberg's North American version of Modernism, had already taken Snow's *Wavelength* as exemplary of a new paradigm, or film concerned with its capacities as a critical and ideological project that could attack the repressive and identificatory procedures of narrative cinema. At that time narrative cinema was seen as "Hollywood film" and identified with "American imperialist aggression," the mantra of anti-Vietnam war protests. For example, a leaflet distributed at the Knokke-le-Zoute competition where *Wavelength* won the $4,000 first prize proclaimed:

> FIGHT AGAINST THE OPEN AND UNDERGROUND AMERICAN IMPERI-
> ALIST AND CINE-IMPERIALIST AGGRESSION ALL OVER THE WORLD.
> The international capital recruits its boys: Gaevert-Agfa
> lends them a roll of filmmaterial and pays the one who is most
> obedient with 4,000 US dollars: every meter of film showing a
> naked ass out of the metropoles keeps silence about a burned
> body in Vietnam making more profit than 4,000 US dollars.[47]

Although realized as objects (a film) and procedure (revelation of process), structural/materialist films were to avoid telling a story or straight documentary about their own making since that would be yet another representative narrative. They concentrated instead on non-narrative relationships between the reality filmed and its transfer on to film. As Gidal defined it: "Structural/Materialist films are at once object and procedure."[48]

> An avant-garde film defined by its development towards increased
> materialism...does not *represent*, or *document*, anything. The film
> produces certain relations between segments, between what the
> camera is aimed at and the way that "image" is presented. The
> dialectic of the film is established in that space of tension between
> materialist flatness, grain, light, movement, and the supposed
> reality that is represented. Consequently a continual attempt to
> destroy the illusion is necessary. In Structural/Materialist film,
> the in/film (not in/frame) and film/viewer material relations,
> and the relations of the film's structure, are primary to any repre-
> sentational content. The structuring aspects and the attempt to
> decipher the structure and anticipate/correct it, to clarify and
> analyse the production-process of the specific image at any specific
> moment, are the root concern of Structuralist/Materialist film.[49]

An ideological concern with testing the viewers' perception was forefront. Ideally, the viewer as subject of the film was activated into "forming an equally and possibly more or less opposite 'film' in her/his head, constantly anticipating, correcting, re-correcting—constantly intervening in the area of confrontation with the given reality, i.e., the isolated chosen area of each film's work, of

each film's production."[50] When faced with film, the viewer should become conscious of the reality of film, of filmic and screen-viewer relationships. While it is evident that the viewer's perception is entrained, what is at stake is the degree of transparency brought into the process, which rests ultimately on the good faith of the filmmaker. In fact, the good faith of the filmmaker maybe part of a film's material relations, part of what the film tests.

Another problem, which Gidal never discusses, is whether a film primarily about revealing its material relationships is sufficiently interesting to watch. Its represented scene, after all, was not the primary concern. Structural/materialist films might be deficient on the side of "having a reason-for," or not taking sufficient account of their viewers, promising nothing and making no appeal. When Gidal published his anthology regarding structural/materialist film four years after *La région centrale* was made, he included the film as an example, but at the price of disowning its represented wilderness and its Canadian context.[51] Since the aim of testing the essentials of materials and conventions, and disgarding the unneeded was the goal of North American modernism, it can be argued that structural/materialist film differs from North American modernism primarily in its ideological concern with viewer identification and narrative convention. While finding that *La région centrale* distances the viewer so that the film is neither fascistic nor entertainment Gidal, however, returns to the phenomenalist description of the film as a reflexive "system of consciousness, a method, an epistemology."[52] To gain this apparent freedom, mind performs *aufhebung*, and leaves embodied perception behind, down there.

LA RÉGION CENTRALE AND MY SELF

It is worth asking whether *La région centrale* disavows the fleshly eye, the embodied presence of its spectators. The film is in colour and lasts for three hours (just under 190 minutes, by my timing). It is composed of seventeen sections of landscape, each lasting between thirty seconds and about thirty minutes, plus a seconds-long interlude of white screen in the first reel. There are five reels, three of forty-five to fifty minutes in length, and two of nineteen and thirty minutes each (reels two and five). The reels and shots are bridged by splices marked with a white X distended horizontally across a black screen. There are no human actors or signs of human activities. The landscape sweeps continuously across the screen without pause and seemingly without edited shots although there are several abrupt changes within sections that suggest otherwise. Approximately halfway through the film, in the third section of the third reel, there is a long passage with the moon trailing a comet-tail effect of long exposure, dancing through a black sky. Many critics interpret the whole film as a diurnal day/night/day cycle, which to me speaks of their wish for narrative totality.

However, given how weather conditions, shadows, and lighting tonality change arbitrarily between and within sections, the film does not seem to report a day length, though it does suggest technical manipulation such as changes of exposure, filters, or film stock. Yet most criticism fails to take into account these arbitrary changes or the return of a second period of darkness (i.e., lacking a moon) which opens the fourth reel, in which landscape details slowly emerge in growing light, a cinematic representation of the emergence of form in chiaroscuro.

To match the camera movement to the idea of wide open space, Snow commissioned Pierre Abeloos, a creative engineer from Montreal, to design and build a machine for a camera mount which could point the camera in any direction and which could be controlled electronically by a preprogrammed musical score or by remote control.[53] The flexible mount and automated control freed camera movement from conventional constraints of imitating the human eye, and of Snow's immediate aesthetic response to what he might see through the viewfinder. The machine holds the camera at the end of a rotating arm offset from the machine's principal vertical axis. It rotates the camera on the axes of three successively smaller circles, each tangential to the "prior" one. The largest circle describes a horizontal plane around the machine's central post. The second circle traces vertical rotations tangential to the perimeter of the first horizontal circle. The third circle, tangential to the second, is where the camera sits and rotates on the lens's own axis. Additionally, the lens can zoom. The machine can change direction and speed on any of these paths while performing these movements simultaneously and independently. Subsequently equipped with a video camera and supplemented by four monitors, the machine has become the sculptural video installation, *De la* (1969–71).[54]

Given this capacity to bring a dizzying repertoire of moving images to the screen, how can anyone ignore the reference to the body made by a film that can literally make you sick? *La région centrale* calls upon a spectator with mobile, stereoscopic vision, with hearing and the ears' semicircular canals, and with long habitual experience of being vertical and seeing at eye-level, of handedness, dorso-ventrality, and human gait. The screen image rends the eyes, attacks balance in the inner ear, challenges the stomach, contests eye-ear integration, and denies the pace and focus of perception constrained in a head that looks forward, on a neck with restricted rotation, on a body that walks, turns, stops, and blinks to see. The film's sound has nothing to do with emotionally interpreting what is on screen but registers the presence of a sensing device with a series of electronic tones and pulse speeds that bespeak machine. Sometimes the pulses and tones are synchronous with the movements on screen and sometimes not. Such irregularity challenges perceptual integration of senses that are conditioned to synchrony, so that Snow's earlier project of liberating the eye and ear from conditioned mutual subjection, which he undertook in *New York Eye and Ear Control*, returns with a vengeance.

At the same time that the film contests the conditioned integration of the senses, the structure of narrative understanding is also negated in favour of other interpretative strategies. The film's sections narrate no story of either human or natural events. Nor are the sections put together like clauses in sentences, paragraphs in an essay, or cinematic shots and scenes in a semiotic chain that cumulatively constructs and refines meaning regulated by a system or grammar. While the X seems to call for a reading spectator, *La région centrale* cannot be read conventionally. Because I cannot read a story, I rely on other strategies for making sense.

The opening shot of the film, a white X distended horizontally on a black screen, is a verbal-visual pun on reading, on the meanings the title can assume in different contexts, on the fact that what is central in one context is marginal and superficial in another, and on "X marks the spot." The X identifies centrality as a problem re-cited by the landscape passages, the camera and its mount, and the relationship of film to spectator. In *La région centrale* anything central is impossible to approach. Just when I get close, what appeared central suddenly becomes tangential to something else. The X, a cipher without a fundamental meaning, is on the surface of one of many frames in a linear strip reflected back from another surface intersecting a projection beam; no central core there. Because the camera mount draws the camera along a path of circles tangential to each other, none of them is central, either, which means that the camera can establish no single central point. The hilltop in northern Quebec is beyond the fringe of urban Canadian culture or its agrarian hinterland. As a possible "centre" of Aboriginal culture, it is beyond the orbit of non-Aboriginal, southern Canadian culture. But it might not be central for Aboriginal culture either because the people are diverse and claim different and overlapping domains. So, we are shown how there is no centre to wilderness.

While both Snow and Elder have referred to a "still" and "empty centre" at the heart of *La région centrale*, such emptiness cannot be verified from the film itself. Given that the camera's inability to point across the vertical axis of its machine mount is not evident in the film, and that this vertical axis as *the* centre is questioned by its own construction, the statement is symptomatic of both filmmakers' external, knowledgeable viewpoint as thinkers and makers. Furthermore, calling the invisible area "still" and "empty" seems to emerge from a prior, theoretical judgement of what *should* be there. For example, frequent critical remarks that the space or form built by the film is a sphere reflects a desire for totality. *La région centrale* is not a cosmic sphere but a cosmic strip: a passage of film.

After the initial X, the first frames show small irregular objects lying on some fuzzy material in a brilliant, raking, red-gold light. The sight is startlingly beautiful. There is no sense of up or down or depth, no sense of gravity or scale,

no horizon line. I receive no reference to what or where these objects are. Rather than still life, which affirms my body's habitual orientation in this world, this brief opening scene is a *trompe-l'oeil* which confounds and questions my orientation, just as the opening X questions centrality and its own legibility. Slowly, the objects pass downwards out of the frame. The scene gains depth, and a horizon line slips by. Suddenly, with a jarring shock, I am "there," standing on a hilltop looking out over the view of hilltops (so beloved by Frank Carmichael of the Group of Seven). Next, sky fills the screen. Gradually a local inventory of terrain builds up: a huge boulder, sometimes so close that its lichens almost scrape my nose; at other times the same boulder is distant, thanks to the zoom. A long, horizontal rock ridge beyond the boulder crosses the middle ground. Beyond it there is a lake with a steep valley to one side and rows of rugged and rocky hills receding in the distance. These views can change abruptly to close-ups of pebbles and lichens on the ground (they were the objects in the opening frames). Despite increasing familiarity, the sight remains disorienting because these crazily sliding scenes belong only in cinema.

Five minutes into the film, the shadow of a strange *personnage* with slowly rotating arms skims by. It stays long enough for me to recognize it as the shadow of the machine mount holding the camera while it tracks through this wilderness. The shadow produces another shock. Until this point, I have had the illusion that I am standing on a hilltop watching this chain of sights career by. The shadow of the machine points directly at "my" feet. It compels my eviction. It is standing where I should be, confrontational yet serenely indifferent to my presence. This "still and empty centre" seems to be over-full. Now the space has been doubled between "it" and "me" in some indefinable sense because I have no place to stand. The sliding images are relentless, indifferent to the pacing and habits of how I look at things granted by my body and history. "Here" and "how" become problematic. "Here I am!" at the point of illusionist privilege is clarified only by "Here I cannot be!" And while I am held straining with the desire to be there, the shadow returns at least six times in the first reel and five times in the fifth, near the end, to remind me of the machine's indifferent usurpation and my floating, other placeness. Yes, we both "want" to take the other's place; we desire the other's sight, and we desire to master that site. But mastery seems improbable.

A different sort of eviction occurs where the image accelerates into coloured smears whirling across the screen (figure 13). When the movements echo each other from each side of the screen, it seems that camera and film become a paintbrush at work, transferring colour, movement by movement. When the movement simply passes in one direction, the rocks become streaks, and the grass and the lichens like rain—rivers of grainy striae in which film material and filmic object converge. I find most of these passages so physically painful that the ten-

sion, especially between the corners of the screen and the moving image, becomes too intense and expels me back to where I am sitting in the dark theatre, beneath the projector's light beam. Thrown out of a "normal" image-spectator relation of following things along, I sit and think about the experience while the images pass by in abstract waves and rivers of colour which no longer trace the narrativizing potential of illusionist space. The process of "following things along" has been transferred from the screen to the theatre where I am sitting, so that if I am outside of one kind of representational relationship, I am still inside another. As the sliding images slow down and details become recognizable, at some point my eyes can follow them and I am jerked back into a more conventional relationship to perspectival space, however weakened by movement, looking for something to happen. So I cannot subscribe to Testa's view that Snow's work distances the spectator by inserting multiple framing devices. The spectator is tossed around in and among them, hardly in control.

Figure 13. *La région centrale* (detail), 1971, 3 hours, colour. Rapid panning changes landscape into flattened, grainy abstraction, "evicting" the viewer from conventional entrainment in slower, near-perspectival passages. Film print VL Custom Photo, Toronto. Courtesy Canadian Film-Makers' Distribution Centre, Toronto.

At the polar opposite to scenes of eviction, there are passages of absorption, although the film sites of their occurrences seem to vary considerably with the spectator. I find particularly absorbing a long, slow passage (about fourteen minutes) at the approximate mid-point of the film (at $1^1/_2$ hours), in the fourth section of the third reel. To the accompaniment of a slow, low electronic pulse tone, the landscape passes by horizontally, upside down, very slowly. Foreground and distant hills take up the upper third of the screen. The sky is cloudy and dark. While the overall landscape passes horizontally, the hills lower across the screen like a window shade. Because the hills do not pass beyond the lower edge of the frame and never reach the upper edge, these tilts give the impression of respecting the screen frame, which then implicitly precedes the movement.

A big boulder descends periodically towards the lower edge like a great tooth (figure 14). Colour, slow speed, and top-heavy composition inspire a heavy, sleepy feeling. Suddenly the sense of looking at an image over there on the screen collapses and I am either looking through the image, or I am the projection plane, or the whole apparatus is inside my skull. The hills are sometimes a great eyelid which is my eyelid, and sometimes a giant's jaw which is also somehow mine. When the hills become more distant, they are a misty illusion on which I chew. The sense of position can suddenly reverse, so that the "eye" or "mouth" on the screen turns to look at or devour me. The result can only be described as monstrous. I no longer read, properly located as the interpreter of codes; instead I consume and am physically, psychically invaded. My sense of self as corporeal constancy has been breached. It has happened: I am suddenly Other, completely unknown and unforeseen.

Signalling the end of this passage, a higher electronic tone alternates with the lower one in series of four, but the sequences are not synchronous with the images' movements. Abruptly, the daylight becomes much lighter and details of the distant landscape, still upside down, become clear. The tilting increases amplitude until it encompasses 180 degrees between pebbles and sky, the nearest and farthest. In a moment I am out of there, returned to a more perspectival space in which I can better orient myself before a scene of pebbles rotating clockwise and counterclockwise.

Figure 14. *La région centrale* (detail), 1971. In absorptive passages, very slow tilts lower and raise the foreground with its rocks as the landscape circles very slowly. Film print VL Custom Photo, Toronto. Courtesy Canadian Film-Makers' Distribution Centre, Toronto.

Mid-way between passages which absorb or evict the spectator are those that grant more conventional orientation. Fifteen minutes into the film, a long passage (about fifteen minutes) of panoramic circling begins, accompanied by beeps in two tones, one in a regular rhythm, the other random. Together they convey "machine vision" which distances me from any possible story. The horizon line is conventionally located two-thirds to three-quarters of the way up the

screen. A nose-scraping close-up of the big boulder, earlier located in the near-middle distance, suggests the zoom function is being used to bring what is closer. The sloping rock ridge in the middle distance repeatedly snakes by, followed by the view carried out over the lake and distant ridges (figure 15). Like painterly perspective, the slow pan secures a spectatorial position of standing on the hill to look at the surrounding view. Although the image is constantly moving, its composition and focus closely resemble the perspectival aspirations that are ground into camera lenses; it centres the spectator before a continuous, focussed space stretching from near to far, and is quickly comprehensible. Just as painted and photographic panoramas constructed the landscape so that it was completely available to a surveying eye, the sweeping landscape of *La région centrale* equalizes what is off-screen with what is framed, so that everywhere is implicitly framed, potentially landscape rather than mute raw nature.

Figure 15. *La région centrale* (detail), 1971. Moderate panning speed across a conventional landscape extending from near foreground through lakes and distant hills centres the viewer before deep, coherent space in a style similar to realist, perspectival landscape painting. Film print VL Custom Photo, Toronto. Courtesy Canadian Film-Makers' Distribution Centre, Toronto.

The image slowly becomes pure sky blue which could be disorienting if it were not punctuated by sun flares that mark rotations of the sky. Nothing escapes, and my orientation is able to reassert itself in a space appropriate for staging human action. Inasmuch as I can, at this speed, search the landscape and compare details, this reasonably stable container of deep space demonstrates its suitability as a privileged site for "reading," discerning differences, and making references. However, given this construction's place in a chain of others which absorb or evict the spectator, it loses its conventional privilege of being natural or truthful. While it becomes simply another mode of spatiotemporal representation, it shows the truth of why it has become a privileged mode: it permits culturally validated legibility and judgement.

However, unlike some forms of painted and photographic panoramas, the filmed landscape disappears at the command of the moving frame and not at the whim of a strolling spectator. The machine shadow repeatedly points to my lack of secure spectatorial place, while other parts of the film are absorptive and still others completely detach me. Consequently, the landscape and my self as spectator are equally subjects of and in the film. So the spectatorial position can hardly be interpreted as a horrified recoil before nature and retreat into a safe enclosure, or as enclosing nature in multiple framing devices, if I am part of that field. The statement and restatement of filmic space, which might refer to the landscape but not necessarily represent it as a stage for human action, triangulates the space of *La région centrale* between spectator, landscape, and the image-machine rather than "represents" the human-landscape relation. Bart Testa argues that the machine-driven camera distances spectator from the landscape spectacle by pushing the viewer back "into the enclosure of the stabilized screen, on the viewer's side of the image," a strategy which places the viewer in a (safe) enclosure and which falls within the tradition of Canadian landscape painting.[55] Giving in too fast, in my opinion, to Frye's, Elder's, and McGregor's discourse, Testa concludes that as intervention by image-machine holds the viewer in a stable position on the viewer's side of the image, the triangulation reproduces "the primal Canadian experience: the encounter with a hostile, alien landscape and a recoiling human presence." The image-machine "can reconcile the co-presence of the human and the natural in the work of art (Snow's beautiful), if only tragically, because, finally, 'it just goes on without us.'"[56] So, while the image-machine, or technology, dominates the triangle, it "saves" human subjectivity from nature by wrapping both in representation: a kindly dominatrix. Following this interpretation, the effect and even task of *La région centrale* must be tragic consolation.

However, Testa seems to have followed most preceding critics in disavowing the resistance, entrainment, or absorption of his own embodied perception when given the task of this field. Like others, he has failed to question whether the exuberant, shifty field of *La région centrale* might be parodic. Panoramic panning in the first section of the first reel is followed in the second section by circling around the lens axis, causing the landscape to somersault around the screen perimeter and a central blue vortex of sky (colour plate 3). After the machine shadow passes by for the fifth time in the first reel (by my count), its arms rapidly turning, the panoramic pans are repeated with the landscape upside down, followed by a large repertory of image movements. Finally, about an hour into the film, the panorama is rotated ninety degrees to the vertical, so that the horizon is congruent with the passage of film through a camera and projector rather than following the surveying human eye (figure 16). Taken together, the proliferating somersaults of the series undercuts high seriousness

while destroying the privileged panorama of the human surveyor, with an exuberant visual "Look, Ma, no hands!" It's a parody of the panorama. As such, *La région centrale* resists critical reduction to the tragic site of the originating clash between Canadian artistic sensibility with insensate nature.

Figure 16. *La région centrale* (detail), 1971. Landscape orientation, film strip direction, and camera movement converge. Film print VL Custom Photo, Toronto. Courtesy Canadian Film-Makers' Distribution Centre, Toronto.

Coincident with image movement which leads to a problem of place, the primary object of manipulation in *La région centrale* is the temporality of viewing. The visual regimes which I have picked out in the film—absorption, eviction, perspectival placing (and there may be others)—suggest that the question of my self can be addressed through an analysis of their temporality without abandoning embodied perception or submitting to tragic reconciliation. Since I search the moving images for what has passed before, it seems sensible to suppose that I search for clues to memory and anticipation, for references to time beyond the present moment which can orient me towards both past and future but which also, in the data of sliding images, exert a voyeuristic pull.

Recurring items other than the landscape include the X, patterns of speed and direction, the range of electronic tones, and some of the pulse patterns. Movements such as the speeding abstract sections, the beautiful vortical rotations around the axis of the lens, upside down and right side up horizontal pans, slow tilts, and giant vertical rotations also become recognizable. Recurring items in the represented landscape include the big boulder, the lake, the low rock ridge, the shadow of the machine, the sky, distant hills, and the loosely circular group of pebbles.

Recurring landscape features like these do not orient the direction of the camera or the film's editing into units of significance. Rather, their relation to the cinematic image is indifferent. Nor is there any intrinsic connection between shots. Testa points out that while the shot/reverse shot of film dialogue has been called the basic unit of film language, it is not a rule that governs mean-

ing. In conventional montage, where breaks between shots are minimized with the aim of constructing units of significance rather than representing real space-time, there is still no overall organizing grammar that corresponds to sentence structure. Nor is there an overall rule that prescribes their order for them to be a meaningful totality.[57] What *La région centrale* expands into yet another huge joke on its title is that it is constructed entirely from empty space pans, passages of the type that are usually omitted from conventional narrative montage. Consequently, while the film substitutes signifiers for things, there is no secure system of differences on the syntagmatic plane of the sort described by Derrida as *différance* and which are discussed sometimes in connection with Snow's films including *La région centrale*.[58] Unlike a suspense narrative or Snow's previous film, *Wavelength*, which eventually flattens its initial space, there is no sense of progress towards an ending because *La région centrale* lacks a determinable space or shape or movement to consume.

To make a film from the type and ordering of shots dropped from most narrative films tests the significance of pure temporality, or movement plus iteration (another kind of time), for my self. The notion that cycles of types of landscape movement and the repeated appearance of recognizable objects across the screen can provide the basis for constructing a meaningful "world" is projected as possible, even while questionable. To be clear, whatever returns, or is iterated in the images or their movements might be recognizable but it is *unpredictable*. The only thing that organizes or connects beyond the recurring X, the movements, and the landscape features is *my* reception. While my argument might seem to finally support Elder's notion of a transcendental subject, Elder's subject is external to the film and disembodied, paradoxically observing from outside of itself while not subject to experience.[59] My argument relies on the demonstration that I, as a viewer, am being worked over inside the field of figuration. Therefore, it is neither surprising nor paradoxical that my search, memory, and anticipation are called upon to figure connections, and that this involvement entails not being able to separate the reader-figure from the field. This is where "what?" slides into "who?" It is a question of selfhood opened by the film experience that can be discussed by returning to Ricoeur's analyses of the subject through temporality.

Within the field of *La région centrale*, different regimes of visual reception become recognizable (e.g., eviction, absorption, and near-perspectival positioning). These can be divided into two modes of persistence in time. The first mode can be subdivided into two categories: continuous persistence and intermittent or recurring persistence. When a quality or object is continuously persistent in time it can be understood as a constant—self-identical with itself and already there. In this case, the continuity of the film strip, one frame after another, then one take after another, demonstrates the film strip and its reception of light as

constant and already there. Continuity of the film strip is parallelled by the continuous movement of the camera, so that the apparatus makes itself evident as already and continuously there in passing. Since the relentless movement equalizes what is off-screen with what is momentarily visible, the land out there also becomes visible as a continuous and pre-existing constant. Land and mediating device come together as landscape-in-motion (not land in motion), the continuously persistent substrate, the same to itself even though it is already a recombinant. Included in the field as the "who? where?" questioned by landscape, "I" am also already there, continuously present wherever there is landscape. Whereas wilderness might just go on without us, landscape cannot.

The second category of persistence in time includes the recurring inventory of items and events which disappear and return for *me*, co-present with landscape. In the context of identity or self-recognition, this set of distinctive marks of appearance or traits of temperament permit identification and reidentification of a person as being the same—what Ricoeur called character.[60] The correlate on the part of the spectator is where cognition becomes recognition. According to Ricoeur, the intermittent recurrence of what is identifiably the same is supplemental to the mode of continuous persistence, so that character joins the category of substance, or nature.[61] Now, clearly landscape is tied to nature through the substance of terrain, just as I am tied to nature through the fleshly substance of my body. So, overturning Heidegger, Frye, and his legacy in Canadian discourse on nature, through Ricoeur my analysis of *La région centrale* finds human character, with the capacity for recognition, as part of nature and not in recoil from it.

In *La région centrale*, incessant movement and a chain of visual regimes figuring wilderness-landscape, accompanied by synchronous and asynchronous beeps, are characteristic. My capacity and desire to recognize them is likewise a characteristic of my self as one who recognizes recurrences and tries to make sense out of them. While I might do other things than watch this film, my capacity to recognize and search for meaning is a persistent habit and desire. Skills for reading and analyzing text, visual art, social situations, and the natural world are crucial to my social survival and acceptance in the many contexts of my life. In a Ricoeur-like way, *La région centrale* reveals that in the forest-landscape as signs—and spun through the visual regimes of the film—I come to myself through an Other and others. Unfortunately, how others remember and anticipate my character almost certainly does not coincide with my self-conception, so that my character is contingent upon the beholder and somewhat messy. Consequently, a claim to authentic characteristics or a true self-identity based on character is tenuous at best.

Given these paradoxically external origins of self-recognition, we must revisit Ricoeur's second mode of persistence which plays an equal part in constituting the self, the capacity to give one's word. Ricoeur argues that when I

answer "Here I am!" I am not simply describing my place, I promise to keep my word in defiance of time.[62] While my answer "Here!" comes from inside myself, it is related to you and can challenge and destabilize the history of character traits accumulated from outside or which are determined biologically. Ricoeur understood the promise as an act of self-designation.[63]

In the swing between passages of eviction and absorption in *La région centrale*, how to answer "Where am I?" (or "Where are you?") is problematic. I can answer the question easily when evicted into the theatre in what I recognize as a self-reflective mode. With some learning (re-cognition) during the film I can also answer "Here!" by temporarily centring myself before deep space during passages of near-perspectival positioning. However, when the great eye or jaw invades my skull, or looks at me from inside-outside, I can neither answer the question nor maintain my certainty about "here" even in the two more objective visual modes. In this context, the more objective modes show themselves as just an illusion also figured by and in the field. They acquire their significance only in relation to the difficulties and uncertainties of absorption. They are actually part of the absorptive field, rather than outside of it. Certainty of the claim that my position in the theatre is objectively outside of the field of the film has been destabilized. Yet, with certainty I answer "Here!" no matter where it is. I am at least in this reflective, analytical mode, so that the question of my self becomes, as Ricoeur inquires, "Who am I, so inconstant, that *notwithstanding* you count on me?"[64] The conflict between my characteristics which others have observed and relied upon, and keeping my word, places my identity in perpetual crisis. On the positive side, the crisis makes my self ethically available to an other who needs me, so that ethics become included in the problem of my self.

The episodes of absorption in *La région centrale* evict me from the nearly perspectival passages as much as the speeding sections do, but not self-reflectively into the theatre. Rather than finding my self remembering, rationalizing, and synthesizing my experiences into anticipation of what might come, I am totally displaced sideways to an other whom I cannot see and have not imagined. The tones and patterns of electronic beeps of the film indicate no fundamental difference from what has passed before; they simply persist in or somewhat out of synchrony with image direction and speed. Elements of the passing landscape are likewise familiar. While the mesmerizing absorption is doubtless helped by my isolation in a dark room, I can even talk with others present while remaining mesmerized. I do not choose this other, it simply grasps me in an unforeseeable embrace, because this is not a memory. Since it is contingent upon a set of external conditions that persistently engage my physical perception from outside, it cannot be called a fantasy or reverie, either. I cannot call it pleasurable: to be other of the shifty ground of *La région centrale* is disorienting and somewhat nauseating. In effect, I become monstrous, as though responding to

a secret injunction, "Be (other)!" Now, you and I are adults who already can rep-
resent fantasies. You and I who can represent things must be presupposed.
There is identification, which cannot be named but which points beyond to an
injunction, "Be!" Be the other who gives birth to me, not as you over there, but
as a structure of affects.

Connecting the two sides of selfhood, character and the self of the prom-
ise, is the task for what Ricoeur called "narrative identity." This emphatically
does not refer to the imposition of smooth narration on my story, but "a dialec-
tic of ownership and of dispossession, of care and of carefreeness, of self-affir-
mation and self-effacement," because the self is always held open by the con-
flict between characteristics internalized through identification and the
capacity for identification, and the self who responds with that self-challenging
promise: "Who am I, so inconstant, that notwithstanding you can count on
me?"[65] This conflict takes into account the temporality of early identifications
and the capacity for identity itself to be in conflict with the adult self who
already circulates self-understanding through representation. It gives my self as
open, precarious, shifty—all of which, I argue, parallels events occurring
between *La région centrale* and my self.

Because *La région centrale* concatenates different visual modes ranging from
monstrous absorption to cool self-reflection, and each more than once, a viewer
is not seduced or coerced into a particular position over the length of the film.
Each mode acts as a distancing mechanism for the next or previous one.
Because these events may have a different effect on different people, or on the
same person at different times, it is not possible to say how I will figure my self
each time, especially as one episode bleeds into the next and retroactively mod-
ifies the effect of previous episodes. The film's effect is cumulative and can
change with experience, which gives my self to myself as historical. Given a his-
tory of viewing and effect, given its different modes, arrangements, and pacings,
given that it approaches "who?" from different shots, the film's spectator, or my
self, is given a chance, even given to some extent as chance: open to the contest
between blind, mimetic identification and promising to an other. So, *La région
centrale* presents a dialectic between having my place and placelessness which are
modes of continuous presence in time contested by mimetic absorption and the
less secure, maybe even false promise of "Here!" Just beyond my capacity to
remain in place, the film calls upon my capacity to identify blindly.

At the other end of the spectrum, my placelessness is traded for a self-reflec-
tive place in the theatre. Exceeded or placed through the capacities of my body,
La région centrale does not ask that I cross the threshold of pain that signifies
turning away from what links me to the animal and nature in disgust. On the
contrary, using the category of empty space pans, the film passes through tem-
poralities of identification and self-reflection, and of places in between, reveal-

ing the substrate of continuous landscape-machine as the correlate of the substrate of my fleshly body, which meet in nature. Consequently, for Michael Snow, nature does not "just go on without us" and our relationship to it is not tragic. *La région centrale* redefines the relationship between the machine and technology as figured by film, and my self. My self includes and responds as identificatory (but not a particular identification), and as ground held open to the promise of new sights. Redemption by *La région centrale* always holds open the dangerous pleasure of re-sighting my self as more, with proliferating returns.

VISUAL AIDS: RE-SIGHTINGS THROUGH SCULPTURE AND PHOTOGRAPHY

After completing the film, Snow continued to pun on the field of nature relayed through photography. This practice is associated with some sculptures which mediate elusive, wry meditations on the relational transformations of the viewer that happen when she or he looks at a screen or pictures on the wall.

Monocular Abyss (1982) memorializes in "cement" (painted resin) the idealized model of the visual cone as a hollow monument set on the ground.[66] At first glance it seems a lament for the loss of my binocular, embodied sight to the ideal of seeing truthfully. However, stooping over to look through the eyepiece reveals nothing; or better, it reveals the nothingness and self-denial of a disembodied mode of seeing. What is revealed, since everyone including myself stops to look into this void, is that we are universally pulled by desire to see through the hole, to find something hidden there and a projected, fictive world. The possibilities for voyeurism and fiction compound each other. However, the seriousness of this abyss is undercut, almost literally, by the shape of the field cast on the floor. Rather than the symmetrical rectangle of illusion and rectitude belonging to perspective, the field has been distorted to a triangle: for one eye, half a field, and my fleshly sight, the body of my self, is redeemed with laughter.

Sighting (1982; figure 17) is a wall relief of square aluminum tubing which again reconfigures relations along sight lines between my self as spectator and the traditional rectangular surface of perspectival painting or photography.[67] Like a window in a wall, it awaits my arrival. While *Monocular Abyss* satirizes the re-configuration of sight through monocular perspective, *Sighting* takes a look at rectangular fields. Unlike *Monocular Abyss*, *Sighting* has rectangular, binocular eye pieces. It foresees a real person with stereoscopic vision *but* submitted nonetheless to the rectangular apertures for sight and field of view offered by cameras and photography. *Sighting* suggests how looking at pictures and photographs, and how they sight me, is always a tussle. As I pass by, pictures snag my sidelong glance. They try to slow me down and centre my ambulatory, binocular body before them, perhaps seducing me with a monocular sight that appeals to pleasure and mind. Waiting for me to pass by, the binocular eyepieces of

Sighting strain beyond the model for straight-on viewing because they are offset to one side, watching for me, which distorts them into trapezoids and similarly distorts the field of view. In one sense they yield a crooked view; no sight of the truth here. On the other, through distortion and binocularity, this sculpture has paid the price to redeem my self from the contract holder of unseen representational conventions.

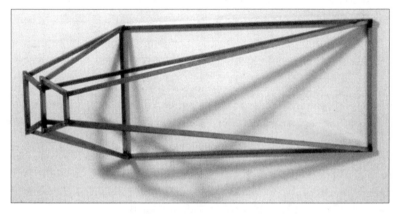

Figure 17. *Sighting*, 1982. Aluminum, 38.5 x 102.0 x 32.5 cm. Art Gallery of Ontario, Toronto; gift of Michael Snow 2001. Photo courtesy Michael Snow.

Another piece that investigates transactions between my embodied self and the image-machine is *Zone* (1982).[68] With its extreme dimensions, *Zone* has the immediate appearance of exploring measurement and censorship of my sight. It is a wedge-shaped Plexiglas frame mounted at someone's eye level on the wall and measures somebody's binocular peripheral vision. The visual field has been reduced vertically to the thickness of the narrow eye-piece, perhaps to the size of some average eyeball or its function. Like *Sighting*, *Zone* foresees a real body, but demands that I submit to it as a standardizing device. So, how is any one of these "mine?" I read them in reverse, as securing attachment, ironically or not, to my embodied perception and setting me at risk. While their initial attraction might be that of a game, these framing vehicles compound the solicitation of voyeurism. Already fitted to my desire to look through, the sculptures test the physical fit between me and the image machine. Each work exerts a power which takes precedence: I attempt to accommodate it, setting myself up to be more malleable than aluminum tubing, Plexiglas, or resin. Since none of them fits, I must conclude that all of them were made to fit another body, or no body at all but rather a norm, but I cannot discern which. Whatever the case, I find my embodied self by judging it against traces of an hypothesized Other, as not-I but as a possible unit. As a consequence, the solicitation of viewing opens me unknowingly to uncertainties rather than mastery before the gaze of the meas-

uring, judging, standardizing Other; I am Heidegger's grasper foreseen and re-presented, but self-dispossessed. However, Snow's practice returns the measure of my self back safely and laughingly cloaked in irony.

Given their association in Snow's production with *La région centrale*, is there anything about these pieces (*Zone, Sighting, Monocular Abyss*) that suggests fear or threat in the face of nature—the wilderness reclaimed for and with myself through the film? As a group they play with the historical disembodiment imposed by restructuring vision, which suggests that understanding embodied seeing as dangerous is propelled by fear of the animal, or nature. Voyeurism—an instinctual desire to see prey or the forbidden while remaining unseen—haunts visual practices and products like perspective, photography, holograms, and visual devices such as stereoscopes. The power of such visual interventions aug-ments their voyeuristic seduction, but they remove the potential embodied dan-ger of being found on the same turf. Snow arguably clarified this point in *Crouch, Leap, Land* (1970), which consists of three photographs of a female nude model taken from below a sheet of Plexiglas.[69] They are installed on horizontally positioned sheets of Plexiglas so that I have to lie down on the floor below them to see them. The first print shows the model in a crouch position from below; the sight is nauseatingly in-your-face. The second catches the feet and legs of the model in midair, disappearing upwards towards an indistinct torso. The third print of the model landing shows her feet sharply outlined on the Plexiglas with an indistinct torso above. The format of *Crouch, Leap, Land* absolutely requires that I re-cite the artist's position as photographer and that my self, artist, and model together submit to the demands of equipment and the disappearance of Heidegger's enframing. But we're also re-enacting Freud's model for scopophilia or voyeurism (based on pure speculation on what a little boy saw when his mother lifted her skirts (i.e., Freud's personal fantasies). The series recalls Baroque ceiling paintings as well as Eadweard Muybridge's photography of sub-jects in motion, questioning the pretence of neutrality of the scientific photo-graph.[70] Whether photograph or painting, for reasons of science, religion, or an art practice questioning sight, all we are left with is the trace of what the artist saw, or imagined, not the sight. This is what a heterosexual Western man sup-posedly wants to see through the power and disembodiment of monocular per-spective. While remaining unseen, out of the picture, he saves himself from the mortality and vulnerability of his body, and reasserts the power of the eye-mind. Meanwhile the trace of the animal in the represented body of the model, of my body on the floor, and the trace in the pictures of an imagined Snow's body and sight here before me, are all flesh like me. Temporally, and in one case, in terms of gender, they are completely other than me, and all of this is brought into the picture. Here I am, I cannot be otherwise, and it is distinctly uncomfortable and mortal. Giving it another shot, however, so blatant is the use of the gaze that

Crouch, Leap, Land is arguably satirical and reverses into laughter, which returns me from the gaze but not from my mortality.

The problem of my self in nature and representation and the potential violence of visual reduction, the whole as lure, are further parodied in *Press* (figure 7), discussed earlier, and *Shutter Bugs* (1973-74).[71] The latter mounts behind Plexiglas a photograph of a car windshield surrounded by thirteen circular enlargements of unlucky bugs splattered in abstract patterns on the windshield in vivid, glowing colour. A line connects each enlarged bug-splash with its place on the windscreen. It's a crime scene and a record of the conquest of the Canadian north woods by car. As the crime's author and master shutter bug irresistibly drawn into this murderous scene (who drove the car and took the shots), Snow and his camera are hazily reflected in the windshield, just as he appears at the back of the picture in *Press* and *Authorization* (figure 10). In *Michael Snow/A Survey*, Snow juxtaposed *Shutter Bugs* with a snapshot of roadside woods seen through a distorting veil of rain streaming down a windshield, suggesting how everyday drivers no less than photographers are constrained to always see from inside and through a mediating vehicle; it dominates and re-configures the field and keeps us from getting figuratively splattered. However, when the snapshot of the rainy windshield is considered next to *Snow Storm, February 7, 1967* (1967), in which three scales of framing redundantly frame views of a city street seen through a heavy snow storm, it looks as though nature provides its own veil which is then compounded by the artifice of framing.[72] This constellation of work seems to support Testa's and Elder's rather pessimistic conclusion that, according to Snow's work, we can only contact nature or the real enclosed in representational vehicles which distance and distort but shelter us.[73]

Or do they? The veil of seductive substantial nature includes my embodied, fleshly self. As Snow's reflections in *Press*, *Shutter Bugs*, and other pieces show, the artifices of viewing are built for my body to see and stage my self. Each work reframes the encounter between object, image machine, and spectator. Like bees drawn to the frame, as in *Bees Behaving on Blue* (1979; a colour photograph of dead wasps framing and enframed by a field of celestial blue watercolour), the encounter results in apparent death.[74] This might imply a hostile nature that representation dominates through death by still life, but irony overturns the proposition of malevolent nature. The crime of the squished bugs, the frame of dead wasps, the squashed fish and matted noodles in *Press* (figure 7), the distorted eyepieces of *Sighting* (figure 17), and the parodic monument of *Monocular Abyss* are all laughable and reverse the claim of hostility by the wildlife. Because of this reversal it could be argued either way that they support an interpretation of retreat behind multiple framing devices while magnifying the allure of the dangerous and forbidden. However, what "kills" is the mix of voyeurism, solicitation, and domination enabled by the machine rather than its represented

object. Drawn by an uncertain mixture of curiosity and allure, I was looking for a pictorial version of a killing, and so was "Snow." But the frame, my love, opens taking chances, as discovered through *Portrait* (figure 5). Each of us got caught, and saved, as a cheeky display.

PLAYING THE FIELD

Field (1973-74; figure 18) is another site which Snow transferred from nature to the field of representation; it names what becomes problematic through the title: what field, whose, for whom?[75] It is constructed in the most objective of styles, a grid of nine rows by eleven columns of ninety-nine small black and white photograms of wild flowers, arranged above two large photographic prints of a field, making a total of 101. Both small and large prints are negative and positive pairs. Due to the odd number of columns, one of a pair is left at alternating ends of each row, the other picked up at the opposite end of the following row, with one exception (in the upper right corner). Like a poetic text regulated by paired rhyming, a well-composed pattern of reading pairs from row to row can be followed.

In its deadpan objectivity and descriptive title, *Field* recalls Joseph Kosuth's *One and Three Chairs* (1965; Museum of Modern Art, New York), a frequently cited example of the intersection of photographic mediation with language, and of the question of art. *One and Three Chairs* presents simultaneously a wooden chair, a photograph of it, the dictionary definition of "chair," and implicitly the question of the whole as a work of art. Both *One and Three Chairs* and *Field* engage the processes of abstraction and transfer from private multi-sensorial fields of perception and memory to collective, coded systems of signs. The switch from object to sign questions whether all seeing is actually reading. Both works juxtapose purely descriptive titles with photographic images and question whether object and word are adequate descriptions of each other, and whether one takes precedence, the object or word. *One and Three Chairs* gives the viewer the most utilitarian of displays which permits only the smallest emotional investment. Aesthetic apprehension has been removed from the game. I am first coerced as a member of social institutions (a speaking and gallery-supporting public) to venture into representation as the necessary link between representation and its object; that is, this is a chair, and these are types of representations, but can the chair and its representations be linked by convention without its collective understanding reproduced by you? Second, I am asked for judgements: are these terms adequate translations of each other? And if art is representation, *and* if we agree that art questions conventions of representation, then is this (*One and Three Chairs*) adequate as art? If art objects like *One and Three Chairs* are both numerable commodities and signifiers, then boundaries separating art

object from utilitarian object, object from representation, and word from image must be dangerously fluid. Much as Duchamp did with his readymades, Kosuth subjects the viewer to performing police work on conventions, and conventions articulate the precedent presence of an agreed-upon or regulatory idea. What emerges is a subject (you or me) as the coerced respondent to the injunction "Judge!" "Here I am," however, not the one who loves or is there for you, but who must make logical judgements or cause-and-effect distinctions about language and reference as well as about art. The model of truth at stake is conformity to norm or fact, not the truth of Being or the self there for you.

Figure 18. *Field*, 1973-74. Gelatin silver prints mounted on cardboard, in painted wood frame, 179.1 x 170.2 cm. National Gallery of Canada, Ottawa. Purchased 1974. Photo courtesy Michael Snow.

To think about the relationship between visual representation, language, and self, let's look at another of Benjamin's theories about language. In 1916, long before he wrote on the empty gestures of Kafka's actors in the Nature Theatre, Benjamin re-examined the Biblical act of naming, arguing that names were not purely arbitrary but were evidence of the immanence of the divine in human mental being and in all creation. In paradise, he mused, the animals stepped forth in the silence of their divine signs to receive their human names. In the beginning, divine name and object were transparent, and were communicable to human being as signs.[76] From human beings things received their names:

> Man communicates himself to God through name, which he
> gives to nature...and to nature he gives names according to the
> communication that he receives from her....All higher language
> is a translation of those lower, until in ultimate clarity the word
> of God unfolds, which is the unity of this movement made up of
> language.[77]

Benjamin casts the Fall in linguistic terms: words are no longer coincident with the mute signs of the creative Word because, with Eve's experiment, humans gained knowledge of what God had *not* named: good and evil. What really bothered Benjamin was that animals and other organisms lost their communicability after the Fall: "speechlessness: that is the great sorrow of nature (and for the sake of *her* redemption the life and language of man—not only, as is supposed, of the poet—are in nature)."[78] So Benjamin is arguing that what needs redemption is nature, not human beings on their own, and for the sake of nature's recovery of communicability the everyday speech and culture of human beings needs to re-find its place continuous with nature, rather than separated by insistence that language distinguishes humankind from nature.

As an extension of this theory, Benjamin understood that judgement is necessary only in the world of the fallen, where universal communicability has failed. Representation in a redeemed world needs no judgements as to its truth or adequacy, because it communicates human mental being with others, without question, as the above quote indicates. The forms of representation that Kosuth used (object, straight photography, dictionary definition, title) allow discussion of the representations or objects in terms of themselves, by comparison, and perhaps other categories, which leave the viewer safely in his objective, external position. By calling on you or me to judge whether these representations are equivalent and whether this work in a gallery is art, *One and Three Chairs* undermines any claim for transparency of the sign and its logic, or a natural language, implicitly calling Benjamin's contention that signs are not arbitrary and that contemporary art is something other than a matter for judgement an impossible and nostalgic dream.

Although as simply and straightforwardly presented as Kosuth's piece, *Field* turns out to be a wilder proposition. If I look closely, I see that the plants refigured in *Field* are recognizably unauthorized, wild colonizers of abandoned agricultural fields. Nature appears as a weed field rather than a garden—weeds are by definition invaders or escape artists, plants of the wrong name, out of bounds. The photograms, direct indices of light on light-sensitive paper, double the historical condition of the weed field: just as weeds spring up again and again in abandoned fields, so have "wild" images reappeared through an abandoned technology. Finally, expelled from direct experience into the field of representation, *Field* is also a visual-verbal pun, another escape artist which leaps

out of bounds across mediums, and out of high modernist discourse. *Field* not only displaces the field of flowers which it pictured; it also puns on the security of its own reference (it's a wild field) which in turn threatens its sign function and the value of its real-world reference. "This" is not "that."

Although *Field*, like *One and Three Chairs*, supports argument that the seen must be legible to enter human discourse, the pun both highlights and destabilizes the divide between reading and seeing, the authorized and the unauthorized, discursive and the non-discursive, and the visual and verbal. So, unlike looking at *One and Three Chairs*, while roving the *Field* something disruptive overflows. *Field* enjoins more than police work on conventions, more than a change in reception from the seen to the read and from individual to collective; it figures a traffic between them which improperly disfigures or unravels my site in my sight. The piece is funny and I get pleasure from this play which draws me into a closer look.

The images on the small prints are fragmentary, indistinct, neither well-focussed nor well-composed. The photograms on a virtual "field" of paper have life-sized recorded images. They are not reduced in scale, structured in clear planes or focussed around a central point. Some of their backgrounds seem very deep, while shapes that seem close to the surface are knife-edge sharp. They were obtained by scattering bits of light-sensitive paper in a field. Snow's method recalls how Man Ray and László Moholy-Nagy, in the early twentieth century, used photograms as a natural process of abstraction and invention, a correlate of Kafka's mimetic empty gestures. Exposed "naked," without the mediation of a lens or other directives on how to read, the papers have perhaps looked sideways at the field, chanced just a roving glance. I should honour them as a true report, but what they report arrives badly focussed, ill-composed, and unregulated. How can I verify the photograms' "truth" about the field, and is the field already the one referred to over there with flowers or that held between the photograms? Because of the haphazard sampling process and the patchwork of photograms, the originating field of this representation can never be seen as a whole, only as a mosaic which offers no guarantee of continuity in scale or space. Transferred to the plane of representation, each one of a pair of prints decentres the other as original. They question the priority of the field of flowers and photography's capacity to represent or preserve the original. For me the wild flower field isn't even a memory, so that the prints are the original idea that I have. The so-called referent or "truth" is demoted to the last to arrive on the scene, if at all. This means that the grid, a sign of objectivity and a will-to-order, is deceptive, a false promise, because it conceals the fact that the "real" field has fallen through the cracks. So, I have to admit that the photograms and flowered field arrived in my sight together with no secure prior referent: let's say from an improperly mixed parentage. No doubt they endanger my discursive security.

The large prints, also in positive and negative versions, are an overview of the field taken with a camera. They present a different kind of seeing, the field seen as an abstraction, whole and all at once. A monocular point of view (such as a camera lens), as "argued" in *Sighting* and *Monocular Abyss*, forgets or represses the roving, viewing body. The lens has framed, cut out, and reduced in scale the view as a field regulated by the focal planes and centre-edge effects of lens optics, while the developing and printing processes have translated light into a scale of tones and contrasts. I halt my playful movements in front of the correct viewpoint, the centre staked out by the lens, to ascertain what is really going on. The lens identifies my sight with the intentions of the viewing instrument, this site prescribed by the technological rule-giver, and of the artist who chose this viewpoint for himself and foresaw it for me. From there, the truth of the rule shows itself: the photographed scene documents the sampling procedure of the light-sensitive bits of paper in the grid above and gives a total comprehension that the photograms do not report.

However, at the same time *Field* parodies statistical sampling procedures used by scientists such as recording frequency distributions or presence/absence within a delimited field. Statistical sampling reconstitutes the given as a field of knowledge which can be expanded from the particular to the general without having to take in the whole thing. The same field can be replicated and reconstituted by someone else, later, using the same method and initial conditions. The haphazard disposition of the photogram paper precludes a claim for scientific method at the level of the photograms, but the overview of *Field* structures a scene which supports analysis and insight; it is theoretical. I can reconstruct the hierarchical and temporal processes of sampling, framing, printing, and mounting this field which transfers it to an abstract, two-dimensional, black and white visual field hanging in an art gallery. Here the process is stopped and fixed, and my self continues its reproduction.

But what opportunities for self-understanding are possible when *Field* vies for my attention and understanding between two different modes? Neither altered nor reduced by a monocular lens, the small prints do not offer a mastered scene of the field; they have simply made fragments of it transferrable and mobile. The photograms' small size and fuzziness draw me close: they offer a charged space between the pairs where something more than framing intervenes and attracts. I am drawn towards what cannot be seen, which detailed areas escape, what light effects fade. I sample their scene, moving my body and sight across their surfaces, trying them out, drawn into the space between them where the field disappears. I become their scene, which is my own. This secret of the garden belies the determined factuality of the larger views. I am seduced into movement, into physical as well as imaginative engagement. Moving and playing give pleasure, a field of playful, mobile, libidinous excitement. Relations to the

photograms call upon my binocular and bilateral mobility and play; at each moment they are experimental, chancy, at each moment mine.

The large prints enjoin order: the imposition of composition and discourse on the field. Play is not invited. I step into the place designated and upheld by the institution of more or less secure codes, and from this position I can discuss the work in terms of itself and leave my self out of it. When knowledge is projected from this kind of framing, authority is transferred from experience and storytelling to modelling, recording, and reading, and we have saved ourselves from the disruptive, embodied vision that flirts with us in self-mirroring. The discursive side of *Field* has "murdered" its thing(s): the space of my playful, chancy, libidinous self.

So *Field* has two moments. Standing in front of it or passing by, I must look both ways. If I call upon the large prints as the truth of the field, I must deny my multi-point body and binocular vision to accommodate this singular view. I stand back, just so, to get the right viewpoint. To see the small prints, I must abandon this place and step closer. While the overviews still my body and call forth my critical, analytical faculties which produce this writing, the pleasure of the others and of playing between them disrupts equivalence of reading as seeing, thinking as seeing, and implicitly, seeing as saying. I cannot play and analyze at the same time. I cannot decide if one "field" hanging before me is more truthful than the other or even independent of it. One gives me discourse about a process, the other a reflection of myself as part of the wild field of representation.

Earlier I suggested that the photograms transferred an unauthorized glance. Yet, the complementary print made later for each one presents a field expanded only by mirroring, an intimation of an infinite process with no determinable beginning, middle, or end, and no change. From the perspective of the viewer, there is no natural progression or regression to future or prior stage. On one hand I am freed from comprehending the totalizing forms of progress or of an abstract principle but on the other, repeated and positive/negative printing seems to be an anxious and interminable process. At the most concrete level, positive/negative printing gets you more, an excessive return on investing in the record of each image. But is *Field* a case of excessive pleasure or anxiety?

Mieke Bal has argued that mirror anxiety is marked by a desire to maintain discourse and visual mediums separately, which is a symmetrical repression of the discursive in the visual and the visual in the discursive. Binocular or "mirroring" visuality is threatening because it is not discursively satisfying: as a non-narrative, we don't know "what happened next" and don't know the formal rules. It has also been associated psychologically with narcissism. However, Bal argues, collapsing the subjective position of mirroring visuality with the discursive position of objective observation, or suppressing the former by the latter, is what is truly regressive.[79] To deny the possibility of passage from one to the other is to deny

the critical potential of self-reflective images.[80] *Field* shows a possible (but unverifiable) connection between the photographs and photograms as two ways of recording information about the same objects, in which the "I" offered remains obdurately double. "I" cannot "have," or "be" around one set of figures without the other. "Having" is dependent on "being" which remains as a subversive questioning of its finality. In keeping them apart but together, *Field* rejects the safety and authority of the subject position offered by a field of mastery. Because the field of *Field* is split between binocular and monocular viewing, the subject position is suspended between them, preventing either a discursive or regressive collapse of one into the other. But there is more. *Field* is a pun which, like nonmonocular viewing, appeals to a transgressive sense of exceeding categories. The rational, discursive body brought to stillness before the photographic prints is dared to overflow, step out of bounds, unfigurable and incalculable.

"See You Later (Au Revoir),"[1]

With Love

The photographic installation *Plus tard* (1977; figures 19-20; colour plate 4) and photographic diptych *iris-IRIS* (1979; cover) solicit me to speculate on the circulation of pictures and spectators through the frame, the "sending machine," and its different kinds of sites such as museums, exhibitions, art sales, catalogues, books, and postcards.[2] Today's commercialized media has realized Heidegger's worst fears regarding enframing by ably demonstrating its capacity to mobilize and consume every element in the representational field as standing-reserve. Continuing the strategy of the *Walking Woman* series, *Plus tard* and *iris-IRIS* work inside the frame of representation on the initial premise that nothing escapes the "sending machine"—there is no "outside." Consequently, the self is mobilized or de-centred inside the frame from an insider's point of view, as in *Portrait* (figure 5) and *Scope* (figures 8 and 9). Snow's manipulations of the distortion inherent in translations between mediums ironically question faith in any certainty to be gained from representation secured through technological media, no matter how precise the instrument. As is the case of written or spoken languages, translations between visual mediums are never complete; resolution or precision is lost. But rather than lamenting the dissolution of certainty in objective images, or composing apocalyptic visions about a crisis of the real, Snow just keeps on mediating uncertainty, the appearance of chancy translations, one after another. So, returning to Eliade, the promise of figuring redemption, of

Notes to chapter 6 are on pp. 187-89.

squaring accounts to fulfil a promise on a loan or to restore the prior order, may be a fool's errand. If so, then what is the return on relentlessly figuring its pursuit? Better yet, what might redemption be?

Plus tard is a sequence of twenty-five colour photographs mounted on the four walls of a room (figure 19). The photographs, of varying sizes, are suspended between layers of Plexiglas and surrounded by uniform, broad, black frames. The installation frames me presently inside this room while the photographs reframe the room in the old National Gallery of Canada where the collection of landscape paintings by the Group of Seven used to hang. In an ironic parody of painting, the camera lens was moved during exposure to mimic the artists' movements recorded by the paintings' layered, gestural impasto. Much like a paintbrush, this process dragged colours and contours, shifting the registration and creating ghost images. The abstraction of photography appears, just as painting abstracts its object. While the impasto of the paintings designates "this painting" for each one, the dragging of photographic registration blends paintings and walls to "paint" a group portrait of the Group of Seven paintings in their enframing institution. As a panorama of the room broken up into sections, some prints frame a single painting nearly in focus (colour plate 4), while others include two or three paintings. The camera is rather indifferent to each painting as an individual. Some paintings are cropped by the edge of the print, while others are smeared into contiguity with the supporting and adjacent wall (figure 20).

Figure 19. *Plus tard* (installation), 1977. Installation at Musée d'art contemporain de Montréal. Twenty-five C-prints, painted wood frames, Plexiglas, 86.4 x 107.2 cm each. National Gallery of Canada, Ottawa. Purchased in 1977. Photo courtesy Michael Snow.

Figure 20. *Plus tard* (detail), 1977. Small, underfit print of paintings, "ghosts" of frames, and corner of gallery in former building of the National Gallery of Canada, Ottawa. C-print, painted wood frame, Plexiglas, 86 x 107.2 cm (framed). National Gallery of Canada, Ottawa. Photo courtesy Michael Snow.

The camera's indifference to the paintings as individual objects makes their room, with its doorways, exit signs, lighting, walls, and corners as much the subject of the photographs as the paintings (figure 20). In a visual pun on the pictorial convention that objects get smaller in receding space, photographed paintings hanging closest to the camera nearly fill the frame, while photographs taken of the far corners of the room include more paintings and more of the room. Even the actual prints of distant corners are smaller than those of closer walls. Since the smaller prints do not fill their large, black frames, the museum wall gets inside the frame in a confusion of institutional reality and work. The inclusion of the museum wall inside *Plus tard* emphasizes how the National Gallery of Canada is an equal player in the portrait of Canadian nature which the gallery institutionalized according to a certain interpretation by the Group of Seven, and which the National Gallery continues to recite and circulate. After the Group of Seven and the intervention by the National Gallery and in exhibitions, texts, and education programs (still pursued by the National Gallery, the McMichael Gallery of Canadian Art in Kleinburg, Ontario, the Art Gallery of Ontario, and the Vancouver Art Gallery in British Columbia), nature in Canada was not and still is definitely not just mute substance or brute force.

The injunction to "Be there!" resonates through every level, from National Gallery and Group of Seven artists to *Plus tard* and Michael Snow, and to you and me, who all desire and promise to be there yet again, *plus tard*.

Prior critical reception of *Plus tard* has focussed on the effect worked by transferring images from one medium to another. In 1980 Regina Cornwell argued that by recycling representations as material for new representations, "the paintings cease to be the subject. They are material for a new work....The sequence recalls in fragments the other space where the actual paintings were hung, while at the same time the new presentation and representations are foregrounded. The history of the paintings takes on a new history in another medium with the traces of photographic time in the sequencing of a new work, *Plus tard*."[3] So, the paintings have been transformed into standing-reserve for a new medium and have acquired a new history, that of photographic installation. However, ignoring the subject matter of the paintings unfairly devalues the Canadian context of *Plus tard* and the historical involvement in landscape painting by the National Gallery of Canada. This relationship is unfortunately overlooked by a formalistic critique that the installation, on the face of it, seeks to escape.

Pierre Théberge, present director of the National Gallery of Canada and art historian-critic, described *Plus tard* as an homage to painting taken as an autonomous phenomenon characterized by colour and texture, and as a commentary on the reperception of painting through another medium, but he added that the translation represented and returned the sight of viewers to the gaze of Michael Snow.[4] While his comments take into account Snow's high regard for painting, in this model, the artist puts you and me into his shoes and controls the scene. Théberge's comments return the scene to Snow masterminding a representation of *his* visit, but the changed circumstances of my visit at the present time are ignored. I wonder whether the sightings that count are limited to those by Snow, and who is policing the activity generated between the apparent layers of sightings. As for my self, I feel that this interpretation dispossesses me of my sight and capacity for self-recognition.

Contrary to Cornwell, Théberge emphasizes with good reason that *Plus tard* places priority on the density of the historical discourse launched by the National Gallery of Canada that reconfigured nature painted by the Group of Seven into nationalist landscape. Former gallery director Eric Brown was already collecting Group of Seven paintings for the National Gallery of Canada in 1913.[5] A collection of paintings by the group was selected by the National Gallery to represent Canada at the British Empire Exhibition at Wembley in 1924, the International Exposition at Ghent in 1925, and again at Wembley in 1925, before travelling to the Jeu de Paume in Paris in 1927.[6] Paintings by the group were prominent in the National Gallery of Canada's retrospective, *A Century of Canadian Art*, at the Tate Gallery in London in 1938, and were the

focal point for the 1991 British-organized exhibition at the Barbican Gallery in London, *The True North: Canadian Landscape Painting 1896-1939*.[7] In 1996 the National Gallery again circulated an exhibition of Group of Seven paintings, *The Group of Seven: Art for a Nation*, through Canada. This time fragments of historical criticism were mounted on the walls next to the paintings which, along with the catalogue text, mapped both nationalist aspirations and resistance. However, the overwhelming presence of the paintings served to re-invigorate the myth of Canadian symbolic identification with a certain landscape and style. So Théberge is correct in arguing that *Plus tard* tells us that we can never return to these paintings as individual pieces, but only as already legible in the context of the National Gallery of Canada.

Enframed and regulated as symbolic capital, the Group of Seven paintings in *Plus tard* construct a nature that's *not* visibly regulated by social institutions associated with survey lines, roads, railroads, power lines, mining camps, and dumps, trading posts, aboriginal and fishing settlements, summer cottages, tourist fishing camps, and lodges, all of which preceded the painters and coexisted in their preferred painting locales of the Algoma region, Algonquin Park, and Georgian Bay. It can be argued that a variety of regulatory institutions had already categorized the land as "resource" which simply awaited processing by art. Even Northrop Frye refered to Tom Thomson's role as pictorially digesting territory.[8] Consequently, the paintings' task did not really include wresting freedom from nature by reporting on its "taming." Instead, the landscape was represented through what was understood as rugged technique to be unregulated nature in order to return value as the fictively wild substrate that supported a mythic, nationalist, "northern" identity.[9] *Plus tard* reviews the profits from the museum practice of circulating the paintings to generate augmented returns on symbolic Canadian identity, on contemporary Canadian art, on Michael Snow as exemplary artist—and in cash if possible. The installation was made for the *Michael Snow* retrospective organized by the Musée National d'Art Moderne in Paris in 1977 (fifty years after the Jeu de Paume exhibition), and then circulated between 1977 and 1979 through Rotterdam, Luzern, Bonn, and Munich, returning finally to Montreal.[10] It continues to generate national and personal value: for example, it was shown in the inaugural exhibition for the Power Plant Gallery for Contemporary Art, *Toronto: A Play of History (Jeu d'histoire)* in 1987 and again in *The Michael Snow Project* in 1994.

However, the group's representation of nature as unregulated needs to be questioned. The paintings are anchored firmly in stable, unified surface design. J.E.H. Macdonald's vertiginous *Falls, Montreal River* (1920; Art Gallery of Ontario), for example, is organized around an X formed by its diagonals, with a small quadrilateral of intense blue at the centre. A.Y. Jackson's paradigmatic *Terre Sauvage* (1913; National Gallery of Canada) is built around a rhythmic grid

of horizontal thirds against vertical halves and quarters. While the horizontal bands of rocks and clouds mimic each other in texture, form, and general colour, the two vertical halves of the painting are symmetrical in composition, colour, and subject matter. Many of Lawren S. Harris's paintings, such as *Above Lake Superior* (c.1922) or *Lakes and Mountains* (1927-28; both at Art Gallery of Ontario), are anchored by a large triangular mass resting on a narrow horizontal band across the bottom of the picture plane, echoed by repeated horizontal bands running across the width of the upper half of the picture. These paintings, too, are symmetrically balanced right and left. Some, especially those by Harris, display a symbolic use of iconography and colour worked out to represent the quasi-religious terms of theosophy or transcendentalism. Although elaborated from sketches made on site, often under subfreezing or wet conditions that doubtless made life and art pure misery, the paintings represent Canadian nature as continuous with and reproducing a unifying cosmic order, and *not* unregulated or a threat to human survival.

As paintings resulting from a group painting project sponsored and supported by public and private institutions such as the National Gallery and the Canadian Pacific Railway (which had a tradition of giving landscape artists free passes to the West), and circulated both nationally and internationally by the National Gallery as symbolic of Canada, these paintings symbolize the Canadian state as part of a unified, intelligible, and intelligent natural order. Despite their ragged contours, rugged impasto, and often harsh colours, despite abandoning the niceties of chiaroscuro and other refined academic realist conventions, these paintings are part of a discourse of natural order, natural law, and wilderness as pure, originary, and good. Cosmic unity, Canadian identity, and the Canadian state appear and slide into one another as enlivened form that is inherently lawful and reveals "the truth." If they appear rough or crude, these qualities announce their non-European character and origins, pregnant with potential: a natural resource for art, *technē*, and the politics of identity and nationhood alongside mines and lumber mills. The actual wilderness seems far removed.

Louise Dompierre has made the pertinent argument that to understand *Plus tard* is to understand how the Group of Seven was made to stand for Canada. But while the issue of national identity might have been formerly modelled as a response to a threatening nature, this is a view which non-aboriginal Canadian culture has surpassed.[11] An historical break has occurred: whatever the fearsome experiences of the past, today we see wilderness as fragile and threatened, and we are the cause of its downfall.[12] Dompierre's view provides ground for interpreting *Plus tard* as a description of what is lost in the transfer of images between mediums, and the question of wilderness as a fictive substrate rather than a reality. In *Plus tard* the scale and resolution of the paintings have been sharply reduced and blurred, and the colour has been altered by transfer to film. The

same alterations are compounded whenever *Plus tard* is reproduced elsewhere. There is no standard of verification, nothing to give the scale and experience of the room of paintings, and nothing comparable to wilderness. These considerations provide a basis for taking *Plus tard* as a metaphor for selective forgetting between the layers of multiple viewings and their dispersal in other formats, so that *Plus tard* re-constructs the "reality" of both paintings and wilderness framed by the project of the National Gallery, as questionable. We can only dream of wilderness. Dompierre argues that the issue addressed in *Plus tard*, as in much of Snow's other work of the 1970s, is individual and social disconnection from reality.[13] She finds that "by first casting doubt on the ability of the camera to represent the Real, Snow soon displaced the Real with the image, acknowledging the difficulty of knowing reality. This was to lead to considerations of the Real as a multifaceted entity, a thought that eventually resulted in acknowledgement of the fact that reality could not be represented or, at least, that the Real existed in a zone other than in its representation."[14] The tone of the text becomes elegiac: "We find ourselves within a[n] ever-evanescent world, and one that is increasingly difficult to hold on to."[15] Taking her analysis together with my description above of *Plus tard*, it is possible to hypothesize that Snow's belated take on the Group of Seven installation has destabilized the notion of wilderness to the point of revealing its textual origin, which leads to several sub-questions. Most simply, wilderness seems to be an attitude towards territory imagined to be organized in a certain way. But the fundamental question is whether it is reality that is slipping out of focus, or our traditional Western conviction that representation can and should reveal the truth, whole and clear. Should we be lamenting the loss of reality or our attachment to a shopworn metaphysic?

To explore these questions, let's turn to Walter Benjamin for a moment. Writing during the same time period as much of the production and pre-World War II European circulation of the Group of Seven paintings, Benjamin maintained that film (I am including photography) brings what seems mysterious or distant close to us. It strips the original (be it nature or sacred icon) of its aura, the mysterious authority of the unique and original, which are core terms in the discourse of authenticity and which fascist interests were appropriating only too easily.[16] Inasmuch as the authority to decipher texts or artifacts of origin has always been used by an elite to its advantage, Benjamin argued that the particular properties of film-based arts could be used politically to counteract the elitism of interpreting the unique or the mysterious.[17] The technique of *Plus tard*, rather than stripping its objects of aura, has veiled the paintings with blurry traces, so that the photographs have become pregnant with potential. The aura of the paintings has compounded rather than disappeared; in fact, it has absorbed photography into its embrace of uniqueness. But what about "wilderness?"

Plus tard suggests that it has no direct line to its referent, the rugged wilderness which has been made symbolic of Canada, because the paintings' construction and institutionalization are not independent of interests vested in that symbolism, whether of the artists or the National Gallery. Wilderness is under scrutiny as an interpretation and as a symbol—not as a reality. *Plus tard* opens on the inseparable bond between the paintings and the National Gallery, which it recites by repeating the framing of the room. Even when hung in another museum, the institution which frames the piece from inside is still the National Gallery. When hung elsewhere, the new site recites the National Gallery yet again. *Plus tard*'s concern is not about distance from the real world but mythic interpretation backed by a specious notion of transparent representation. Consequently, *Plus tard*'s regress into an abyss of representation, which might appear apolitical and nostalgic in its passages of dreamy beauty, names the mythic version of Canadian identity, the rugged, untamed, innocent inhabitants of *terra nullis* (which was not and is not empty) governed by natural order, as a speculative site which has and continues to generate enormous returns.

If *Plus tard* suggests that Canadian identity, either menaced by the North or identified with a transcendent natural order, is only a symbolic transaction with nationalist overtones, the work nonetheless declares its faith in photography. Faith, Ricoeur argued, rests on the notions of witness and testimony. *Plus tard* seems to be saying that photography is faithful to whatever is out there being reported via film stocks, light, lenses, filters, camera movement, and editing, as full members of the apparatus. From this perspective, the privilege granted to "authentic" mediums such as painting or poetry, because they manifest the self-expression and individuality of the artist, are arguably properties totally external to the medium. If that's true, then painting and poetry are arguably *indifferent* to what appears and are, instead, inauthentic reports. So which types of medium are more faithful? By blending the paintings through sweeps of the camera into a single ground, Snow hoped to turn a group of works by seven very different people painting over a number of years into a whole without making the painters' subject, the question and interpretation of an elusive nature, disappear.[18] So, *Plus tard* holds faith and witnesses the overlapping projects of the Group of Seven and the National Gallery. Declaring faith in photography and its objects can be considered the first moment of redemption in *Plus tard*.

Another approach, departing from the installation's point of belated review and title, is to argue that *Plus tard* returns time to photography, and that this is its second moment of redemption. Since recording mediums are always later rather than secondary, and *Plus tard* emphasizes this aspect, the overarching issue is a mode of temporality, chronology: then...then...then, one moment after another, one shot after another, or one frame after another. Chronology and its

possible expressive effects shape a sense of time that the camera's "click" usually eradicates in favour of seeing the whole all at once. Snow himself remarked:

> The title refers to the time gaps between the painting of the several landscape paintings...and their installation together in a room at the National Gallery of Canada and my personal photographic recording of them *in situ* and the spectator's personal present in seeing the final superimposition of these times....If you just photograph the paintings "straight" which in some cases I almost did there is almost no time left from the camera's side.[19]

Following from the aspirations (in straight photography) to a lawful and legible image, what has been recorded—these paintings in this room—is an analogue of the layered and blurring effects of multiple visits and processings by public discourse, successive visits, and exchanges between spectators, artists, writers, critics, historians, and you and me.[20] So the third moment of redemption through *Plus tard* is of historicality, the return to me of the historical and dialogic sedimentation of memory on the part of spectators, writers, and critics, another cumulative effect that the camera's "click" usually elides. *Plus tard* makes a claim on me on the part of the unseen sedimentation by discourse. Destined toward future circulation and others, *Plus tard* itself witnesses, among other things, the desire and ability to move beyond the bounds of the instant, to enter discourse. Neither *Plus tard* nor my eyes are "naked"; they have a history and witness a desire to say "Here I am!" So, supplementary to finding historicality, I find it as constitutive of my self in conjunction with entering public discourse.

However, *Plus tard* also makes it evident that, if I use photographs to remember you by, photography, which has public conventions and codes, colonizes private memory. Private moments are opened for the taking by public discourse. Snow himself was wary of the invasion of the public into private memory. Technology has the capacity to record the to-be-remembered easily and quickly, and to make it more publicly available, he claims, "so that [the] sharing of them produces a unification of the social body," which can be regarded as beneficial. On the other hand, "the experience is on a level that is above or below personal interchange and it equalizes," which describes some aspects of memory and experience as vulnerable, malleable, and beyond critical control.[21]

Plus tard, however, redeems my self from putty to be shaped in the travails of representation, by restoring possibilities for projecting "I can, I want, I do." The point of view in *Plus tard* mimics my "reading" behaviour in a gallery, or how I go about looking in order to make sense. Instructions are not sent only by reference and conventions of reading horizontally, but by appeal to my moving body and roving eye. When walking through a gallery, I do not stop at every painting. Especially in a large collection, I pass by some hurriedly, looking at

them sideways, not focussing on them, looking ahead or thinking about something previously seen or read. Sometimes I back up to compare several paintings, or I turn around from different places in the room, or I compare separated works while trying to ignore the intervening ones. I might compare some to a catalogue text, or sit down to read. In other words, the way I look at paintings in a museum or gallery has a syntactic aspect that includes retrospection and anticipation, and is very similar to reading a book, like the Kunstmuseum Luzern catalogue. However, my memory is also involved, not only of what I have just seen and its involvement in the schema that I anticipate, but also of earlier articles and other museum visits.

In this installation, Snow has parsed my ambling, direct experience of reading a room by locating me physically inside a room (as in *Portrait*) and by isolating images in heavy black frames. I'm here to see the room, not the paintings. The black frames seem to mourn, wickedly, this loss of my attention on each painting. Each frame signifies "Stop here," "Break." Yet every picture has the same frame, connecting them as if by accretion—and...and...and—authorizing me to go on or to look back, and to accumulate memories. This is Snow's parsing, not mine, but it forces me to take his reading into account and the possibility of others before him. Because images of some paintings are nearly lost to blur and others are reasonably distinct, I find myself imitating the pause or sending myself on without pause along the tracks of ghostly forms and streams of blurred colour to the next stop. I stop before the prints that fill their frames with their multiple, vibrating contours and borders, such as those of Tom Thomson's *The Jack Pine* (1916-17) or Macdonald's *The Solemn Land* (1921; colour plate 4), or with a gentle smear, such as Harris's *Snow II* (c.1916). I pass others quickly and look back sporadically. Correlative with my movements, the temporality given by the displaced registration says distinctly "again" or "later." The combined references to the history of painting, the museum, and to reading anticipate me remembering and knowledgeable about a cultural discourse on art.

Théberge thought that the camera stood for Snow's sight and returned viewers to his eyes (the authorial seduction), but the traces of motion and cropping in the photographs argue that Snow's reading takes account of itself as only one of many, and that paintings, revisits, and rereadings exceed his grasp.[22] And while the National Gallery's installation delivers a centralized "lecture" on a kind of landscape as symbolic of Canada, *Plus tard*'s photographs subvert these didactic machinations. *Plus tard* is unstable and destabilizes. I take Snow's and Théberge's sight, into account but am not restricted to either, because neither visit is mine. So coming now, late again, and enjoying every moment circulating between catalogue photographs, computer screen, written notes, and memories of walking through the last exhibition of *Plus tard* in Toronto, in deep discussion with another visitor, I recite by my own performance many forms of the injunc-

tion to "Be there!" "Read this!" "Look back here!" "Don't stop there—look ahead!" "Hurry!" "Full stop; take a break."

Plus tard's visual joke about distances situates me ideally at the centre of the room—not where I would normally stand. Showing themselves as taken from a single central point, although in motion, these photographs do not represent the ambling viewpoint from which I see the paintings, stepping closer or backing away as needed. Whereas I may see distant things as smaller than close ones, I do not understand them to be of different sizes, nor in an expanding or contracting space. I do not see objects blur while I pass by on foot (with some exceptions), and I see neither the world nor representations in layers referring to prior visits by others or myself. The conflict in viewpoints and foci distributes my reception and recognition through the multiple and competing sights of one who sees through a monocular lens, one who is moving around and looking at the work, and one who reads, as well as one who mimics and one who is empowered to answer "But I am over here!" My embodied response to a pulse of circulating viewing delivers me from the grasp of a singular fate. So I cannot turn away from my embodied responses in disgust, for those are what *Plus tard* calls upon for the promise to be there, however shifty my perspective.

Exploring more radical speculations on possibilities for my self in the design of the "sending machine," *iris-IRIS* (cover) is a forthright diptych combining painting and photography on its panels, and bearing a postcard with an alpine landscape. One panel presents the real postcard against a solid-coloured ground, while on the other the postcard reappears in a photograph of a bedroom. Transferred from one medium to another, from one side to another, reading the postcard in *iris-IRIS* is a loan operation. The postcard travels on more than one circuit, soliciting me to speculate on its many returns. When the diptych was first shown in 1980, Regina Cornwell analyzed it as part of a turn in Snow's work from a concern with self-descriptive photographic objects, such as *Authorization*, towards the interpenetration of object and narrative. Furthermore, despite Snow's often ephemeral subject matter such as reflections or flames, Cornwell felt that the presence of narrative moments in pieces such as *iris-IRIS* confirmed that his work had nothing to do with the critical paradigm of the decisive moment.[23] In 1993 Louise Dompierre took a different approach, arguing that not only was *iris-IRIS* part of Snow's exploration of representational reflection, but alongside *Plus tard*, it was part of a trend in Snow's work during the 1970s and '80s exploring how the intervention of representational processes might effect self-understanding as a fundamental disconnection from reality. In *iris-IRIS*, narrative was explored as yet another strategy of representational self-containment, she thought.[24] My point is that while this work turns representation into the question of self-recognition, as I have argued for much of Snow's earlier practice, in the case of *iris-IRIS* my return or redemption, and not as

merely a "textual" figure, relies on a speculative loan of my sight transferred to and "reread" from concrete pictures, which has the chance of returning a pro-liferation of connections with reality rather than a disconnection.

iris-IRIS is backed by two square panels of whitish board, placed side by side. The right panel is painted a faint, dull blue-grey, while the left one is paler grey. A real postcard bearing the photograph of an uninhabited alpine scene is affixed to the right panel. The postcard's reverse side is hidden. The same postcard, now pictured rather than picture-object, reappears at exactly the same scale and place on the left panel which is, moreover, a photograph of a bedroom scene. Below the pictured postcard is a slightly mussed bed and a small bedside table on which lie some loose change and a pile of more postcards. In an ashtray next to these a small fire burns brightly, but no one is in the scene. What is given on the right, then, is a postcard scene with unknown address; on the left, a moment in a narrative scene to which the postcard has returned; together, a double return as a whole posted on these gallery walls, to you and me. From both sides, diptych and postcard promise through their two-sided transfers, incurring debts and obligations but then, suddenly so do I. The multiples of *iris-IRIS* promise something to read, and I promise to be here to read. The postcard gives itself to this field, and so do I. Call it a *pas de plaisir*, for once the ground is cleared, promises can just keep on coming.

Immediately, giving is sending something from me to you, a situation which undermines the alleged objectivity of the given whether utilitarian objects, art works, or philosophical positions. When something is given it is designated. Designation reframes, and reframing is always by a purposeful "I." Designation implicitly sends to; it solicits my gaze, my position constituted by this solicita-tion. As the *Walking Women* and *Scope*, *Plus tard*, and *La région centrale* made so clear, the framed itself becomes mobile. In transferring the given (postcard) from one to another chain of signifiers, from object to panel to photograph, the given becomes contingent. This unstable sight is given to me just now, included in the chain of signifiers trafficking back and forth across the diptych, but a "me" without name or address, a chance passage in an art gallery, just visible as a speculative return.

Standing in front of the postcard, I am given a generic alpine scene, famil-iar from thousands of tourist photos of the Alps, Scandinavia, the Rockies. These are mementoes of being out in "nature" where few live but many visit, write about, or paint, or photograph, all to find an Other. "I" have travelled away to this place and send this record to "you." While this bit of nature, to which I have travelled, is not my abode, recording and sending it transfers it to a discursive circuit, making my abode and "nature" now discursive. The photo-graphic postcard splits the time of the scene into two moments of which the second promises returns to the first: I am here, and I will-have-been-here by the

time you see this; together we will return (or I might return alone). Tourists' photos are to be enjoyed by oneself and explained to friends in a social gathering. In this context, the return on borrowing a scene from wilderness yields a two-fold gain: the promise of an intimate meeting, and a pleasurable intimacy already accomplished in the imagination.

However, the photograph's scene is projected into the corporate domain of proper names by two captions. Printed above the highest peak: Mont Blanc 4807 metres; in the lower right corner, IRIS, the brand-name of a postcard company. This is not my photograph of anonymous snowy peaks; IRIS has labelled the scene twice and copyrighted it. The message of IRIS's double imprint is "reproduction prohibited." It means no filiation, no issue, or proper return either to Mont Blanc, from which the scene is borrowed and to which knowledge is irrelevant, or even to IRIS itself. In its proper function of circulating postcards as commodities, IRIS sends itself as its own obstruction, for what IRIS surely desires is neither its own reflection clear and whole nor intimacy with me, but cash. IRIS arrives on the scene only to erase itself as a proper author: IRIS cannot be pictured, thus, no true filiation, but false promises and a perversion of proper returns. Mont Blanc, meanwhile, returns as a scene whose destiny is travel. Since one does not travel to a postcard, the scene sustains itself by never arriving, establishing a circuit with no destination, yielding returns on a blind transfer to a different exchange by IRIS which dreams of other things.

While tourist photographs and postcards alike circulate this scene, transferring the same photograph to a postcard dispatches it to a different addressee: absent, even unknown at the time of rerouting, which means that the card must be legible to others who are strange to me and can arrive elsewhere. By taking ownership of lens and print and sending sight to scene, present moment to past, IRIS sends my experience to memento. The scene's immediate nostalgia is offset by an ironic reversal. This photograph—small, flat, without sound or smell or the touch of wind on my face—corrodes memory of my experience and imposes itself. Have I ever been there, or did I just buy this from IRIS? Since the postcard is a commodity, I don't have to visit Mont Blanc, and you don't have to be "there," either. I can simply buy the postcard either to send to you or to keep. The only requirement imposed by "postcardness," the condition by means of which IRIS expropriates and profits by the scene, is that I like it. It has been produced for my pleasure, its allure drawing me into a chain of allusions. I, too, am sent. Yet, while the return on the capital of the tourist photograph—which boils down to intimacy—has been transferred and collected by IRIS, has intimacy itself been dealt out of the picture, or has it been simply set underway out of sight? After all, I buy postcards.

The postcard that I bought to send has already arrived—unless you bought one too—on the left panel of *iris-IRIS*, a photograph of a room with a white bed

and small bedside table. The second panel's viewpoint is divided between a direct look at the back wall holding the alpine postcard and including the bedside table, and the bed framed by its footboard, to the right of the panel's centre but left of the central space between panels. Like the viewpoint between panels or the hyphen between the two terms of the work's title, the bed frame divides and holds together an entity in which neither part stands for the whole, between which my sight must traffic. The colours of the postcard have changed slightly and details are less clear. It's no longer the same given, but now part of this panel, and an invitation to remember the postcard on the panel over there, to the right. I am trying to read two sides at once, postcard-like. The atmosphere of the room with its white, functional furniture is institutional: this is a road trip, not a home-coming. On the bedside table I see money, more postcards, and an ashtray which holds a cigarette and a brightly burning small fire. I look immediately to the right through the bed frame, the foot rail blurred from being seen too close. The foot rail both pulls me closer to see and distances its enclosure, which is in sharp focus, distinguishing a separate, private space. The rail frames a bed and pillow, blanketed in brilliant blue, slightly disordered and tense with the impression of someone's body. The empty bed is intimate, compelling; I look for you. All these traces of things which pass (money, postcards, flames), including my thoughts of you, are a category of the circulating and evanescent. A narrative moment, or bet-ter, a moment through which time passes, is photographed, calling me to see, and disappears as I look over there. In all your returns, *iris-IRIS*, commercial and oth-erwise, traces of time passing are what you send, but time passing does not seem a loss, but full of possibilities.

Standing here, I feel your appeal: "Be there! Love me!" Well, yes, what is the message of a photographic postcard? With one full side taken up by the pic-ture and half of the other reserved for the address, postcards have little space for their ostensible purpose. But it doesn't matter, really. Think of how many times have you written several to me and put the bunch in an envelope to mail. I send them anyway, and so do you, you who attached it to the(se) wall(s); they keep popping up.

I send postcards to close friends or to someone I love with the implicit mes-sage: "I am here, now—wish you were here. Love." Now, though the postcard might call, do I really wish you were here? Seated (maybe) at a table below Mont Blanc, I send this postcard as evidence that this glorious and highest peak in Europe is now my scene. I do not send an airline ticket. What would I do if you were really here? Would we like to take the same hikes, eat the same food, sleep the same hours, visit the same museums, argue over the same pictures? Maybe you wouldn't like it here. It could be very burdensome. I might be enjoying even more the possibilities of your absence. Since you are already here in my imagi-nation, which might be preferable, the message of the postcard has already

arrived as a direct call, a "house call," self to myself, with no operator in the way. Is this internal, self-sufficient calling circuit—with no unpaid debts, no illicit affiliation—my true and guilty desire? But no, I needed the postcard and its legible appeal. While Heidegger's *Dasein* had to accept its indebtedness to the deictic I-you structure residing inside language, in the call to itself it masters the difference.[25] Certainly neither *Dasein* nor the reciting poet commits, signed, to contaminating circulation by IRIS or the everyday legibility by unknown others.

The postcard's return to the same place on both panels (exhibited at or just above eye-level, depending on one's height) visually holds the panels together and me in place before and between them. Yet, they are neither the same, nor is this such an easy a place to occupy. My first place before and between the panels is pulled down to one side by the partial frame of the footboard in the left panel, marking another "here," while yet another place calls from in front of the single postcard to the right. And while I want to stand very close to the right panel in order see this small postcard, it is difficult to comprehend the larger scene of the left panel from so close—see, the foot rail is out of focus—and I have to stand further back still to see the entire piece. While I tend to read images from left to right, before *iris-IRIS* I want to read from the simple to the complex, from right to left to both at once, and from close to farther away. "Here" between the panels is a contested, difficult place of non-convergence. The postcard's return keeps sending me—just to this point of seeing my place disappear.

But you solicit me. "Wish you were here," my love. I see the empty bed, this intimate impress held aside and blanketed in blue. I fix my eyes on this well-defined place, a focal point posted to me. Maybe I was called from the bed by the postcard to take the picture, to send it to you with love. Why record this scene, and why send it to you? Because the eye is desirous of sending? The eye posts its sight here on the bed for you to see; you recognize the site, and the bed becomes the read (*le lit, le lit*), you "setting your eyes on it in turn like moistened lips."[26] Can I love without this detour, without sending this postcard, without *iris-IRIS* which must come between us? That blue-blanketed bed, the blue field you leave to be read returns from many other times, but specifically as loving sight drenched in blue from *Venus Simultaneous* (1962; colour plate 2). I send these cards, I am called by these to you but the field burns with love, and with knowledge, information written on the picture to be addressed on the other side, all markings presuming legibility to which I am indebted but which flee "here" as I write. Derrida argued that not only does all marking owe to the "postal principle" (legibility, sending, receiving), *but so do love and knowledge.* I can have none of these, no knowledge, no love, no writing either, without you, over there, beyond and independent of the reach of my memory and calling, so distant and distanced that the only way to reach towards you—but not reach you—is by sending marks which can be read by others or otherwise go astray.[27] Now they burn over

there on the other gallery wall: *Blue Blazes* and *Was Red* (both 1979).[28] The meaningful moment of arrival and its incendiary self-erasure disappear in fuming colour, but they leap to another register in verbo-visual puns and traces reproduced in photographs posted on these walls. Shunted around among viewpoints, trafficked between "I" and "you," moved by the disquiet appearing in these residuals, obliged to understand the leap of verbo-visual puns, here I am. Motivated by love, the loan of my sight augments being underway. Reading is framing on the move: nothing and nobody can stand still or all is lost.

Mobilized on the circuit of the postcard, all of the eyes of *iris-IRIS* have become indefinite. Thierry de Duve has remarked how the pronouns *I*, *you*, *we*, and *they* remain ungendered in English, the Romance languages, and German, leaving *he* and *she* the oddballs of the field. In English and German *you* can be both singular and plural, but only in English do the corresponding verb forms also converge.[29] Such a shifty field allows transitivity between feminine and masculine, singular and plural, and *you*, who can be all of these including *I*, at least with transitive verbs. You and I can be androgynous and multiple. The evanescent colours of Iris, messenger-goddess of the rainbow, play on this condition of transitivity: you are the nearest other to whom I can send pictures and other marks, whom I can send, who can send me. While the field of shifters argues for the possibility of universal identifications, they take effect only in a field of marking, sending, and reading, which sets up obstructions to full delivery of the message and full convergence between *I* and *you*, however mobile. In *iris-IRIS*, you leave the bed as the read for me, and not just the seen. When I read, my horizons cannot mesh uniquely with what you, he, or she reads because reading is lodged in time and substance, which argues that love, knowledge, and commerce come from the other. They all depend on keeping these positions unreachably apart. I must never reach you—our eye sites will never converge in *iris-IRIS*, however many times the postcard promises otherwise. Far from being a tragic condition which mourns disconnection with reality, this situation suggests self-description based on difference, one thing after another, a mosaic which does not presume a pre-existing integrated whole that has been lost: rather, potentially multiple connections and liberation at last.

Regina Cornwell has questioned whether Snow's photographic work of the 1970s, including *iris-IRIS* and *Plus tard*, returned the nineteenth-century hierarchy of painting as photography's originating matrix, relegating photography to a lesser status as a derivative art.[30] In the same critical paradigm (although arguing for film as a politically superior medium) Walter Benjamin argued that painting moves spectators around in soliciting their gaze, thereby asserting what Benjamin called its aura, a not-too-specifiable blend of uniqueness with the power to call one face to face. Spectators are constituted, "sent" or gathered to paintings in a phenomenon pointing to a signified that is nowhere evident.[31] It

remains a mystery, and might be called "spirit." He found "aura" again in some early nineteenth-century photography. Some painting as well as photography, then, aspires to send "spirit" as a mysterious possibility to persons unknown, but the possibility has to be sent through the painting or the print, the "read." But isn't this somewhat like a postcard? The notion of aura could be Benjamin's de facto recognition that painting, fully immersed in substance, like film or photography, is part of the postal system that subverts authentic filiation.

While the right-hand panel of *iris-IRIS* holding the postcard is completely innocuous, it is painting. Its status is enigmatic: ground, frame, matte, or all of these as the French *passe-partout* implies. None of these in particular and somewhat all of them, it suggests an undoing of the traditional problem and boundaries of representational painting: to locate a figure on a ground, in colours, in an autonomous field. And the blue-grey is neither one specific colour, nor bound to figuration, nor bound by painterliness to the touch of the artist. It has no debts. While IRIS's postcard is displayed against this ground, it is not integrated as understood by painting. Affixed to the ground behind it yet a member of a circulating open set, the postcard leaves painting behind. The break is palpable (I can take the postcard off the panel), yet the two retain an undeniable relationship. *iris-IRIS*, recalls that "in the beginning," tourist painters preceded tourist photographers, at least in Europe. The postcard photograph speculates on a scene made already familiar by Scandinavian painters such as Ferdinand Hodler, Edvard Munch, Harald Sohlberg, and Gustaf Fjaestad; it is a legatee of Northern Symbolist painting of the homeland and spirit.[32]

However, *iris-IRIS* also recalls that, in the nineteenth and early twentieth centuries, Canadian both landscape photographers and painters were subsidized by the Canadian Pacific Railway. In 1884, the Notman Studio of Montreal was granted free rail travel for its photographers to record the building of the railroad and opening of the West. The CPR even supplied a private car equipped as a darkroom.[33] The studio retained control over the negatives and was given exclusive rights to sell its prints in trains and stations, and at Canadian Pacific hotels.[34] During 1885-86 the CPR commissioned John A. Fraser, painter and former Notman photographer, to make watercolours from photographs of the West for the 1886 Colonial and Indian Exhibition in London.[35] Between 1886 and the First World War, the railway also subsidized travel for many artists and photographers as part of a policy to sell landscape to attract tourism.[36] Painters used photography and followed in the footsteps of photographers; photographers were sometimes painters, and vice-versa. Both were sent on their way, standing-reserve serving the commercial interests of the CPR and Notman Studio. The studio, in turn, understood itself as engaged with artistic projects and concerns, exhibiting its work in art exhibitions in England and Canada beginning in 1860.[37] In this history, painting, photography, and commerce hold

each other in a tight embrace without reliable antecedent, to generate proliferating returns of cash and fame. Contrary to Benjamin's thesis, considered from the point of view of reception, painting returns in Snow's practice and in the context of Canadian landscape painting with no claims of authenticity or priority over photography. Contrary to Cornwell's claim, then, *iris-IRIS* cannot reliably return landscape painting as the proper matrix of photography in Canada. Here the priorities and content are problematic, and they return again and again as in Cornwell's writing, articulating her desire to know.

While I am left with the feeling that within *iris-IRIS* Snow is paying a debt of affection to painting, especially Canadian landscape painting, it is inadequate to claim that the work is nostalgic. The couple painting/postcard returns in *iris-IRIS* insistently. In this liaison, painting declares that it works recto-verso. It is a scene to which Snow has returned, like winter, again and again. Pleasure as a *pas de plaisir*; a step taken and taken back; a promise which clears ground as groundless; a circulation incorporating spectators into a symbolic field which was already there, all accomplished by borrowing and transferring images. Nothing can begin without borrowing to generate interest, as Derrida has it, borrowing is the law; it even secures the proper funds.[38] And yet, and this is the good part, borrowed funds can yield unforeseen and even illicit returns when transferred speculatively elsewhere. The represented-real sent by *iris-IRIS* includes a set of readers who buy, send, and receive postcards and go to art galleries, perhaps without having ever seen Mont Blanc. Through IRIS and the Art Gallery of Ontario, regulatory exchanges, being-there is already faked. The postal principle is indifferent to this glitch in referentiality or indebtedness; it sends anyway, with love. So the redundant, proliferating apertures of *iris-IRIS* project the possibility of overflowing the lawful. The possibility of closing accounts seeps away, as has Michael Snow. For of course he was the sender, unseen as the (im)proper of the snow scene on the postcard. As represented figure or image, he has already receded into the generic. As a play on words, he can appear only improperly transfigured. Apprehensible only through puns and speculating on borrowed funds, the figure of disappearance taking a *pas de plaisir* comes again and again, with love, to you and me.

Refiguring Redemption

RESIGHTING MY SELF

While criticism concurrent with Michael Snow's practice has focussed on critical paradigms concerned chiefly with materiality and consciousness, the focus here has been how my self can be refigured through selected work from Snow's practice, taken in conjunction with a comparative debate on readership posed through texts by Heidegger, Benjamin, Ricoeur, and Derrida.

As Heidegger envisioned it art could redeem the self from the damage wrought by the corrupted notion of *technē*, modern technology. While Heidegger had argued since the publication of *Being and Time* that the self was fundamentally without foundation ("thrown" into the world and responsible for its own possibilities) he also had a basic fear that the Western notion of self was being irretrievably damaged by fascination with its own invention: modern technology with its emphasis on efficiency and resource value. As an antidote, he argued that art (and especially spoken poetry) granted you and me the possibility of opening ourselves to a true filiation from authentic origins in Western thought. Given the suspect political potential of Heidegger's vision of the function and structure of art, Snow's practice plays with the impossibility of authenticity and "true" origins and offers what must be welcomed as an entirely different approach to the question of "who." Yet, his work does not turn its back on Western art history and thought.

The *Walking Woman* (whether figure or frame) walks off with both my sight and my site. She is a frame rather than a fixed window in a wall or a photograph

Notes to chapter 7 are on p. 189.

focussed by a monocular lens. This contrast delineates my initial subjugation in visual art in single point perspective (where I "fell" from mediaeval all-inclusive sacred, pictorial, and lived space), its analogue reproduced in the lenses of cameras and transferred to photographic prints. With the introduction of cinema, I was not only centred by the photographic apparatus but by the cinematic processes of narrative construction and entrainment. There I was: monocular, centred, disembodied, well-regulated and well-composed, rational and rationalized, master of the visible world, and my mastery foreseen as theoretical. But the *Walking Woman* walks off with my sight. She mobilizes it because she's a relationship, a *Duet*, she and I, between my eye and what is sighted through her frame, or collected as a sight around her. Propelled by many transfers, the *Walking Woman* began to escape containers coded for art such as galleries and studios in the early 1960s. She appeared everywhere, rupturing the scene and isolation of high art, jumping into contemporary sites of daily life.

Because she walks everywhere and through everything, she makes all the world the project of my concern and interest, not just some of it. We're not on the outside looking in, objectively looking at an object, or making an aesthetic judgement about the beautiful. However, I am still making judgements, for she sets an examination to which I must assent in advance. The test question is: is this art—in this place, this medium, this figuration? In today's life, is this what art can be, or should be doing? How do I find my self in making this judgement? I alone cannot make this decision meaningful for my larger community; it must be endorsed by others and local institutions. To be an interlocutor of the *Walking Woman* requires you and me as necessary partners, so that she is a discursive field where the notion of art is structured and circulated by debate and judgement, by myself, others, and public institutions. As a result, the *Walking Woman* presides over the emergence of my self as a subject of enunciation redeemed from the domains of techniques, consumers, message receivers and senders, and from the wastebin of purely subjective taste, into public discourse, all by a judgement about art. And since she has given me all the world as the concern of art, then my sight is not limited to aesthetic objects, nor my site to the aesthetic domain, but expanded into questions about my practice of all-encompassing representational relationships.

Being an abstract relationship rather than a representation which appears in so many different sites and forms, the *Walking Woman* leads you and me through many avenues, many escape hatches. She is neither singular nor masterable, but opens different sights, different shots, different sites, so there is no singular perspective, no narrative, no drama, no Oedipus, either, although any of these might surface in a particular piece. Although a flat construction rather than a representation of reality, she practises a relationship of love. I'm sure that it's love and not lust. *Duet*, for example, carries an X across her heart. This X is

for my sight; she asks me, in Ricoeur's words, "Thou! Be there! Love me!" *Venus Simultaneous* is named for love and fills the whole field, walking into my space and the world around her. Snow's practice tells us while the mind and the eyes are both sexual and perceptual organs they are also a means to open my self to connections and to keep it all together. Internally, the *Walking Woman* often explodes boundaries between mediums while respecting their differences. It's the differences that she often works upon, especially in visual-verbal puns. Consequently, ironic *Walking Women,* having become illegitimate, are loaded with potential for the desire of speculative returns. Unquestionably, sensuality propels punning, jokes, memories, the effectiveness of colour, and much of the task of making sense. No mind-body separation, here, certainly.

Many of the *Walking Women* function like a Benjaminian constellation that makes the past suddenly legible, such as the gendered division of labour between seer and seen continued today in much popular culture as well as art: he looks (lustfully) at her. For many, this is a moment of danger and the *Walking Woman* is a trap. However, in my sight she redeems me from this singular view. Works like *Duet, Olympia, Carla Bley,* or *Adam and Eve* are frames, drawings, or even photographs not-from-life. As a simple, abstract silhouette explicitly drawn to an arbitrary code of proportions, she is not a first-order representation of a woman out there, not someone with whom to identify, but a construction with a history associated with an historical and gendered perspective. I can read or interpret this, but I am neither asked nor coerced into identifying with being either "her" or "there." Now, when the perspective of "he looks lustfully at her" is restructured to obstruct identification with a viewpoint or object, the structure of uncomfortable affects is reversed into play between reflection and imagination. As Ricoeur argued, analysis and imagination are found intrinsically together in the dialectic foundation of discourse and cannot be separated. So in the present, a moment when women are rebelling against the danger of being visual targets in representation and in real life, women can read this position but are no longer figured into that sight and site. In the flatness of this abstraction and relief afforded by irony, in the many ways of escaping a site, I can even find a practice of care rather than lust, of love offered tongue in cheek.

When Snow delivers something as outrageous for me to see as *Projection* or as bold as *VUEƎUV* (1998; a nude photographed from the back, printed on transparent fabric), I might be looking at a practice of Snow, artist, loving art, loving being the trickster of art, twitching the veil of illusion.[1] In this very transparent process, I can see his sight, exposed, from behind. In pieces such as *Projection, VUEƎUV,* or *Crouch, Leap, Land,* which are richly ironic, the possible fusion of desire between the unnamed artist as maker and his practice becomes visible. These works are rather shocking in their exposure of representation of the female body and the obvious fusion of sight with masculine desire. However,

all three are rich in puns and satire, including Freud's little drama of small boys peering up their mother's skirts as the origin of scopophilia. Puns and irony, which destroy realist reading, can also open to an audience how a piece works. They are reflexive processes on one hand and distancing devices on the other. Reflexive processes open an intimate space within them where "he looks at her" can unravel to the artist looking at work and practice. Our gazes cross as I see this and "he" sees "me," because of course "he" is visible only as traces to be read, or not read. Coming later, I become witness rather than voyeur, a witness to art done possibly for the love of art, for the love of reproduction's double which opens me, and "him," to the desire for mimesis, which brings us wanting to be close once more as intimate watchers for the other's gestures.

The question of whether the sight of the *Walking Woman* is seeing or reading circulates insistently through her. With the bookmark, a juxtaposition of text and her profile, I collide with the question of reading, of finding my pleasure in reading and projecting my possibilities in reading. My self is challenged by a flat profile, by the relationship of reading. Back and forth my eye travels, from "real" reading with secure grammar and "true" reference, to mimesis, the task of making sense of images taken as meaningful. Medium and interpretation are not transparent to each other, a problem that shifts me into another register to negotiate between mediums and possible outcomes, or the task of making sense. The *Walking Woman* imitates nothing other than herself—she escapes—but she unburdens reading of its relationships to truth, and brings about its pleasures.

While she keeps passing through, fugitive and elusive, promising more to read, she nevertheless issues a form of injunction: "Thou! Be there! Love me!" As a frame she has no effectiveness without my keeping a promise to show up. But as a writer, woman, mother, art collector, biologist, gardener, I cannot be sure who will arrive at any particular time; there are many possibilities and I might just make one up. Nonetheless, the possibility through puns and irony that I promise in one of my several guises, or a new invention, increases the speculative potential, the opportunities to take *mes chances méchantes*. This may be bad faith except that my other guises are still properly "mine." Going further, is it improper or unjust to simply transfer funds or take out a loan to get my self going? If I wish to live well with others, is it unjust to take chances with borrowed capital under an improper name? Well, that's fraud, unless the capital is imaginary and symbolic and unlocks accounts of other fictional worlds, in which case the returns might have more than legitimate interest. Perhaps I can just try some of this out rather than be a drudge of singular, realist reading, unless the *Walking Woman* uncovers a centralizing police force which wants to keep me in sight and on site. It seems to me that she slips between the gaps of a promise of something to read, something to see, and a promise to be true to reproduction, escaping determinacy for herself, for "you," or for "me," except that some of us have to meet here at some time to realize our gains.

So as reproduction's double, the *Walking Woman* mimics the open-ended conundrum of mimicry and returns to an ancient Greek tradition, but redeems you and me quite differently from the tradition addressed by Heidegger. In their irony and play with eroticism, many of the *Walking Women* disrupt discourses of purity, authenticity, and the problem of the gendered division of labour between seer and the seen. I am saved from the sentimentality and limitations of these historical discourses without being cut off from historical Western art or from the dialectical resources of discourse. The *Walking Woman* makes a critique in the midst of analysis, making it clear that there is no analysis or reason without understanding and imagination coupled, in her case, with love. And it is love, because the *Walking Woman* appeals to my imagination to be there, with love and understanding for her position and mine. As a reader of reproduction's double, of a notation of notation, I can escape the constraints of productive and acquisitive mimicry: she is not a true report of the real world, but notation, a speculative return on the interest of sight. Haunted as she is by the possible falsity of mimicry and the potential for failure at the heart of all promises, I don't know whether she is truthful or not, and neither does she, but we speculate on meeting, in all of our differences, to transfer funds again and again. As Derrida put it so aptly, *j'accepte*, I accept it all, I have to or I'll lose you and love itself. X marks the spot.

The X in the frame, the primary loan vehicle of my sight signed with love, is extended from the *Walking Woman* to framing in general by *Sight*, a frame in a wall. From either side, *Sight* makes it very clear that framed seeing is not about distracted viewing; it's about the attempt by the frame to focus and detach sight from its immediate context and from normal perception, which is unbounded, fuzzy around the edges, and haunted by distraction. So while the frame centres and focuses my sight and attention, it also mobilizes them. The frame acts in much the same way that Ricoeur explained how written discourse structures a work and makes it autonomous from ostensive conversation. While representing the invisible insertion of discourse between seer and seen, *Sight*, with love, unravels the rules for this container by slitting open the sight that the rules were designed to overcome: a passing, fugitive scene; a "movie" passing through which I cannot master for my enjoyment or contemplation. The framing sculptures *Sighting*, *Zone*, and *Monocular Abyss*, and the photographic works *Bees Behaving on Blue* and *Shutter Bugs*, are similarly exposés drenched with black humour about assumptions regarding viewer mastery. In the photographic works, where the rules are enfolded in photographic technology, only *nature morte* survives. I, too, as part of the wild life, have suffered. The sculptures joke darkly about the lack of fit between an ambulatory, binocular body which is mine, and the visual requirements exerted by framing in traditional painting, photography or by extension, narrative film. Together they show how traditional

framing and camera technology police and suppress the relationship between my body and how and what I have been trained to expect to see, without my noticing or consent. By inserting yet other frames into the discourse of framing, this collection of pieces redeems me to other sights and fugitive visions in a body reclaimed and refigured.

While *Sight* exposes a coercive discursive structure between seer and seen, *Portrait* neutralizes the rules holding these positions in place. I am neither seen nor seer; I am both at the same time. All security or priority is removed. Since *Portrait* relies on surrounding architecture and converts it into a frame, I now dwell inside the frame and its scenes. It's my site. The masculine erotics of voyeurism, master of the scene seen through a keyhole (or frame) is turned around; I can either see "back" or move into an erotics of self-exposure. I chance my self in sending my sight and circulating it through an other who might plead, intimately, or an Other who enjoins me to be there. I find my sight already fractured and dispersed. I discover that I am already self-dispossessed, that my sight is shifty, an illusion. But I risk the frame. What comes back to me is the *frisson* of speculation, the dangers from self-exposure and the return of unknown sights, which return as though from nothing.

The mobilization of my sight initiated by the *Walking Woman* and *Portrait* is returned through some reflexive pieces where this term, owing to construction playing on the word, becomes the site not of an enclosed circuit, but an opening which can return always more. But they "begin" by incorporating a strong movement of self-dispossession. *Scope*, *Portrait*, and *Membrane* send my sight and the sight of me away. The first two return nothing recognizable of my self. The third satirizes from low down the tradition of recognizability associated with representation of the face while undermining my self-esteem. Yet, although these pieces send my sight away, they incorporate a counter-movement. *Scope* sends me literally the sight of others, *Portrait* the imagined sight of others and Other, and *Membrane* the sight of self-exposure from below. Together they make the point that what is returned is my imagined viewpoint from the site of others and a composite, multivalent Other, and that this is no less part of my self and my sight than the true-to-life mirror reflection or portrait of my features that I expect of mirrors, portrait painting, or photography. These pieces fracture and disperse the imagined, centralized, and controlling sight of my self, and the self-understanding of my self figured within it. What is returned are many sights inflected already by others, by the chance of desire and its underside.

Authorization tantalizes with a promise made to a reader; it doesn't merely make a declarative statement. In my reading I ask, "Is this how the work was truly made?" "Yes," Snow promises twice, in the succession of Polaroids and in his signature in the bottom right corner. But he slips away as an individual and reappears as photographer and signer, that is, the artist. Eroticism arrives in the

flash of self-exposure when our gazes cross as he slips away. It is tantalizing to speculate on how "I" listen for the appeal issued by this chronologically and logistically clear construction. He promises, but to whom, given that I'm a chancy proposition passing by? "I" and I together are left suspended between the frames. But look, like "Snow," I have been doubled and recaptioned, so to speak, by *Authorization*: I have a new head of readership which leaves "me" looking at my self from a distance. Snow has negotiated my redemption as reader by disappearing, handing over the re-iteration of sight through time as a promise to hold us all together.

Snow "sends" this problem as a comedy in *Venetian Blind*, where he takes his own picture over and over, but smudges it. He sends this recorded gesture to "me" repeatedly, but he doesn't seem able to figure it out. With humour, "Snow"—most competent artist and photographer—appears to have forgotten how to focus and compose a clear picture to send me, but no matter what, *he'll be there. He promises*...even if he can't get it quite straight, and even if he's not sure who will be there. "Snow," "you," and "I" remain undetermined variables, and so does the focal point of the picture. As a result the possibilities for "you," "I/me," or even "Snow," to read between the sheets of photographs ranged across the wall are beyond closure or calling to account, leaving open room to play or escape. From their obscurity they return renewed delight, again and again.

Work such as the *Walking Woman, Scope,* and *Portrait* capitalize on the capacity of a still frame to mourn my fallen site and simultaneously retrieve my sight as already dispersed in multiple viewpoints or sites. But *La région centrale* brings the temporality of this problem into play in the context of the Canadian discourse on European colonization as suffering and the fear of wilderness. The discourse is grounded in an historically and politically significant description of the country as wilderness, a "natural" empty space (including its prior inhabitants) open for claiming by the frequently overlapping interests of church and state, institutions such as the Hudson's Bay Company, the Canadian Pacific Railway, mining and logging interests, and supplemented by cultural organizations such as the Royal Canadian Academy and the Ontario Society of Artists. In the context of this historical perspective, *La région centrale* robs me of the false sense of security of my site, like *Portrait* or *Scope*, and gives me the Other's image: "empty" wilderness. As *La région centrale* engulfs and evicts me, I experience that what makes the terrain "wilderness" historically and today is that legible signs of others' inhabitation are absent. The possibility arises that "wilderness" is another term for illegibility, or alternatively, a refusal to read. The historical mode of domination is supported by seeing emptiness, so that familiarity with much literature or visual culture about wilderness does not permit seeing with intimacy or love. Intimacy requires that you or I are already looking for and listening to others and the Other, as Ricoeur said, from a space that is suddenly clamorous.

The frames of *La région centrale*, accompanied by its beeping, move across the screen without a filmmaker's or my emotions in mind. Yet, the film is not truly indifferent to me because it plays unceasingly on my bodily senses and on its ability to disorient and reorient them. While my body ties me to nature out there as the substrate of the film, because the film addresses me I am for the same reason part of the landscape in the frame and we are both "sent" or mobilized, now in the picture. One result: nature and "I" no longer suffer each other, either on the ground or in representation. Through my self and these new sights, the binary division between representation and the "real" world, "hostile" nature and my self, have been undone. Nature need no longer mourn, now becoming legible through mediation.

In the different viewing regimes in the film, I find the temporality of my perception visible as different degrees of absorption, distancing, and the viewer entrainment appropriate to perspective. The film shows them to be reading regimes, in that I have to read or interpret these relationships, and that my temporality as a reader depends on speed. Conflict between viewing regimes makes evident that the discursive field of film, nature, you, and me is neither whole, closed, or organically integrated even if nature, film and I find common ground. However, empowered by conflicts and differences, recognition builds up. The sweeping landscape and the projected different ways of seeing construct recognition: the character of the terrain or site; the character of these sights; and my character as the one who can recognize the others' characteristics. My responses become recognizable, too, so that I am constant in time. Furthermore, the mediated production of conflicts and differences produces my self as a self-critical spectator but not divorced from how I find my self otherwise in the space-time of the film. Conflict and difference hold the field of representation open, the field on and in which I play as a subject of various and competing sites and sights, the visual regimes that spin through the film one after another so that their succession holds the other open as "this" is "not-this," and "not-this" either. As a result I am not redeemed to a centre under my control, but shifted to revised and decentred sights of my self as the landscape, from the landscape which regards me, and as a reader.

As Elder and Testa argued, the Canadian discourse of nature can be organized as a binary of hostile domination and fear. The reaction in visual terms, according to them, appears as multiple framing devices. *La région centrale*, like *Field*, can be considered analogous to a drawing from life. Like drawings from life circulated through the blindness of drawing itself, Snow did not direct the camera through a viewfinder, and since the film is not in real time, it reports neither the filmmaker's nor the machine's direct perception. However, the film serves the truth of place and process in that it returns a report of light reflected from that place mediated by the drawing machine and the editing process; it

reports on its reproduction of northern grounds as reproduction. Like the *Walking Woman, La région centrale* tells us that this reproduction has no secure or single model, since the film reports nobody's or nothing's vision. It's a construction, shot in the dark as the X's between the film strips suggest. Owing to the artist's abandoning of traditional authoritative or directorial roles and the non-differentiating sweeps of the terrain across the screen, *La région centrale* also reports surrender through equalization, which becomes problematic for me where seer/reader and seen/read become confused. It opens other sights and sites, a fictive world referring only to other shots, one after the other. It embraces itself; it embraces me, sometimes with what seems murderous intent, but it also gives me time out. So, it promises new sites and no harm. While the early gestures of Europeans have come to be interpreted as those of domination and defence, *La région centrale* does not reproduce these gestures. "Here I am!" it gestures towards northern grounds, but only as witness, reproducing notations of their coincidence on film. Not watching, Snow slipped away. Returning later, "Snow" intervened in the film as editor.

However, since "landscape" in the film is an already processed entity where my body and sight join nature and reproduction, could domination happen here? My argument is that *La région centrale* not only destabilizes gestures of mastery: it cannot be a recoil before nature because the film's mobile perspective and speed subvert the binary of hostility and fear and already includes my self. Mastery and fear are closed destinations, predetermined identities. While on one hand the film repositions "me" as the "ground" of film and nature, it also picks apart my reading practices so that I don't get absorbed or finalized in any particular section of the film or its action, not assigned to any particular identity. To do this it must return me to my physical, responding, natural body which the film coerces me into declaring as *mine*, but which I share emotionally and physically with my surroundings, including film and an idea of wilderness. The validity of the original claiming gestures and perspectives are undone, unframed. As a result, I am redeemed from the destiny of Canadian discourse on hostile nature before which I am helpless, and which I must dominate, exploit, or die. On the contrary, the film promises: something to read, new sights, a new kind of desire, a different nature perhaps brought forward by what Youngblood called great harmonic opposites and which play on my kinaesthetic self. So I promise to be here, *j'accepte* it all, as long as I don't get up and leave.

Despite the relentless camera movement which equalizes all that is before the lens and displaces "me" as its centre, the film is discursive in Ricoeur's sense—it refers to prior Canadian discourse and sets a task for readers *as* readers who must make sense of the film. The film cannot be termed a "text" which "burns" and is "reborn" with every shot because it builds recognition over time; its temporality of constancy is part of being there, whether as character or a

promise. Nonetheless, its shifty sights threaten psychological ground if not physical security. Although I am safe in the cave of the theatre, the challenge of the film is no less real: to refigure the world and my sight of my self outside of the cave. What comes back to me is beyond calculation: grasped, grasping, absorbed, frightened, evicted, seduced. It sends me back, alive but recognizable over there, not at the centre of *La région centrale*, but as an interlocutor in the discourse of nature and mediation as part of the question of my self.

While *La région centrale* involves the cinematic image, *Plus tard* looks at the question of returns through a still camera in motion across still paintings. As *Plus tard* revisits the translation of nature made by the Group of Seven paintings and The National Gallery of Canada, coming later, it unravels the perspective of natural and empty wilderness as a metaphor for Canadian identity and cosmic harmony, the true north. *Plus tard* also intervenes in my normal habit of looking at either paintings or photographs by encouraging me to track its own traces of movement. I retrace the passage of *Plus tard* through a room of Group of Seven paintings, a tour which comes after that of the curators of the National Gallery and that of Snow, artist. The camera is positioned and passes through differently than I do. Although I follow, I cannot promise to appropriate or mimic this tracing in good faith because it's not possible. This is not "my" view of the room, "my" journey around an exhibition, but a conflicting view which holds open my sight. The photographs are quite beautiful, and framed in black like mourning cards. Perhaps they mark the death of "naked" seeing, of the aspirations to an aesthetic of cosmic harmony by members of the Group of Seven, of a certain interpretation of Canadian identity, of the hope of imposing an interpretation of paintings as the true north suggested by A.Y. Jackson's *Terre Sauvage*. *Plus tard* intervenes doubly in my tour, and as a result I can read neither the Group of Seven exhibition nor *Plus tard* as a transparent document.

On the levels of physicality and understanding I recite "Here I am!" unfaithfully as "Here I cannot be!" because my body (which the distance of looking imposed through *Plus tard* makes me certain is mine) allows me to escape a predetermined interpretation. The intervention of *Plus tard* "finds" me between reading practices fissured by hisorical and political differences and wondering about how this was seen as wilderness and empty land, the "clean" and pure true north. After *Plus tard* and *La région centrale*, an uncontaminated self-understanding is impossible, as I try and fail to follow *Plus tard* on its way. Yet this disillusionment does not leave me abandoned. The dreamy beauty of *Plus tard* returns my sight haunted by the sight of these others, which return me, later, multiply. Here the technology of the camera undoes the visual domination imposed by its own centralizing perspective and gives back to me from a distance a certain history of sight.

Field operates between the difference of two technologies: photograms and modern photographs. It is a visual-verbal pun which jumps out of bounds beyond the immediate site of one medium, and its subject matter, weeds, compounds the joke. But it's also a miniature history of this corner of the representational field. The lower prints, taken with a modern lens, suggest a narrative of laying out bits of photosensitive paper for the photograms above them. The precise, narrative-laden account of the modern lens competes with the non-narrative index of light-sensitive paper lying around in the field. But it is difficult if not impossible to distinguish what is "true" in these documents. The question of truth itself, how truth comes about, is placed under the lens. The photographs appear to borrow the photograms by relating the story of their placement in the field. The photograms were already there, temporally and historically; photography borrowed the process of printing on light-sensitive paper. "Everything begins with the transference of funds," as Derrida wrote, "and *there is interest* in borrowing, this is even its interest. To borrow yields, *brings back*, produces surplus value."[2]

And the yield? We don't know the true relationship between the sets of prints, so this is not a loan which can be properly amortized. Photography, in fact, has a price: it reports monocular vision and promises to tell the truth from a well-calculated viewpoint. But the prints' promise to report the truth is haunted by falsity; they don't reveal whether the photograms are the same bits of paper or not, and they say nothing about the process that must have intervened to give the matched sets of positive and negative photograms. But there is something more enticing. Historically suppressed, the photograms and their particular delights are an out-of-date technology, forgotten gestures which reappear in *Field*. Made without a lens and "closer" to nature, they are appropriate to my binocular, roving, natural body. In fracturing regulated sight, they return the "more" of inviting me to walk on the wild side.

While *Field* returns me to play between unregulated and regulated fields of photography, *iris-IRIS* capitalizes on circulating a scene between the interest of my eye (iris) and the commercial interests of IRIS, a scenario returned as a photographed bedroom scene. While *iris-IRIS* and its postcards post a promise of a message in exchange for the promise to read, the trademark of IRIS makes the intervention of the market in the visual field problematic to understanding my self. Today, Heidegger's technological imperative rules the market, and efficiency is the mantra trumpeted by the triumphant business agenda, to produce profits which frequently do not figure the costs and responsibilities of being part of a larger social and environmental network. However, Heidegger did not write about desire, only that enframing was self-perpetuating. Benjamin understood the intertwined code of the market: efficiency as another name for domination, and domination's link with desire and seduction. Something similar occurs

with IRIS's successful invasion into the private area of love letters in order to drain off returns for its own profit. No true filiation or returns to sender—only the circulation of what is written.

The circulation of the autonomous postcard from object to picture to pictured to gallery is a loan between mediums and institutions which gets things going: transfers augment possibilities for further loans and rereading. Since these transfers jump across mediums and institutions, there is potential for corrupted reading and illegitimate returns. Passing by, the several possible and conflicting viewpoints within *iris-IRIS* keep deferring my place of "Here I stand!" The different views send me a sight of non-convergence, a point of seeing my single and fixed place disappear. But I keep promising anyway, producing interest on the interest, because this site of reading, a blue bed beneath a postcard-snowfield which keeps reappearing, is a message of love that "you" posted for "me," *le lit le lit*. No posts are possible without you and me still out there, and for us to be out there, there must be a fundamental unity of event (saying) and said (meaning or reception), as Ricoeur argued, even if I cannot fully understand your posting.

This is Derrida's challenge: what is written and "you" amount to the same, in the end. Despite its danger, what the postal principle holds open is not the opportunity to dominate the beloved's sight or reading viewpoint but, through the possibility of reading from an other's viewpoint, to find distanciation which looks at him.[3] In other words, writing to an other as the other can hold off domination but cannot be guaranteed to keep eye-sights from converging. The price: metaphorical murder. But he writes love letters anyway to a fictional "you." Who knows if he ever posts them, or if they are not self-addressed? It is only metaphorical annihilation and, to make up for it, produces literature, less common genres. And because he writes love letters, he arguably understands himself enjoined as does Ricoeur's intimate listener, "Thou! Be there! Love me!" It's open to chance, or to you, or you further away, alive over there, unforeseen and unreachable, but who reads.

However, as I keep shopping for postcards (see the pile on the table), I have agreed through *iris-IRIS* with Derrida that all messages on postcards amount to the same: wish you were here, with love. As the absent beloved to whom the postcard of Mont Blanc is posted, "we" arguably resemble one another, but we chance by at different times and places. Our readership skills will be different, so the post will never amount to the same. And the experience of delight and capacity to move or be moved from viewpoint to viewpoint, here at this moment, ascertains *my* arrival and my capacity to decide to what degree "I want, I move, I do," listen for my designated others, however contrary. Addressed by multiple, non-convergent viewpoints which acknowledge my ambulatory body, I am over there. The interference with identification with a single viewpoint found within *iris-IRIS* and throughout what has been discussed of Snow's prac-

tice does not allow "you" and "me" to converge, and addresses us as inhabitants of a fictive, discursive domain, "you" and "me." Meanwhile, you and I are beyond, as readers. *iris-IRIS* holds open a place for me to escape, to be saved.

iris-IRIS, many of the *Walking Women*, *Scope*, and *Press*, among others, lead to the understanding that first mediation's and then the market's view of my self is part of my sight; these are components of the Other. Snow's practice allows me to see that the commercial element of the Other enjoins me to desire and buy, so that the market has become an intimate correspondent. Yet, only with the help of IRIS does the message of love keep arriving and I promise to be here, notwithstanding. So the insertion of new frames into my sight by IRIS, whether it drains profits or not, prevents a return to sender and offers the potential for new readings. IRIS offers the chance to gamble and speculate.

Within Snow's practice itself, in *Projection* and *Adam and Eve*, *Scope*, *Membrane*, and others as much as *iris-IRIS*, the circulation of desire through practice, artist and myself becomes a subject of ironic self-exposure. Reflexive reading, where I see the work and my involvement with it appearing while Snow disappears, opens a gap for my entry into the process as promised reader. I have argued that this is not only an appeal for love from an intimate distance even as Snow disappears, but a double appeal made on behalf of the love of art. It's both a matter of erotic *Projection* and a visual, kinaesthetic fusion with the field of representation, represented by *Adam and Eve*, *Authorization* or *VUEƎUV* . The biographical Snow, doubled by "Snow" the artist, "loves" art and posts this on the wall. Always arriving later, I can look over his shoulder without being a target. In understanding that double appeal and loaning it my sight, love for "you" infiltrates a love of art, on both the artist's part and mine, along with a love of play and a love of these elements being acknowledged, no matter how gendered. There is no way to master this figuration, and given its multiple viewpoints, there is no way for it to dominate me.

Snow's practice breaks open the framing devices that have historically enclosed the visual codes for structures which have centred me before the lens, or painter, clear and whole, object of efficient structuring, desire, domination, narration—the terms by which I have recognized my self as metaphorically damaged. Beginning with the *Walking Woman*, Snow opened art to the world of materials and place, mobilizing sight in ambulatory bodies for passages through everything and everywhere. The world is my concern through art, not the mysteries of Being, the purity of origins, the world-earth struggle as a metaphor for art or culture (and artist) versus something called nature, all in the name of an elusive truth. Snow's practice works towards democratizing the world of art and opening different avenues by which to recognize and refigure my self. The practice of ranging between apparent opposites seen in *La région centrale*, *Field*, and found in many *Walking Women* bring back to me a multi-sighted mind-body with

different temporalities and pleasures. Pleasure found in work like *La région centrale* and *Field* which plays on oppositions also liberates me from the strict determination of an instinctual theory of desire. Pleasure can come through mediation of other sights, a phenomenon which also finds me as part of nature (my physicality) while displacing us together as others to a film strip. This is accomplished by calling me to understand that I read signs, I don't just see them, and it is through making sense of them that I come to refigure my self in a world taken as potentially legible.

As for payment, Snow pays by abandoning the mythic role of the originating and uniquely inspired artist; he dips his brush in other sites, points his lens at many views and then runs them by. He hands over his practice of mediation to be read by you and me, for love and for chance. I contribute too, agreeing in advance as I step up to the frame that an absent reader unforeseen, coming later, I cannot read everything with complete accuracy. This is not to say that an art practice frees me directly of domination or damage, but that it can elucidate how there are ways to refigure my self so that I, my self, and you over there, can become less prone to participating in models of seeing which enframe modes of thinking, living, and being. Over and over, "Snow" promises to keep the problem open: "he" promises through the love of puns, irony, jokes, mimicry, and the uncertainty of reproduction, and I arrive to read, which returns me in my embodied self, here at this moment. Recognizable *and* unforeseen, incalculable in advance, my returns exceed reasonable and legitimate interest, and I love it. Do "you," receding, ineffable, leaving only legible *traits*, send me back then, unreachable and still alive over there, but with love and a promise of more?

Notes

CHAPTER 1

1 For example, R. Bruce Elder, *Image and Identity: Reflections on Canadian Film and Culture* (Waterloo, ON: Wilfrid Laurier University Press, 1989), 396; Annette Michelson, "Toward Snow: Part 1," *Artforum* 9 (June 1971): 31, and "About Snow," *October* 8 (Spring 1979): 116-17; and John Noel Chandler, "Reflections on/of Michael Snow," *artscanada*, nos. 188-89 (Spring 1974): 51.

2 Peter Gidal, "Notes on *La Région Centrale*," in *Structural Film Anthology*, ed. Peter Gidal (London: British Film Institute, 1978), 52-53.

3 Louise Dompierre, "Embodied Vision," in Michael Snow, *Visual Art, 1951-1993 (The Michael Snow Project)* (Toronto: Art Gallery of Ontario/Power Plant and Alfred A. Knopf, 1994), 396, 427; hereafter referred to as Snow, *Visual Art*. Elder, *Image and Identity*, 25. Elder discusses the Canadian intellectual history of recoil before a hostile nature (27-35). Bart Testa, "An Axiomatic Cinema: Michael Snow's Films," in *Presence and Absence: The Films of Michael Snow, 1956-1991 (The Michael Snow Project)*, ed. Jim Shedden (Toronto: Art Gallery of Ontario and Alfred A. Knopf Canada, 1995), 68; and Bart Testa, "The Machine in the Garden," *Spirit in the Landscape* (Toronto: Art Gallery of Ontario, 1989), especially 68-71, where Testa sums up contemporary critical arguments about Snow's film *La région centrale* in terms of the Canadian debate regarding hostile nature.

4 Amy Taubin, qtd. in Kathryn Elder, "Michael Snow: A Selective Guide to the Film Literature," in *Presence and Absence*, 235 (#1253) and 237 (#1274); Teresa de

Lauretis, *Alice Doesn't: Feminism, Semiotics, Cinema* (Bloomington: Indiana University Press, 1984), 74-76.

5 Mircea Eliade, "Redemption," *Encyclopedia of Religion*, ed. Mircea Eliade (New York: Macmillan, 1987), 12, 228.

6 De Lauretis, *Alice Doesn't*, 78-81. De Lauretis discusses narration as the condition for signification and identification and whether it functions in perception itself, in an interesting critique of Snow's film *Presents* (1980-81, 90 min., colour).

7 John Tagg, *Grounds of Dispute: Art History, Cultural Politics, and the Discursive Field* (Minneapolis: University of Minnesota Press, 1992), 125-26.

8 Regina Cornwell, "Snow-Bound Camera," *Artforum* 17 (April 1979): 42; Philip Monk, "Around Wavelength," in Snow, *Visual Art*, 294.

9 Martin Heidegger, *The Question Concerning Technology and Other Essays*, trans. William Lovitt (New York: Harper and Row, 1977), 119.

10 Ibid., 129, 148-49.

11 Ibid., 14.

12 Ibid., 23.

13 Ibid., 20.

14 Ibid., 27. Heidegger was reading W. Heisenberg's work (23).

15 Ibid., 32.

16 Heidegger, *The Question Concerning Technology*, especially 13-14, 23, 27.

17 Ibid., 25.

18 Martin Heidegger, *Being and Time*, trans. John Macquarrie and Edward Robinson (1927; reprint, New York: Harper and Row, 1962), sec. 27, 165, 167.

19 John Sweetman, *The Panoramic Image* (Southampton, UK: The University, 1981), 11.

20 Ibid., 15.

21 Jonathan Crary, *Techniques of the Observer: On Vision and Modernity in the Nineteenth Century* (Cambridge, MA: MIT Press), 112-13.

22 Ibid., 118.

23 Ibid., 135-36.

24 Some of these photographs are reproduced in Stanley G. Triggs, *William Notman: L'empreinte d'un studio* (Toronto: Art Gallery of Ontario/Coach House Press, 1986), 38-42.

25 Heidegger, *The Question Concerning Technology*, 34.

26 Heidegger, *Being and Time*, sec. 36, 217.

27 Heidegger, *The Question Concerning Technology*, 13.

28 Ibid., 11.

29 Ibid., 13.

30 Martin Heidegger, *Poetry, Language, Thought*, trans. Albert Hofstadter (1936; reprint, New York: Harper and Row), 20.

31 Heidegger, *The Question Concerning Technology*, 12-13.

32 Heidegger, *Poetry, Language, Thought*, 41.

33 Ibid., 49.

34 Ibid., 63.

35 Ibid.

36 Ibid., 42.

37 Michael Snow, *Immediate Delivery*, 1998, backlit transparency, electric light box, transformer, 116.2 x 200 x 16.5 cm (light box), Art Gallery of Ontario, Toronto; Heidegger, *Poetry, Language, Thought*, 41.

38 Heidegger, *Being and Time*, sec. 31, 187.

39 Ibid., sec. 36, 214.

40 Heidegger, *Poetry, Language, Thought*, 66-67, 71.

41 Ibid., 68.

42 Ibid., 39.

43 Ibid., 55.

44 Ibid., 53.

45 Ibid., 51.

46 Ibid., 44.

47 Ibid., 42.

48 Ibid., 78.

49 Ibid., 32-35, 40-41.

50 Ibid., 74.

51 Martin Heidegger, *On the Way to Language*, trans. Peter D. Hertz (New York: Harper and Row, 1971), 73, 88, 90.

52 Heidegger, *Being and Time*, sec. 34, 208.

53 Heidegger, *On the Way to Language*, 99-101.

54 Ibid., 114, for references to mouth; for the hand, see Martin Heidegger, *Basic Writings*, ed. David Farrell Krell (San Francisco: Harper and Row, 1977), 357.

55 Heidegger, *On the Way to Language*, 112.

56 Heidegger, *Basic Writings*, 351.

57 Ibid., 200-201, 203.

58 Ibid., 206.

59 Ibid., 202.

60 Ibid., 206, 204.

61 For an accessible discussion and critique of this term in Lacanian and feminist psychoanalytic theory, see Elizabeth Grosz, *Jacques Lacan: A Feminist Introduction* (London and New York: Routledge, 1990).

62 Quoted in Heidegger, "Language" (1959), *Poetry, Language, Thought*, 194-95.

63 Heidegger, "Language in the Poem" (1953), *On the Way to Language*, 159-98.

64 Heidegger's usage, as translated by A. Hofstadter, *Poetry, Language, Thought*, 204.

65 Heidegger, *Poetry, Language, Thought*, 63.

66 Walter Benjamin, *Reflections: Essays, Aphorisms, Autobiographical Writings*, ed. Peter Demetz, trans. Edmund Jephcott (New York: Schocken, 1986), 93, 129.

67 Ibid., 93.

68 Walter Benjamin, *Illuminations: Essays and Reflections*, ed. Hannah Arendt, trans. Harry Zohn (New York: Schocken, 1969), 258-59.

69 Ibid., 241.

70 Emilio Marinetti, qtd. in Benjamin *Illuminations*, 241.

71 Benjamin, *Reflections*, 192.

72 Ann Thomas, *Fact and Fiction: Canadian Painting and Photography, 1860-1900 / Le réel et l'imaginaire: Peinture et photographie canadiennes, 1860-1900* (Montreal: Musée McCord/McCord Museum, 1979), 47-48.

73 Benjamin, *Illuminations*, 126; *Reflections*, 334.

74 Benjamin, *Reflections*, 66.

75 Benjamin, *Illuminations*, 133.

76 Ibid., 235-37.

77 Sigrid Weigel, *Body- and Image-Space: Re-reading Walter Benjamin*, trans. Georgina Paul (London and New York: Routledge, 1996), 156.

78 Ibid., 153.

79 Benjamin, *Illuminations*, 263-64 (sec. A-B).

80 Ibid., 136.

81 Benjamin, *Reflections*, 334.

82 Ibid., 336.

83 Benjamin, *Illuminations*, 122.

84 Ibid., 253-54.

85 Benjamin, *Reflections*, 181-82.

86 Benjamin, *Illuminations*, 221, 224, 238.

87 Ricoeur, *Oneself as Another*, trans. Kathleen Blamey (Chicago: University of Chicago Press, 1992), 310, 314.

88 Eliade, *Encyclopedia of Religion*, 12: 229.

89 E.g., *The Holy Bible*, The New Testament, The New King James Version, "The Epistle of Saint Paul the Apostle": Romans 5:8-18; Romans 14; Corinthians 13; Ephesians 2: 8-10.

90 Paul Ricoeur, *The Philosophy of Paul Ricoeur: An Anthology of His Work*, ed. Charles E. Reagan and David Stewart (Boston: Beacon Press, 1978), 220.

91 Ricoeur, *Oneself as Another*, 317.

92 Ibid., 119.

93 Ibid., 321.

94 Ibid., 129.

95 Ibid., 324.

96 Ibid., 121.

97 Ibid., 124.

98 Ibid., 351.

99 Ibid., 354.

100 Ibid., 353.

101 Ibid., 354.

102 Ibid., 309.

103 Heidegger, *Being and Time*, sec. 56, 318-19.

104 Ricoeur, *Oneself as Another*, 352; 312 n. 15.

105 Ibid., 352. The seventh study of this book is devoted to this phrase.

106 Ibid., 352.

107 Paul Ricoeur, *From Text to Action: Essays in Hermeneutics, II*, trans. Kathleen Blamey and John B. Thompson (Evanston, IL: Northwestern University Press, 1991), 76.

108 Ibid., 84-86. Much of this material was first presented in "What is a Text? Explanation and Understanding" (1970; in French), and "The Hermeneutical Function of Distanciation" (*Philosophy Today* 17 [1973]: 129-43), republished in *Paul Ricoeur: Hermeneutics and the Human Sciences*, ed. and trans. John B. Thompson (Cambridge: Cambridge University Press, 1981), 145-64; *A Ricoeur Reader: Reflection and Imagination*, ed. Mario J. Valdés (Toronto: University of Toronto Press, 1991), 43-64.

109 Ricoeur, *From Text to Action*, 83.

110 Ibid., 83.

111 Ibid., 87.

112 Ibid., 88.

113 Ibid., 122.

114 Ricoeur, *Oneself as Another*, 22, 302.

115 Derrida made the reasons for his mistrust clear in *Of Spirit: Heidegger and the Question*, trans. Geoffrey Bennington and Rachel Bowlby (Chicago: University of Chicago Press, 1989), an analysis of Heidegger's Nazism through his texts, especially those on language and poetry.

116 Jacques Derrida, *The Post Card: From Socrates to Freud and Beyond*, trans. Alan Bass (Chicago: University of Chicago Press, 1987), 21.

117 Ibid., 6. Derrida signs his proper name for authorship of the postcards, a promise that he is there, to reduce your anxiety. But in note 1 he immediately retracts the promise of either the addressee's or his own singularity. The mark, or writing, is legible and can be made by several, as he says.

118 Ibid., 17.

119 Ibid., 33.

120 Ricoeur, *A Ricoeur Reader*, 322.

121 Ibid., 321.

122 Ibid., 322.

123 Derrida, *The Post Card*, 29.

124 Ibid., 29.

125 Ibid., 29.

126 Ibid., 24.

127 Derrida, *The Post Card*, 5, 6.

128 Ibid., 382-83.

129 Ibid., 384, 385.

130 Ibid., 404-405.

131 Ibid., 26.

132 Jacques Derrida, *Dissemination*, trans. Barbra Johnson (1972; reprint, Chicago: University of Chicago Press, 1981), 186-87n. 14.

133 Ibid., 181.

134 Ibid., 206-207.

135 Ibid., 206.

136 Ibid., 219.

137 Ibid., 224.

138 Stéphane Mallarmé, qtd. in Derrida, *Dissemination*, xx, xxii.

139 Michael Snow, *So Is This*, 1982, 43 minutes, colour, silent. A facsimile copy of the handwritten text with the amount of screen time assigned to each word, followed by a typed transcript, appears in *The Collected Writings of Michael Snow*, ed. Louise Dompierre (Waterloo, ON: Wilfrid Laurier University Press, 1994), 209-31.

CHAPTER 2

1 Michael Snow, "A Lot of Near Mrs." (1962-63), *The Collected Writings of Michael Snow*, 18.

2 *Duet*, 1965, polymer, acrylic, and enamel on canvas, 173 x 33 cm, Canada Council Art Bank, Ottawa.

3 *Mixed Feelings*, April 1965, acrylic on canvas, 253.5 x 150.5 cm, Vancouver Art Gallery (Snow, *Visual Art*, 151).

4 Personal conversation with Michael Snow, 12 September 1995.

5 *Clothed Woman (In Memory of My Father)*; *27 Ladies (Women)*; *Encyclopaedia*; *Torso*; *Gone*, all from Snow, *Visual Art*, 155, 166-68, 173-74.

6 *Carla Bley*, June 1965, *Toronto 20* portfolio, edition of 100, photo-offset print and line block, black and blue ink on paper, 66.2 x 51 cm; Art Gallery of Ontario, Toronto. *Negative Figure*, 1967, stainless steel over plywood core, 230.5 x 91.5 x 4 cm, Art Gallery of Ontario, Toronto. Film still from *New York Eye and Ear Control* (*Visual Art*, 150, 146, and 57).

7 *Cry-Beam*, 1965, enamel on canvas over wood, 37 x 70.2 x 140.5 cm, Snow, *Visual Art*, 152; *Hawaii*, 1964, enamel on two canvases and plywood, 149.9 x 309.9 cm, National Gallery of Canada, Ottawa (colour plate 2, Snow, *Visual Art*, 130); *Morningside Heights* (profile only), 1965, acrylic and enamel on plywood, 67.7 x 91 cm (Snow, *Visual Art*, 153); *Test Focus Field Figure*, 1965, spray enamels on canvas, 152.4 x 203.2 cm, Art Gallery of Ontario, Toronto (colour plate 1, Snow, *Visual Art*, 129).

8 Robert Fulford, "World of Art: Snowgirl," *Toronto Daily Star*, 31 March 1962; qtd. in Snow, *Visual Art*, 44.

9 Donald Judd, "In the Galleries: Michael Snow," *Arts Magazine* 38 (March 1964): 61.

10 Elizabeth Kilbourn, "Michael Snow at the Isaacs Gallery," *Canadian Art* 19 (May-June 1962): 178.

11 Kilbourn, "Michael Snow," 178.

12 Snow, *The Collected Writings of Michael Snow*, 17-19.

13 *New York Eye and Ear Control*, 1964, 34 minutes, black and white; first shown 5 April 1965 in the Ten Centuries Concerts at the Edward Johnson Building at the University of Toronto. First shown in New York at the Astor Playhouse later in 1965 as part of the Film-Makers' Cinematheque program.

14 Snow, *Collected Writings*, 17, 19.

15 Snow, *The Collected Writings of Michael Snow*, 17.

16 Michael Snow, *Wavelength*, 1967, 45 minutes, colour.

17 *Theory of Love*, January 1961, oil and metallic paint on canvas, 162.8 x 101.2 cm, Art
 Gallery of Ontario, Toronto; *Title*, 1960, charcoal on folded paper on board, 35 x
 24.5 cm, National Gallery of Canada, Ottawa; both in Snow, *Visual Art*, 203, 209.

18 *Self-Centered*, January 1960, oil on canvas, 126.5 x 101.5 cm, National Gallery of
 Canada, Ottawa (colour plate 11, Snow, *Visual Art*, 139).

19 Clement Greenberg, "The New Sculpture (1948, 1958)," *Art and Culture: Critical
 Essays* (Boston: Beacon Press 1965), 139.

20 Greenberg, "Modernist Painting," in *The New Art*, ed. Gregory Battcock (New York:
 E.P. Dutton, 1973), 67.

21 Andrée Hayum (1972), "Information or Illusion: An Interview with Michael
 Snow," in Snow, *The Collected Writings of Michael Snow*, 83.

22 Robert Rauschenberg, qtd. in Daniel Wheeler, *Art Since Mid-Century: 1945 to the
 Present* (Englewood Cliffs, NJ: Prentice-Hall, 1991), 131.

23 *Four to Five*, 1962, edition of 3, 16 gelatin silver prints mounted on cardboard,
 framed, 68.0 x 83.3 cm, Art Gallery of Ontario, Toronto.

24 Snow, *Collected Writings*, 18.

25 Jasper Johns, qtd. in Wheeler, *Art Since Mid-Century*, 136.

26 Snow, *Collected Writings*, 18-19.

27 Sidra Stich, *Made in U.S.A.: An Americanization in Modern Art, the '50s and '60s*
 (Berkeley and Los Angeles: University of California Press, 1987), 25.

28 Ibid., 19.

29 Snow, qtd. in Gene Youngblood, "Icon and Idea in the World of Michael Snow,"
 artscanada 27 (February 1970): 4.

30 *Venus Simultaneous*, 1962, oil and lucite medium on canvas, cardboard, and ply-
 wood, 200.7 x 299.7 x 15.2 cm, Art Gallery of Ontario, Toronto.

31 Snow, *Collected Writings* 17-18.

32 Ibid., 17.

33 Youngblood, "Icon and Idea," 3.

34 Dennis Reid, "Exploring Plane and Contour: The Drawing, Painting, Collage,
 Foldage, Photo-Work, Sculpture and Film of Michael Snow from 1951-1967," in
 Snow, *Visual Art*, 37-38.

35 Lucy R. Lippard, *Pop Art* (New York: Praeger 1966), 195.

36 Reid, *Visual Art*, 115.

37 Graham Coughtry, qtd. in D. Burnett and M. Schiff, *Contemporary Canadian Art*,
 (Edmonton: Hurtig and Art Gallery of Ontario, 1983), 85.

38 Snow, *Collected Writings* 17; Dompierre, *Walking Woman Works: Michael Snow 1961-
 67. New Representational Art and Its Uses* (Kingston: Agnes Etherington Art Centre,
 Queen's University, 1983), 26-28.

39 *Sketch for Painting* 1959, ink and chalk on paper, 19.5 x 26.5 cm, private collection;
 Sketch for Painting, 1959, ink and chalk on paper, 36 x 19.9 cm, private collection;
 Blue and Purple Drawing, 1959, gouache and ink over graphite on paper, 27.6 x 43
 cm, Guido Molinari (Montreal) in Snow, *Visual Art*, 226-27.

40 *Blues in Place*, September 1959, oil and paper collage on canvas, 203.6 x 127.9 cm,
 National Gallery of Canada, Ottawa (Snow, *Visual Art*, 225).

41 *Secret Shout*, January 1960, oil and charcoal on canvas, 132 x 190 cm, L.V.N. Pavlychenko, Claremont, ON (Snow, *Visual Art*, 222).

42 *Reclining Figure*, 1955, photo dyes on paper, collage on board, 76.2 x 94.3 cm, Mr. and Mrs. Ray Jessel, Los Angeles; *Enchanted Woman*, 1956, photo dyes on paper collage on board, 54.5 x 64.7 cm, The Isaacs/Innuit Gallery, Toronto (Snow, *Visual Art*, 141, 253).

43 *January Jubilee Ladies*, 1961, chalk, gouache, and paper collage on corrugated cardboard, 137.2 x 190.5 cm, External Affairs and International Trade Canada (Snow, *Visual Art*, 196-97).

44 Snow, "Title or Heading," *Collected Writings* 13.

45 Judd, "In the Galleries," 61.

46 Judd, "Specific Objects," *Arts Yearbook* 8, *Art Digest* 1965, 23-35.

47 Mel Bochner, "Art in Process—Structures," *Arts Magazine* 40 (September-October 1966): 38-39; "Primary Structures," *Arts Magazine* 40 (June 1966): 32-35; "Systemic," *Arts Magazine* 41 (November 1966: 40; and "Serial Art Systems: Solipsism," *Arts Magazine* 41 (Summer 1967): 39-43

48 *Projection*, 1970, edition of 50, two-colour lithograph on Arches paper, 51 x 61.2 cm, Michael Snow, National Gallery of Canada, Ottawa, and others. *Adam and Eve*, 1997, colour photograph, earth and glue mix, wooden frame, 161 x 56 x 4.5 cm, Michael Snow; in colour in *Michael Snow: Panoramique. Oeuvres Photographiques et Films 1962-1999* (Brussels: Société des Expositions du Palais des Beaux-Arts de Bruxelles, 1999), 33; a photograph of Snow digitally distorted into an undulating WW figure walking across a field of northern ground vegetation, against a "ground" of earth.

49 Robert Morris qtd. in Ursula Meyer, *Conceptual Art* (New York: E.P. Dutton, 1972), xiv.

50 Ian Burn and Mel Ramsden, conceptual artists, qtd. in Meyer, *Conceptual Art*, xix.

51 Meyer, *Conceptual Art*, xiv-xv, and n. 21.

52 Walter Benjamin, *Illuminations: Essays and Reflections*, ed. Hannah Arendt, trans. Harry Zohn (New York: Schocken, 1969), 264.

53 Thierry de Duve, "Echoes of the Readymade: Critique of Pure Modernism," *October* 70 (Fall 1994): 65.

54 Ibid., 69.

55 Ibid., 68-69.

56 Marcel Duchamp, qtd. in Ibid., 72.

57 Ibid., 72.

58 Joseph Kosuth, *Art After Philosophy and After: Collected Writings, 1966-1990* (Cambridge, MA and London: MIT Press, 1991), 16-17.

59 *Switch*, 1963, oil on canvas, 153.5 x 114 cm, Geraldine Sherman and Robert Fulford, Toronto (colour plate 4, in Snow, *Visual Art*, 132).

60 Snow, qtd. in Dennis Reid, "Exploring Plane and Contour: The Drawing, Painting, Collage, Foldage, Photo-Work, Sculpture and Film of Michael Snow from 1951-1967," in Snow, *Visual Art*, 116.

61 Snow, *Collected Writings*, 18.

62 Snow, qtd. in Reid, *Visual Art, 1951-1993*, 50.

63 Duchamp, qtd. in Meyer, *Conceptual Art*, ix.

64 *Precision Optics* is a rotating glass disk engraved with a spiral/eye and bordered by the motto: *Rrose Sélavy et moi esquivons les ecchmyoses des esquimaux aux mots exquis* (Eros, that's life, and I prefer the bruises of the Eskimos to exquisite words), which has an erotic meaning intelligible through homonymic puns on slang.

65 De Duve, "Echoes," 69, who cites the list compiled by André Gervais in *La raie alitée d'effets* (Montreal: HMH, 1984).

66 De Duve, "Echoes," 74.

67 Ibid., 73.

68 Linda Hutcheon, *Splitting Images: Contemporary Canadian Ironies* (Toronto: Oxford University Press, 1991), 11.

69 Ibid., 130-31.

70 *General Idea, FILE Magazine* 4, 1 (1978: 13; qtd. in Hutcheon, *Splitting Images*, 131.

71 Contemporary photographs of salon nudes by these artists, including purchases by the French state, are reproduced in T.J. Clark's "Olympia's Choice," *The Painting of Modern Life: Paris in the Art of Manet and His Followers* (Princeton: Princeton University Press, 1984), 118-25. Clark discusses the already problematic status of the salon nude and its reception in 1865, when *Olympia* was exhibited at the salon of 1865.

72 All of these are reproduced in Snow, *Visual Art: Seen*, 152; *Register*, 158; *Stairs*, 163; *Olympia*, 172; *A Falling Walking Woman*, 184; *Half-Slip*, 162; *Rolled Woman I*, 189; and *Touched Woman*, 193.

73 Snow, *Visual Art*, 211-15.

74 Krauss, *The Optical Unconscious*, 23.

75 Ibid., 24.

76 Snow, *Collected Writings* 17, 19.

77 *Stereo*, 1982, mixed media and Polaroid photograph, 22.9 x 38.1 x 33 cm, Snow, *Visual Art*, 455.

78 Laura Mulvey, "Visual Pleasure and Narrative Cinema," in *Visual and Other Pleasures* (Bloomington: Indiana University Press, 1989), 21.

CHAPTER 3

1 Snow, *La région centrale*, 1971, 3 hours, colour.

2 For example, Michael Taussig, in *Shamanism, Colonialism, and the Wild Man: A Study in Terror and Healing* (Chicago: University of Chicago Press, 1987), 112-19, discusses documentary photographs of the Huitotos and the interests that the photos served in terms of voyeurism, colonialism, and terrorism.

3 Michael Fried, "Art and Objecthood," *Artforum* 5 (June 1967): 12-23.

4 Frances Colpitt, *Minimal Art: The Critical Perspective* (Seattle: University of Washington Press, 1990), 69.

5 Ibid., 59.

6 Ibid., 71n. 21.

7 Ibid., 71-72.

8 Described in Rosalind Krauss, *Passages in Modern Sculpture* (Cambridge, MA: MIT Press, 1983), 201.

9 Donald Judd, "In the Galleries: Michael Snow," *Arts Magazine* 38 (March 1964): 61.

10 *Sight*, 1967, aluminum, engraved plastic, 142.2 x 106.7 cm, Vancouver Art Gallery (Snow, *Visual Art* [*The Michael Snow Project*] [Toronto: Art Gallery of Ontario, et al., 1994], 315-16).

11 *Portrait*, 1967, aluminum, approx. 60.9 x 91.4 cm (adjustable), private collection, Ottawa.

12 *Morningside Heights*, 1965, two elements: enamel on timber and plywood, Plexiglas, 172.7 x 290 x 20.5 cm; acrylic and enamel on canvas, 67.7 x 91 cm, Michael Snow, Toronto; *Sleeve*, 1965, installation piece of 12 parts, 365.8 x 365.8 x 304.8 cm, The Vancouver Art Gallery (Snow, *Visual Art*, 153, 448-49).

13 Martin Heidegger, *Poetry, Language, Thought*, trans. Albert Hofstadter (New York: Harper and Row, 1971), 218.

14 Ibid., 151-53.

15 Leon Battista Alberti, *On Painting* (1436; reprint, trans. John R. Spencer, New Haven, CT: Yale University Press, 1966), 56.

16 Jean-Claude Lebensztejn, "Starting out from the Frame (Vignettes)," *Deconstruction and the Visual Arts: Art, Media, Architecture*, ed. Peter Brunette and David Wills (Cambridge and New York: Cambridge University Press, 1994), 121.

17 William V. Dunning, *Changing Images of Pictorial Space: A History of Spatial Illusion in Painting* (Syracuse, NY: Syracuse University Press, 1991), 13.

18 Dunning, *Changing Images*, 13.

19 Alberti, *On Painting*, 55.

20 Ibid., 57.

21 Dunning, *Changing Images*, 2-3.

22 Heidegger, *Poetry, Language, Thought*, 42.

23 Paul Ricoeur, *Oneself as Another*, trans. Kathleen Blamey and John B. Thompson (Chicago: University of Chicago Press, 1992), 351.

24 *Membrane*, 1969, chromed steel, wood, rubber, 49.3 x 67.6 x 8.7 cm, Art Gallery of Ontario, Toronto; first shown in the retrospective *Michael Snow/A Survey*, Art Gallery of Ontario, 14 February-15 March 1970.

25 Jacques Derrida, *Dissemination*, trans. Barbara Johnson (Chicago: University of Chicago Press, 1981), 213.

26 Ibid., 212-13.

27 Ibid., 209-10.

28 Ibid., 214.

29 *Scope*, 1967, stainless steel, mirror; two elements 68.5 x 68.5 x 37.5 cm, one element 305 x 69 x 36 cm, two elements 137.5 x 71 x 26 cm, two elements 106.5 x 84 x 33.7 cm, National Gallery of Canada, Ottawa; 302-306 in *Visual Art*.

30 Sigmund Freud, "Beyond the Pleasure Principle" (1920), in *On Metapsychology: The Theory of Psychoanalysis*, ed. and trans. under James Strachey, ed. Angela Richards, 11, The Pelican Freud Library, Penguin Books (Harmondsworth: UK, 1985), 284-85.

31 Snow, qtd. in Philip Monk, "Around *Wavelength*: The Sculpture, Film and Photo-Work of Michael Snow from 1967-1969," *Visual Art*, 319.

CHAPTER 4

1 *Authorization*, 1969, black and white Polaroid photographs, cloth tape, mirror, metal, 54.6 x 44.4 cm, National Gallery of Canada, Ottawa (Snow, *Visual Art*, *1951-1993*, 356). Many reproductions of this work have the mirror masked so that the viewer's reflection looking at or rephotographing the piece is excluded (Regina Cornwell, *Snow Seen: The Films and Photographs of Michael Snow* [Toronto: PMA Books, 1980], 42). *Venetian Blind*, 1970, edition of 3, 24 colour photographs, framed in four sections, 126 x 234 cm, The Canada Council Art Bank, Ottawa (Snow, *Visual Art*, 394-95).

2 Philip Monk, in Snow, *Visual Art*, 364. John Noel Chandler, "Reflections on /of Michael Snow," *artscanada* 31 (Spring 1974): 52.

3 Robert Fulford, "Apropos Michael Snow," in *Michael Snow/A Survey* (Toronto: Art Gallery of Ontario, 1970), 11.

4 Dennis Young, "Origins and Recent Work," in *Michael Snow/A Survey*, 15-16.

5 Cornwell, *Snow Seen*, 43.

6 Gene Youngblood, "Icon and Idea in the World of Michael Snow," *artscanada* 27 (February 1970): 5.

7 Amy Taubin, "Doubled Visions," *October* 4 (Fall 1977): 34-35.

8 Peter Gidal, "Beckett and Others and Art: A System," *Studio International* 188, no. 971 (November 1974): 183.

9 Ibid., 183.

10 Ibid., 184.

11 Ricoeur, *Oneself as Another*, trans. Kathleen Blamey (Chicago: University of Chicago Press, 1992), 59.

12 Ibid., 63.

13 Cornwell, *Snow Seen*, 35.

14 Ibid., 34.

15 Ibid., 33.

16 Snow, *Visual Art*, 355.

17 Chardin's three pastel self-portraits are reproduced in Jacques Derrida, *Memoirs of the Blind: The Self-Portrait and Other Ruins*, trans. Pascal-Anne Brault and Michael Naas (Chicago: University of Chicago Press, 1993), 74-75; their dating is discussed 135-36. Chardin, sensitized to the pigments for oils and going blind, switched to pastels from 1771-79.

18 Derrida, *Memoirs of the Blind*, 68.

19 Ibid., 69.

20 Snow, *The Collected Writings of Michael Snow* (*The Michael Snow Project*), ed. Louise Dompierre (Waterloo: Wilfrid Laurier University Press, 1994), 224, 282.

21 Dompierre, in Snow, *Visual Art*, 393.

22 Ibid., 392.

23 Heidegger, *Poetry, Language, Thought*, trans. Albert Hofstadter (New York: Harper and Row, 1971), 59.

24 Hubert Damisch, *The Origin of Perspective*, trans. John Goodman (Cambridge: MIT Press, 1994), 59-68. E.g., Antonio Averlino detto il Filareto (probably between 1460 and 1464), Antonio de Tucci Manetti (after 1475), and Giorgio Vasari (c. 1575). Damisch discusses how aspects of authorship, attribution, and content of these texts are debatable.

25 Ibid., 90-91. Damisch discusses whether Brunelleschi's panel was neither square nor one-half *braccio* per side, but argues that whatever the precise shape and size, it was small and easily handled.

26 Ibid., 120.

27 Ibid., 122.

28 Ibid., 139.

29 Ibid., 139.

30 Ibid., 140.

31 Ricoeur, *Oneself as Another*, 155-56.

32 Ibid., 123.

33 *Egg*, 1985, hologram and iron skillet on base, 91.4 x 106.7 cm, Musée National d'Art Moderne, Centre Georges Pompidou, Paris (also in Snow, *Visual Art*, 391).

34 Derrick de Kerckhove, "Holography, '*mode d'emploi*': On Michael Snow's Approach to Holography," in Snow, *Visual Art*, 506.

35 *Redifice*, 1986, installation-structure containing nine holograms and eleven photographs, 2.4 m x 6 m x 76.2 cm overall, Art Gallery of Hamilton, Hamilton, Ontario; in Snow, *Visual Art*, 469. The Zeus panel and a *vanitas* still life of candle, bottle, and glass of wine appear on pages 504 and 505, respectively.

36 De Kerckhove, in Snow, *Visual Art*, 503, 506.

37 Dompierre, in Snow, *Visual Art*, 396.

Chapter 5

1 Snow, *La région centrale*, 1971, approximately 3 hours, colour.

2 Bart Testa, *Spirit in the Landscape* (Toronto: Art Gallery of Ontario, 1989); *La région centrale* is discussed 61-71.

3 For example, Northrop Frye, *The Bush Garden: Essays on the Canadian Imagination* (Toronto: House of Anansi, 1971), 138-43, 199, 225-26; Margaret Atwood, "Nature the Monster," *Survival: A Thematic Guide to Canadian Literature* (Toronto: House of Anansi, 1972), 47-67; Gaile McGregor, *The Wacousta Syndrome* (Toronto: University of Toronto Press, 1985), 9-21.

4 Frye, *Bush Garden*, 141.

5 Barbara Novak, *American Painting of the Nineteenth Century: Realism, Idealism, and the American Experience*, 2nd ed. (New York: Harper and Row, 1979), 62.

6 Ralph Waldo Emerson, qtd. in Novak, *American Painting*, 62.

7 C. Stuart Houston, ed. *Arctic Artist: The Journal and Paintings of George Back, Midshipman with Franklin, 1819-1822* (Montreal and Kingston: McGill-Queen's University Press, 1994), figures 17 and 15, respectively.

8 George Grant, *Technology and Empire: Perspectives on North America* (Toronto: House of Anansi, 1969), 20.

9 Ibid., 23.

10 Ibid., 138.

11 Ibid., 137.

12 Ibid., 23, 25, respectively.

13 Maria Tippett and Douglas Cole, *From Desolation to Splendour: Changing Perspectives of the British Columbia Landscape* (Toronto and Vancouver: Clarke, Irwin, 1977), 27, 49.

14 Ibid., chap. 4.

15 Back, *Arctic Artist*, figures 23 and 21, respectively.

16 C.W. Jefferys, qtd. in Dennis Reid, *A Concise History of Canadian Painting* (Toronto: Oxford University Press, 1973), 137.

17 Ann Davis, *The Logic of Ecstasy: Canadian Mystical Painting 1920-1940* (Toronto: University of Toronto Press, 1992), 42.

18 Michael Snow, qtd. in Charlotte Townsend, "Converging on *La Region Centrale*: Michael Snow in conversation with Charlotte Townsend," *artscanada* 28 (February/March 1971): 46.

19 Snow, qtd. in Elder, *Image and Identity* (Waterloo, ON: Wilfrid Laurier University Press, 1989), 393.

20 Snow, qtd. in Townsend, "Converging," 47.

21 W.J.T. Mitchell, "Imperial Landscape," in *Landscape and Power*, ed. W.J.T. Mitchell (Chicago: University of Chicago Press, 1994), 14.

22 Snow, qtd. in Townsend, "Converging," 47.

23 Richard Foreman, "Critique: Glass and Snow," *Arts Magazine* 44 (February 1970): 22; Gene Youngblood, *Expanded Cinema* (New York: E.P. Dutton, 1970), 122.

24 Snow, "Letter from Michael Snow," *The Collected Writings of Michael Snow*, ed. Louise Dompierre (Waterloo: Wilfrid Laurier University Press, 1994), 45-46.

25 Michael Snow, <----->, 1968-1969, 50 minutes, colour.

26 Foreman, "Critique," 21.

27 Ibid., 22.

28 Youngblood, *Expanded Cinema*, 110-11.

29 Ibid., 111.

30 Michael Snow, *Breakfast (Table Top Dolly)*, 1972-76, 15 minutes, colour, silent.

31 Annette Michelson, "About Snow," *October* 8 (Spring 1979): 115. Elder, *Image and Identity*, 369.

32 Michelson, "About Snow," 114.

33 Elder, *Image and Identity*, 371.

34 Elder, *Image and Identity*, 393.

35 Elder, *Image and Identity*, 369.

36 Paul Ricoeur, *Oneself as Another*, trans. Kathleen Blamey (Chicago: University of Chicago Press, 1992), 118.

37 Snow, *The Collected Writings of Michael Snow*, 40, which is a facsimile of the cover of *Film Culture* 46 (Autumn 1967) on which appears the statement Snow wrote about *Wavelength* for the Fourth International Experimental Film Competition, Knokke-le-Zoute, Belgium (1968).

38 Elder, *Image and Identity*, 395.

39 Michelson, "About Snow," 118.

40 Jean-Louis Baudry, qtd. in Michelson, "About Snow," 120-21.

41 Elder, *Image and Identity*, 397.

42 *Standard Time*, 1967, 8 minutes, colour, pans 180 degrees around an apartment; <----->, 1968-69, 50 minutes, colour, pans horizontally and vertically in a classroom; *So Is This*, 1982, 43 minutes, colour, silent, projects a text word by word; *Seated Figures*, 1988, 42 minutes, colour, composed of trucking shots of the ground travelling from paved road to a field of wildflowers, with a soundtrack of audience-like and projector noises.

43 Elder, *Image and Identity*, 399.

44 Michelson, "About Snow," 122.

45 Ibid., 123.

46 Ricoeur, *Oneself as Another*, 318.

47 Philip Monk in Michael Snow, *Visual Art* (Toronto: Art Gallery of Ontario, et al., 1994), 375n. 30.

48 Peter Gidal, "Theory and Definition of Structural/Materialist Film," in *Structural Film Anthology*, ed. Peter Gidal (London: British Film Institute, 1978), 14.

49 Gidal, *Structural Film Anthology*, 1.

50 Ibid., 3.

51 Ibid., 15, 53.

52 Ibid., 54-55.

53 Townsend, "Converging," 47.

54 *De la*, 1969-71, aluminum and steel with electronic controls, television camera, four video monitors, painted circular wood base, 182.9 x 182.9 x 243.8 cm, National Gallery of Canada, Ottawa.

55 Bart Testa, "An Axiomatic Cinema: Michael Snow's Films," in *Presence and Absence: The Films of Michael Snow 1956-1991 (The Michael Snow Project)*, ed. Jim Shedden (Toronto: Art Gallery of Ontario/Alfred A. Knopf, 1995), 68.

56 Ibid., 68.

57 Ibid., 59-60.

58 For example, Gidal, *Structural Film Anthology*, 6; Elder, *Image and Identity*, 319.

59 Elder, *Image and Identity*, 394.

60 Ricoeur, *Oneself as Another*, 119.

61 Ibid., 118.

62 Ibid.

63 Ibid., 129.

64 Ibid., 168.

65 Ibid.

66 *Monocular Abyss*, 1982, alkyd-painted polyester resin, 111.8 x 69.2 x 139.7 cm, Art
 Gallery of Ontario, Toronto; gift of Michael Snow 2001; Snow, *Visual Art*, 457.

67 *Sighting*, 1982, aluminum, 38.1 x 104.1 x 27.9 cm, Art Gallery of Ontario, Toronto;
 gift of Michael Snow 2001.

68 *Zone*, 1982, Plexiglas, 7.9 x 2.97 x 36.5 cm, Art Gallery of Ontario, Toronto; pur-
 chased with funds from an anonymous donor 2001; Snow, *Visual Art*, 454-55.

69 *Crouch, Leap, Land*, 1970, colour photographs (3 parts), Plexiglas, metal, 40.6 x 35.6
 cm each, Art Gallery of Ontario, Toronto (in *Visual Art*, 399).

70 Louise Dompierre, in Snow, *Visual Art*, 405, 409, discusses Muybridge and Snow.

71 *Shutter Bugs*, 1973-74, colour photographs, Plexiglas, 55.9 x 121.9 cm; John Noel
 Chandler, "Reflection on/of Michael Snow," *artscanada* 31 (Spring 1974): 51.

72 *Snow Storm, February 7, 1967*, 1967, black and white photographs, enamelled
 masonite, 121.9 x 121.9 cm, National Gallery of Canada, Ottawa; Snow, *Visual
 Art*, 320.

73 Testa, "An Axiomatic Cinema," 68; Elder, *Image and Identity*, 303-304.

74 *Bees Behaving on Blue*, 1979, colour photograph, 74.5 x 90.5 cm, Canada Council
 Art Bank, Ottawa; Snow, *Visual Art*, 449-50.

75 *Field*, 1973-74, gelatin silver prints on cardboard in painted wood frame, 179.1 x
 170.2 cm (framed), National Gallery of Canada, Ottawa.

76 Walter Benjamin, *Reflections: Essays, Aphorisms, Autobiographical Writings*, ed. Peter
 Demetz, trans. Edmund Jephcott (New York: Schocken, 1978), 326.

77 Ibid., 331, 332.

78 Ibid., 329.

79 Mieke Bal, *Reading Rembrandt: Beyond the Word-Image Opposition* (Cambridge:
 Cambridge University Press, 1991), 274.

80 Ibid., 276.

CHAPTER 6

1 From the title of *See You Later (Au Revoir)*, 1990, 18 minutes, colour film.

2 *Plus tard*, 1977, 25 C-prints, painted wood frames, Plexiglas, 86.4 x 108 cm each,
 National Gallery of Canada, Ottawa; *iris-IRIS*, 1979, chromogenic print, acrylic
 paint, postcard on masonite mounted on plywood, 121.9 x 119.4 cm each panel,
 Art Gallery of Ontario, Toronto.

3 Regina Cornwell, *Snow Seen: The Films and Photographs of Michael Snow* (Toronto:
 PMA, 1980), 58.

4 Pierre Théberge, "Sept Films et 'Plus Tard'," in *Michael Snow* (Paris: Centre Georges
 Pompidou, Musée National d'Art Moderne, 1978), 9.

5 Charles C. Hill, "The National Gallery, a National Art, Critical Judgement and the
 State," *The True North: Canadian Landscape Painting 1896-1939*, ed. Michael Tooby
 (London: Lund Humphries/Barbican Art Gallery, 1991), 72. Although the group
 did not adopt a name until their 1920 exhibition in Toronto, they began working
 together in 1913, moving into the Studio Building of Canadian Art constructed for

them by Dr. James MacCallum and Lawren Harris (see Dennis Reid, *A Concise History of Canadian Painting*, 139-40).

6 Hill, "The National Gallery," 77-78. Théberge *Michael Snow*, 9.

7 Michael Tooby, "Orienting the True North," *The True North*, 29.

8 Frye, *The Bush Garden*, 199-201.

9 The Group of Seven project in this regard, and its concrete roots in Northern Symbolist painting, is analyzed by Roald Nasgaard, *The Mystic North: Symbolist Landscape Painting in Northern Europe and North America 1890-1940* (Toronto: Art Gallery of Ontario and University of Toronto Press, 1984).

10 Exhibition schedule in Théberge, *Michael Snow*, facing title page.

11 The perspective of Canadian nature as a threat to human survival, especially prior to the twentieth century, is reviewed by such writers as Northrop Frye, Margaret Atwood, Gaile McGregor (cited in chapter 5), and Ramsay Cook in *Canada, Quebec, and the Uses of Nationalism*, 2nd ed. (Toronto: McClelland and Stewart, 1995.)

12 Louise Dompierre, *Toronto: A Play of History (Jeu d'histoire)* (Toronto: Power Plant, 1987), 23.

13 Dompierre in Snow, *Visual Art, 1951-1993*, 439.

14 Ibid., 427.

15 Ibid., 444.

16 Benjamin, *Illuminations*, 220-21; 218.

17 Ibid., 242.

18 Théberge, *Michael Snow* (Luzern), 21.

19 Snow, qtd. in Théberge, *Michael Snow*, 21-22.

20 Joel Snyder, "Picturing Vision," *The Language of Images*, ed. W.J.T. Mitchell (Chicago and London: University of Chicago Press, 1980), 232-33.

21 Snow, qtd. in Théberge, *Michael Snow* 22-23.

22 Théberge, *Michael Snow*, 9.

23 Regina Cornwell, "Michael Snow: The Decisive Moment Revised," *artscanada* no. 234-235 (April/May 1980): 2, 8.

24 Dompierre, in Snow, *Visual Art*, 439.

25 Heidegger, *Being and Time*, sec. 57, 322.

26 Derrida, *The Post Card*, 34.

27 Ibid., 29.

28 *Blue Blazes*, 1979, colour photograph, 87.6 x 72.4 cm, McIntosh Art Gallery, University of Western Ontario, London ON; flames consume flashes of a dark blue field in a near-black, indeterminate ambiance which is the new print; Snow, *Visual Art*, 410. *Was Red*, 1979, colour photograph, 199.0 x 67.3 cm, Fine Arts Program, Department of External Affairs and International Trade Canada; Cornwell, "Michael Snow," 5.

29 Thierry de Duve, public lecture, Art Gallery of Ontario, Toronto, 24 May 1994; my personal notes. As published: "Michael Snow: The Deictics of Experience, and Beyond," *Parachute* 78 (April-June 1995): 38.

30 Cornwell, "Michael Snow," 9.

31 Benjamin, *Illuminations*, 220-21.

32 Nasgaard, *The Mystic North*, 3. These particular painters were an important influence on Lawren Harris and J.E.H. Macdonald, who have acknowledged the impact of a Northern Symbolist exhibition in Buffalo in 1913. As future members of the Group of Seven, they participated in changing the predominant style and interpretation of Canadian landscape painting. Snow later set his camera to circulate through the Group of Seven's room at the National Gallery of Canada for the photographs of *Plus tard*. First destined for an exhibition in France and later, the National Gallery of Canada, it remains in circulation. Snow returned the northern landscape again in *La région centrale*. Symbolist landscapes, including some from the 1913 exhibition, reappeared in Toronto in 1984 in *The Mystic North* exhibition mounted by Roald Nasgaard at the Art Gallery of Ontario.

33 Denis Reid, *"Our Own Country Canada": Being an Account of the National Aspirations of the Principal Landscape Artists in Montreal and Toronto 1860-1890* (Ottawa: National Gallery of Canada, 1979), 370.

34 Stanley G. Triggs, *William Notman: L'empreinte d'un studio* (Toronto: Art Gallery of Ontario, Coach House Press, 1986), 70.

35 Reid, *"Our Own Country Canada,"* 384-86.

36 Ibid., 389, 436-37.

37 Ibid., 16.

38 Derrida, *The Post Card*, 384.

CHAPTER 7

1 *VUE∃UV*, 1998, 162 x 130 cm, colour photograph on cloth, *Michael Snow: Panoramique*; 115 in colour.

2 Derrida, *The Post Card*, 384.

3 Ibid., 27.

Bibliography

Alberti, Leone-Battista. *On Painting*. Trans. John R. Spencer. 1436. Reprint, New Haven: Yale University Press, 1966.

Atwood, Margaret. *Survival: A Thematic Guide to Canadian Literature*. Toronto: House of Anansi, 1972.

Bal, Mieke. *Reading Rembrandt: Beyond the Word-Image Opposition*. Cambridge, UK: Cambridge University Press, 1991.

Benjamin, Walter. *Illuminations: Essays and Reflections*. Ed. Hannah Arendt. Trans. Harry Zohn. New York: Schocken, 1969.

——. *One-Way Street and Other Writings*. Trans. Edmund Jephcott and Kingsley Shorter. London: NLB, 1979.

——. *Reflections: Essays, Aphorisms, Autobiographical Writings*. Ed. Peter Demetz. Trans. Edmund Jephcott. New York: Schocken, 1978.

Bochner, Mel. "Art in Process—Structures." *Arts Magazine* 40 (June 1966): 38-39.

——. "Primary Structures." *Arts Magazine* 40 (June 1966): 32-35.

——. "Systemic." *Arts Magazine* 41 (November 1966): 40.

——. "Serial Art Systems: Solipsism." *Arts Magazine* 41 (Summer 1967): 39-43.

Brunette, Peter, and David Wills, eds. *Deconstruction and the Visual Arts: Art, Media, Architecture*. Cambridge, UK: Cambridge University Press, 1994.

Burnett, David, and Marilyn Schiff. *Contemporary Canadian Art*. Toronto: Hurtig and Art Gallery of Ontario, 1983.

Chandler, John Noel. "Reflections on/of Michael Snow." *artscanada* 31 (Spring 1974): 49-52.

Clark, T.J. *The Painting of Modern Life: Paris in the Art of Manet and His Followers.* Princeton: Princeton University Press, 1984.

Colpitt, Frances. *Minimal Art: The Critical Perspective.* Seattle: University of Washington Press, 1990.

Cook, Ramsay. *Canada, Quebec, and the Uses of Nationalism.* 2nd ed. Toronto: McClelland and Stewart, 1995.

Cornwell, Regina. "Michael Snow: The Decisive Moment Revised." *artscanada* nos. 234-35 (April/May 1980): 1-9.

——. "Snow-Bound Camera." *Artforum* 17 (April 1979): 42-45.

——. *Snow Seen: The Films and Photographs of Michael Snow.* Toronto: Peter Martin Associates, 1980.

Crary, Jonathan. *Techniques of the Observer: On Vision and Modernity in the Nineteenth Century.* Cambridge, MA: MIT Press, 1990.

Damisch, Hubert. *The Origin of Perspective.* Trans. John Goodman. Cambridge, MA: MIT Press, 1994.

Davis, Ann. *The Logic of Ecstasy: Canadian Mystical Painting 1920-1940.* Toronto: University of Toronto Press, 1992.

de Duve, Thierry. "Echoes of the Readymade: Critique of Pure Modernism." *October* 70 (Fall 1994): 60-97.

——. "Michael Snow: The Deictics of Experience, and Beyond." *Parachute* 78 (April, May, June 1995): 28-41.

de Lauretis, Teresa. *Alice Doesn't: Feminism, Semiotics, Cinema.* Bloomington: Indiana University Press, 1984.

Derrida, Jacques. *Dissemination.* Trans. Barbara Johnson. Chicago: University of Chicago Press, 1981.

——. *Memoirs of the Blind: The Self-Portrait and Other Ruins.* Trans. Pascale-Anne Brault and Michael Naas. Chicago: University of Chicago Press, 1993.

——. *Of Spirit: Heidegger and the Question.* Trans. Geoffrey Bennington and Rachel Bowlby. Chicago: University of Chicago Press, 1989.

——. *The Post Card: From Socrates to Freud and Beyond.* Trans. Alan Bass. Chicago: University of Chicago Press, 1987.

Dompierre, Louise. "Toronto: A Play of History (Jeu d'histoire)." In *Toronto: A Play of History (Jeu d'histoire),* 11-29. Toronto: Power Plant, 1987.

——. *Walking Woman Works: Michael Snow 1961-67. New Representational Art and Its Uses.* Kingston, ON: Agnes Etherington Art Centre, Queen's University, 1979.

Dunning, William V. *Changing Images of Pictorial Space: A History of Spatial Illusion in Painting.* Syracuse, NY: Syracuse University Press, 1991.

Eliade, Mircea, editor in chief. *The Encyclopedia of Religion.* 16 volumes. New York: MacMillan, 1987.

Elder, Katherine. "Michael Snow: A Selective Guide to the Film Literature." In *Presence and Absence: The Films of Michael Snow, 1956-1991,* ed. Jim Shedden, 208-49. Toronto: Art Gallery of Ontario and Alfred A. Knopf, 1995.

Elder, R. Bruce. *Image and Identity: Reflections on Canadian Film and Culture*. Waterloo, ON: Wilfrid Laurier University Press, 1989.

Freud, Sigmund. *On Metapsychology: The Theory of Psychoanalysis*. Ed. and Trans. under James Strachey. Vol. 11 of *The Pelican Freud Library*. Harmondsworth, UK: Penguin, 1985.

Foreman, Richard. "Critique: Glass and Snow." *Arts Magazine* 44 (February 1970): 20-22.

Fried, Michael. "Art and Objecthood." *Artforum* 5 (June 1967): 12-23.

Frye, Northrop. *The Bush Garden: Essays on the Canadian Imagination*. Toronto: House of Anansi, 1971.

Gidal, Peter. "Beckett and Others and Art: A System." *Studio International* 188, no. 971 (November 1974): 183-87.

Gidal, Peter, ed. *Structural Film Anthology*. London: British Film Institute, 1978.

Grant, George. *Technology and Empire: Perspectives on North America*. Toronto: House of Anansi, 1969.

Greenberg, Clement. *Art and Culture: Critical Essays*. Boston: Beacon Press, 1965.

——. "Modernist Painting." In *The New Art: A Critical Anthology*. Rev. ed. Ed. Gregory Battcock, 66-77. New York: E.P. Dutton, 1973.

Grosz, Elizabeth. *Jacques Lacan: A Feminist Introduction*. London: Routledge, 1990.

Heidegger, Martin. *Basic Writings*. Ed. David Farrell Krell. San Francisco: Harper and Row, 1977.

——. *Being and Time*. Trans. John Macquarrie and Edward Robinson. New York: Harper and Row, 1962.

——. *On the Way to Language*. Trans. Peter D. Hertz. New York: Harper and Row, 1971.

——. *Poetry, Language, Thought*. Trans. Albert Hofstadter. New York: Harper and Row, 1971.

——. *The Question Concerning Technology and Other Essays*. Trans. William Lovitt. New York: Harper and Row, 1977.

Hill, Charles C. "The National Gallery, a National Art, Critical Judgement and the State." In *The True North: Canadian Landscape Painting 1896-1939*, ed. Michael Tooby, 64-83. London: Lund Humphries/Barbican Art Gallery, 1991.

Houston, C. Stuart, ed. *Arctic Artist: The Journal and Paintings of George Back, Midshipman with Franklin, 1819-1822*. Montreal and Kingston: McGill-Queen's University Press, 1994.

Hutcheon, Linda. *Splitting Images: Contemporary Ironies*. Toronto: Oxford University Press, 1991.

Judd, Donald. "In the Galleries: Michael Snow." *Arts Magazine* 38 (March 1964): 61.

——. "Specific Objects." *Arts Yearbook* 8. *Art Digest 1965*, 23-35.

Kilbourn, Elizabeth. "Michael Snow at the Isaacs Gallery." *Canadian Art* 19 (May-June 1962): 178.

Kosuth, Joseph. *Art After Philosophy and After: Collected Writings, 1966-1990*. Cambridge, MA: MIT Press, 1991.

Krauss, Rosalind E. *The Optical Unconscious*. Cambridge, MA: MIT Press, 1994.

——. *Passages in Modern Sculpture*. Cambridge, MA: MIT Press, 1983.

Kunz, Martin, ed. *Michael Snow*. Luzern: Kunstmuseum Luzern, 1979.

Lippard, Lucy R. *Pop Art*. New York: Praeger, 1966.

McGregor, Gaile. *The Wacousta Syndrome: Explorations in the Canadian Landscape*. Toronto: University of Toronto Press, 1985.

Meyer, Ursula. *Conceptual Art*. New York: E.P. Dutton, 1972.

Michael Snow/A Survey. Toronto: Art Gallery of Ontario, 1970.

Michael Snow: Panoramique. Oeuvres photographiques & films/Photographic Works & Films, 1962-1999. Brussels: Société des Expositions du Palais des Beaux-Arts de Bruxelles, 1999.

Michelson, Annette. "About Snow." *October* 8 (Spring 1979): 111-25.

———. "Toward Snow: Part I." *Artforum* 9 (June 1971): 31-37.

Mitchell, W.J.T., ed. *Landscape and Power*. Chicago: University of Chicago Press, 1994.

———. *The Language of Images*. Chicago: University of Chicago Press, 1980.

Mulvey, Laura. *Visual and Other Pleasures*. Bloomington: Indiana University Press, 1989.

Nasgaard, Roald. *The Mystic North: Symbolist Painting in Northern Europe and North America 1890-1940*. Toronto: Art Gallery of Ontario and University of Toronto Press, 1984.

Novak, Barbara. *American Painting of the Nineteenth Century: Realism, Idealism, and the American Experience*. 2nd ed. New York: Harper and Row, 1979.

Reid, Dennis. *A Concise History of Canadian Painting*. Toronto: Oxford University Press, 1973.

———. *"Our Own Country Canada": Being an Account of the National Aspirations of the Principal Landscape Artists in Montreal and Toronto 1860-1890*. Ottawa: National Gallery of Canada, 1979.

Ricoeur, Paul. *From Text to Action: Essays in Hermeneutics, II*. Trans. Kathleen Blamey and John B. Thompson. Evanston, IL: Northwestern University Press, 1991.

———. *Oneself as Another*. Trans. Kathleen Blamey. Chicago: University of Chicago Press, 1992.

———. *The Philosophy of Paul Ricoeur: An Anthology of His Work*. Ed. Charles E. Reagan and David Stewart. Boston: Beacon Press, 1978.

———. *A Ricoeur Reader: Reflection and Imagination*. Ed. Mario J. Valdés. Toronto: University of Toronto Press, 1991.

Shedden, Jim, ed. *Presence and Absence: The Films of Michael Snow, 1956-1991 (The Michael Snow Project)*. Toronto: Art Gallery of Ontario and Alfred A. Knopf Canada, 1995.

Snow, Michael. *The Collected Writings of Michael Snow (The Michael Snow Project)*. Ed. Louise Dompierre. Waterloo, ON: Wilfrid Laurier University Press, 1994.

———. *Visual Art, 1951-1993 (The Michael Snow Project)*. Toronto: Art Gallery of Ontario, Power Plant, Alfred A. Knopf Canada, 1994.

Snyder, Joel. "Picturing Vision." In *The Language of Images*, ed. W.J.T. Mitchell, 219-46. Chicago: University of Chicago Press, 1980.

Stich, Sidra. *Made in USA: An Americanization in Modern Art, the '50s and '60s*. Berkeley: University of California Press, 1987.

Sweetman, John. "The Period to 1850." In *The Panoramic Image*, 9-16. Southampton, UK: The University, 1981.

Tagg, John. *Grounds of Dispute: Art History, Cultural Politics, and the Discursive Field*. Minneapolis: University of Minnesota Press, 1992.

Taubin, Amy. "Doubled Visions." *October* 4 (Fall 1977): 33-42.

Taussig, Michael. *Shamanism, Colonialism, and the Wild Man: A Study in Terror and Healing.* Chicago: University of Chicago Press, 1987.

Testa, Bart. "An Axiomatic Cinema: Michael Snow's Film." In *Presence and Absence: The Films of Michael Snow 1956-1991 (The Michael Snow Project)*, ed. Jim Sheddon, 26-83. Toronto: Art Gallery of Ontario/Alfred A. Knopf, 1995.

——. *Spirit in the Landscape.* Toronto: Art Gallery of Ontario, 1989.

Théberge, Pierre. *Michael Snow.* Paris: Centre Georges Pompidou, Musée National d'Art Moderne, 1978.

Thomas, Ann. *Fact and Fiction: Canadian Painting and Photography, 1860-1900. Le réel et l'imaginaire: Peinture et photographie canadiennes, 1860-1900.* Montreal: Musée McCord/McCord Museum, 1979.

Tippett, Maria, and Douglas Cole. *From Desolation to Splendour: Changing Perspectives of the British Columbia Landscape.* Toronto/Vancouver: Clarke, Irwin, 1977.

Townsend, Charlotte. "Converging on *La Region Centrale*: Michael Snow in Conversation with Charlotte Townsend," *artscanada* 28, nos. 152-53 (February/March 1971): 46-47.

Tooby, Michael, ed. *The True North: Canadian Landscape Painting 1896-1939.* London: Lund Humphries and Barbican Art Gallery, 1991.

Triggs, Stanley G. *William Notman: L'empreinte d'un studio.* Toronto: Art Gallery of Ontario/Coach House Press, 1986.

Weigel, Sigrid. *Body- and Image-Space: Re-reading Walter Benjamin.* Trans. Georgina Paul with Rachel McNicholl and Jeremy Gaines. London: Routledge, 1996.

Wheeler, Daniel. *Art Since Mid-Century: 1945 to the Present.* Englewood Cliffs, NJ: Prentice-Hall and New York and Paris: Vendome Press, 1991.

Youngblood, Gene. *Expanded Cinema.* New York: E.P. Dutton, 1970.

——. "Icon and Idea in the World of Michael Snow." *artscanada* 27 (February 1970): 1-14.

Index